Homage to the Himalayas

I dedicate this book to René Collet and to the memory of Anna. All the expeditions we undertook together—from the Karakorum to Dolpo, from Mustang to Tibet, from Sikkim to Bhutan—enabled me to bring back such a wealth of images for this book and to scale the highest peaks of friendship.

Olivier Föllmi

Homage to the Himalayas

Preface by His Holiness the Dalai Lama

In collaboration with Benoit Nacci

Translated from the French by Simon Jones

Harry N. Abrams, Inc., Publishers

Preface by His Holiness the Dalai Lama

Profound changes have rocked many regions of the world over the last century. Undoubtedly, there is a pressing need to improve people's living conditions, facilitate access to education, and develop transport links. However, in passing from one way of life to another, there is a risk of rejecting everything that has stood the test of time, of favoring the new at the expense of the old—and thus of losing all sense of our values. Perhaps this largely explains people's fascination with regions that are still untouched by the modern world, where ancestral customs and values survive.

Olivier Föllmi and his wife have shared the day-to-day life of Himalayan people over many years. Their strong bond with the region, its inhabitants, and its landscape is reflected in the intimate quality of Olivier's photographs. His penetrating gaze conveys both the natural beauty of the Himalayas and the uniqueness of its peoples.

The region's mountainous terrain makes access difficult, and even today the Himalayas remain more resistant to change than other lands. Their inhabitants live in harmony with the seasons, and they perceive time differently than people who live in huge, overpopulated cities. They could be defined by their patience and their calm. Although I know the Tibetans best, I have observed that most other Himalayan peoples share their placid attitude to life. They are content with their lot and do not fear

hardship. Although this can be attributed to the harsh climate and rugged environment, there is also another contributing factor: Buddhist culture, which has existed in the Himalayas for more than 1,000 years. With its teachings based upon love, kindness, and tolerance, its doctrine of compassion and nonviolence, and its sense of relativity, Buddhism permeates the soul and the spirit of the Himalayan peoples, endowing them with great reserves of inner peace.

My aim is not to preach a return to ancient ways of life, for modern civilization offers many benefits for humankind. However, whether they are living in a developed or a developing country, people today face a stark challenge: to achieve inner harmony, a source of peace, as traditional communities do, while at the same time enjoying the material benefits of the modern world. With Homage to the Himalayas, *Olivier Föllmi offers the reader a wonderful opportunity to explore a world rich in its own vital values, for which each of us feels a profound affection.*

TENZIN GYATSO, FOURTEENTH DALAI LAMA, JULY 2004

I discovered the Himalayas at age seventeen, when my longing was mainly to climb their peaks. I saw these mountains as an adventure playground, and it was in this spirit that I approached them. However, after twenty-five years in their valleys and the nourishment of my experiences among their people, I learned to consider my presence in the Himalayas as a life journey. Many are the men and women who, though utterly ignorant of the world beyond their remote villages, have been my teachers. Humbly, they have shown me by the light of the butter lamps in their mud huts that no knowledge, no law, can replace the light of love.

When I was twenty, I threw myself into my first great Himalayan adventure, accompanied by Danielle, who was to become my wife. We followed the Jumlam path to reach Zanskar, an ancient Buddhist kingdom that is buried under snow for nine months of the year. The beginning of our journey—from Ladakh, at 11,480 feet (3,500 meters)—was idyllic. Upon our arrival at Zanskar, however, after a ten-day trudge following a yak caravan over snowy paths, I was at death's door—my feet were frozen, and I was developing gangrene. This journey of initiation led us slowly out of the villages and deep into gorges, where we followed the trails of wild beasts. Despite its nearness, death seemed to us as beautiful as life. As we surmounted each pass, plodding through the snow, intoxicated by the wind and the vast space, the horizon of white crests stretching to infinity revealed to us the abyss of eternity.

My affinity for Tibetan culture was confirmed at the monastery of Phuktal, where for a winter I lived and shared the monks' way of life. I did not learn any great truths there—I was far too green to try reading the texts—but I prayed in the sun, on the terrace overlooking the Frozen River, alongside monks who pointed me along the path their hearts followed. With them I felt free to grow gently, smiling as much at my faults as my strengths, to reach beyond the contradictions in myself and find riches in the differences.

"There is no path to happiness; the path itself is happiness." —BUDDHA

One winter evening, in the low light of a butter lamp that made the room as solid and cozy as a cellar, we linked our destiny with that of two children, themselves destined to a peasant life. Their parents, Lobsang and Dolma, entrusted us to introduce Motup, a boy of eleven, and his eight-year-old sister, Diskit, to the world by accompanying them on the ten-day journey to their school. Our common karma would eventually go even further and unite us as a family. On this trip, we followed an icy path beside a river that wound through the bowels of the earth, constantly probing its frozen surface with our staffs. Sometimes I advanced with confidence, stepping firmly onto the solid ice; but sometimes I hesitated, preferring to retrace my steps and find a better way. In exploring this uncertain path, I began to see that existence is like the trek along a frozen river, each of us groping through the canyon of life. The children followed in our footsteps over the crackling ice, and we bore the heavy burden of responsibility for them. One question haunted me. Would what Motup and Diskit learned at school be of equal value to what they forgot of their valleys? I was afraid that the school where we were taking them would destroy what we loved in them. How could we reconcile the Buddhist values of these ancient valleys with the adaptation to change they so strongly advocated?

Our education continued at Dharamsala, at the foot of the Himalayas, among the community of exiled Tibetans living in India. In the Tibetan schools where Motup and Diskit studied for a few years, we encountered the same ardor, the same alert attentiveness as in the mountains of Zanskar. However, we also discovered a more sophisticated society. Just as the peasant families of the remote mountain valleys had offered us their hospitality, so those who ran the Tibetan schools allowed us to share their values. Anxious to hand down the heritage of Tibetan culture to the thousands of children of all ages—some orphans, others living apart from their parents throughout their schooling—the schools had not only to teach them to adapt to modern learning but also to look after their food, health, accommodation, clothing, and recreation—all the while preparing their students for their future lives. These teachers were models of courage, devotion, and day-to-day altruism.

Filled with admiration for this sense of identity, we set off for the high plateaus of Tibet, where the culture that forged these people had developed. The Tibetan civilization was built slowly, over centuries and through the generations, by dedicated people of vision; in those plateaus, however, we saw that a few decades and some cowardly fanatics with weapons had been enough to annihilate it. The People's Liberation Army first invaded Tibet in 1950, sowing death and destroying all the monasteries. Chairman Mao's agricultural reforms, and his indoctrinated gangs, had caused the death of 1.5 million people. China, happily, has moved on from those dark years. But as the country rebuilds itself, it also flaunts a showy materialism, the consequence of a past devoted to the extinction of its culture's human dimension. Tibet serves as China's amusement park, and Tibetan culture is always denigrated. I have thus developed an undying admiration for those monks and nuns who, from the depths of their Lhasa prison, affirmed their spiritual devotion to their master the Dalai Lama, even at the cost of suffering torture that ended in death.

I, also, came to venerate this man who preaches nonviolence. So I followed in the footsteps of the Tibetans who traveled on foot to Bodh Gaya, in India, crossing mountain passes and braving armed border guards to listen to their spiritual father's teachings on peace. They were tasting freedom for the first time in three generations. Though suffering marked the faces of some, their eyes betrayed no hint of a painful past. Pilgrims in the hundreds of thousands came to sit cross-legged around the stupa—marking the spot where the Buddha had attained enlightenment more than 2,500 years ago—and to pray in the same deep voice for the good of all people. There, I discovered the strength that sustains this people. Each wanted to sow the seeds of peace. For the people of Tibet, the desire to take action achieves as much as the action itself.

"Where there is a will, there is a way."— BUDDHA

In Bhutan, I found a Buddhist country that had survived the Communist revolution unscathed. The country's northern mountains protected it from invasion by Maoist China. To the south, its jungles protected it from Indian influence. This small kingdom, the only Asian country whose state religion is Vajrayana Buddhism, has thus been able to develop in harmony. Bhutan may be second from the bottom on international, economic-statistic tables, but the country I traveled was at peace, with decorated houses and dazzling festivals. As the king has explained, "gross national happiness" comprises modernization and access to communications along with the traditional values of respect for one's elders, for religion, and for the country's cultural heritage. He tried to ban television in his kingdom, conscious that this cultural scourge is even more dangerous and insidious than rebels or separatists. However, he was forced to yield to commercial pressures from more powerful countries; obsessed with the profits that the airwaves yield, such countries have lost sight of the infinite power of human communication.

It was in the Mustang and Dolpo regions of Nepal that I discovered the value of commerce as a link with the outside world. These high, remote valleys were too sparsely populated to excite the greed of their big neighbors. For centuries villagers had lived by bartering salt for grain and wool for utensils. The bawdy songs of the caravan traders returning home after weeks of travel did not spring from the pleasure of having made a profit, but from the satisfaction of having fulfilled a duty in keeping with their tradition. They felt connected to their ancestors, who had trudged the same paths, experienced the same joys, and faced the same fears. By living this life dictated by the seasons—with its nights spent unexpectedly under the stars and its long waits in the event of snow—they were always in pace with time and in harmony with the universe.

Echoing along the rocky slopes, the traders' vigorous voices also expressed their joy at coming home with tales to tell and adventures to share. They wasted no energy in trying to make their material circumstances more comfortable. They considered themselves satisfied to be bringing food home and that their families had clothes on their backs, a roof over their heads, and gods in every valley. In these little villages clinging to the vast flanks of snow-capped mountains, I realized how having wisely modest aspirations can keep life both happy and meaningful.

In contrast, I encountered extreme hardship among the Dumka road builders, who are hired by the Indian army in the poor region of the Bihar plain. These armies of frail-looking men dig thousands of miles of strategic highways—the highest in the

world—by hand. Caked with mud, shrouded in a cloud of tar smoke, they advance like so many slaves, digging, shoveling, raking, and laying asphalt under a beating sun, sometimes enduring sudden blizzards from which not all survive. In their vast numbers, they can finish jobs that would be impossible for rudimentary machinery to carry out in the space of a summer—the only season when work is feasible. The vastness of the task does not frighten the Dumkas, who are accustomed to living from day to day and who never complain. They would rather endure the hell of road-building work than be idle, or be held ransom in their villages by the bandits, loan sharks, and politicians who are driving the state of Bihar to ruin.

I wanted to highlight the work of the Dumkas because once it is complete, no traveler who climbs these passes, some reaching heights of 20,000 feet (6,000 meters), could imagine that this titanic work was achieved with human hands. At the same time, I want to link the recognition of their work to the economic development of the Ladhakis, who do not hold the Dumkas in high esteem.

The inhabitants of Ladakh and even those of Zanskar are well-off compared to the Dumkas. In each village, every family owns land and a house. It can count on its assets to provide a solid foundation upon which it can reliably enjoy the fruits of its labor. Surrounded by mountains, which are home to their protective deities, these people benefit from permanent reference points, the signs of interior peace.

Such conditions seem indispensable for survival at high altitudes in winter. However, the shepherds of Rupshu do not enjoy this privilege: their life is the most precarious I have observed in the Himalayas. This small community lives by rearing goats and selling their pashmina wool. Four times a year, the shepherds migrate with their flocks from one mountain pasture to another, carrying all their possessions, which are limited to what their animals can carry. They have refined frugality to an art, confining themselves to the bare necessities for survival. However, their constant migration means they cannot build up any stores. At any time a spring may go dry, or the close-cropped grass may wither and put their lives in danger. For generations they have lived in tents of coarse yak's wool, continuing to depend on the whims of the weather, from season to season, lifetime after lifetime.

One winter I ventured as far as the encampments at Tso Kar, where the shepherds shelter with their flocks in a bowl-shaped valley that is supposed to be spared from snowfalls. That year, however, the snow had fallen to an altitude almost 1,000 feet (300

meters) lower than usual, covering all the valleys like a white sheet. The animals were starving, having been unable to graze for weeks. Every morning the shepherds found more animal carcasses. When all the animals had died, it would be the humans' turn, in the implacable logic of the chain of life.

Despite this extreme precariousness, despite their infinite sadness during that terrible winter, the shepherds kept alive their link with the sacred. They took the time to devote themselves to their rites and to recite religious texts. They taught me how the obsession with improving the material side of life is a meaningless distraction when it becomes an end in itself. For them, nourishing the spirit is as vital as feeding the body.

"Life is not a problem to be solved, but an experience to be lived." — BUDDHA

Thanks to the Himalayas, I have also had incredible adventures when climbing their summits in the company of my fellow mountaineers. Each climb, regardless of its success, left me filled with an indefinable nostalgia, and I paid homage to the mountain and to my companions for the emotions I was given to experience. The immaculate snowy slopes, which we climbed like so many insects; the fragility of our existence in tents anchored with precarious ropes on the edge of chasms; a modest glance, furtively exchanged, after hours of grueling effort to seal an ephemeral victory: such were the graces that allowed me to live that period of my life at a high intensity. On the descent from one of these difficult climbs we were caught in a violent, howling windstorm, and I thought I would not survive. This experience made me aware of the precariousness of life, but above all of its beauty. After we had returned to base camp, I gazed in wonder at the first autumn bushes and the first withered flowers. The stream that had quenched my thirst became a torrent, crashing against the rocks like a hymn to life. Dazzled, I smiled at the forest, which rose out of the mist like the earth's great mane. The first glimpse of a village far below—plumes of smoke rising from its thatched roofs—reminded me of the sweetness of home. That was when I felt the need to start a family.

As a gift for life, after all these years of conversations and confidences, the community of Tibetan exiles entrusted us with two of its children to adopt: Yvan Tharpa Tsering and Léonore Pema Yangdon, with whom Danielle and I have shared our lives

ever since. Once settled in the West, we tried for their sake to understand their past and trace their roots. The Tibetan community had not deemed this necessary. As far as it was concerned, the children's new lives began with us, and what had happened before belonged to a past life. We should seize this rare opportunity. Although I fully accepted this view when I was in the Himalayas, I found it difficult to adhere to once in the West, because it concerned my children. After years of searching, therefore, we traced their families and returned to Kathmandu and to Bylakuppe, southern India, to meet the children's fathers.

We had gone against the principles of the Tibetan community, but it never disapproved of us. On the contrary: it congratulated us. This was my best lesson in tolerance.

It seemed to me that in bringing our two children to the West, I was completing my Himalayan journey—all the more since our two elder children, Motup and Diskit, are now on the verge of adulthood. Through our journeys together and our shared lives over the past fifteen years, they have learned to juggle the codes of behavior of three different cultures: Tibetan, Indian, and Western. They are equally at ease when they return to their native country, sitting cross-legged in a mud room and eating barley meal, as they are sitting at a gala dinner. Will this adaptability prove to be the key to their happiness? They must now make their own life choices, and probe their own frozen river.

Thanks to Motup and Diskit, Yvan and Pema, Nyima Lhamo, Rigzin Tundup, and all those children whom we so loved in that country, we have preserved our link with the Himalayas, proving now and forever that love that binds us together, like a lotus born of our travels, which blooms anew every day.

OLIVIER FÖLLMI

"Do not forget to live according to your heart, close to men,
to discover the god that dwells in each of them."

—TASHI NAMGYEL GYALPO, FORMER KING OF ZANSKAR

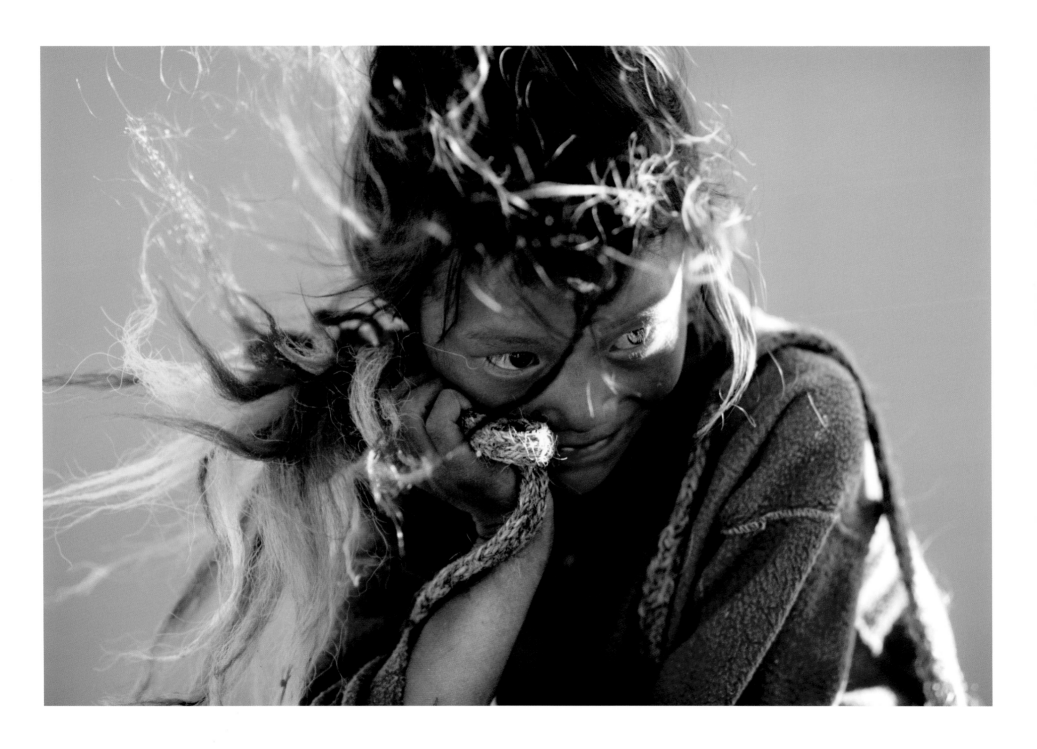

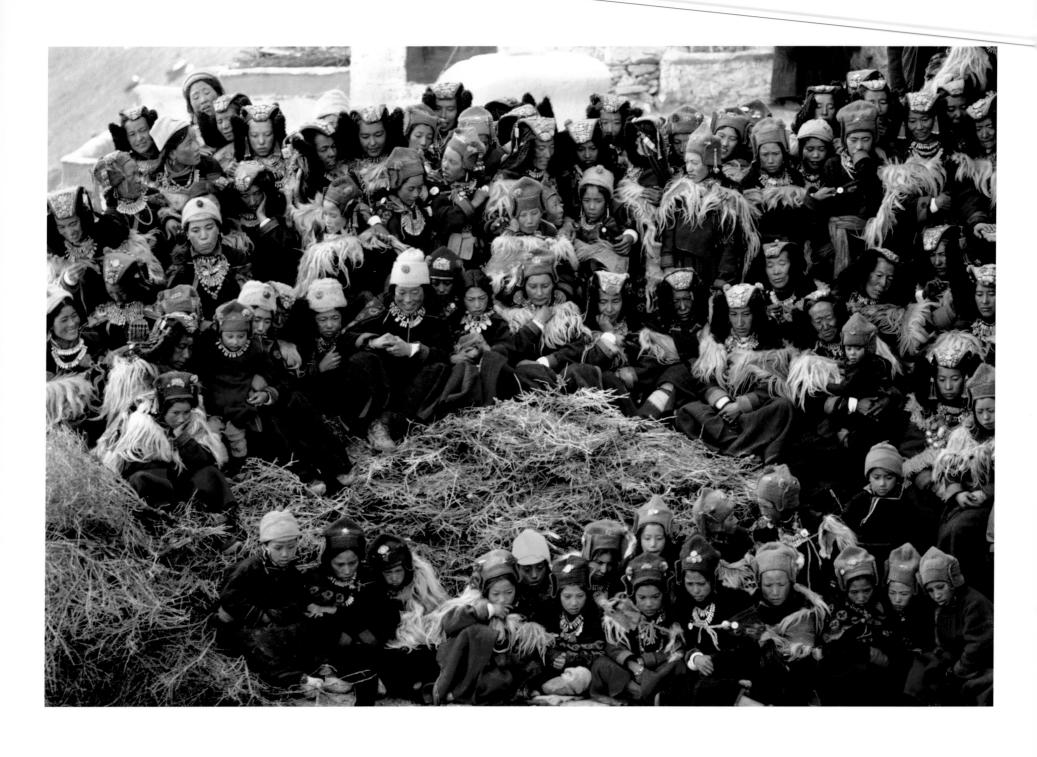

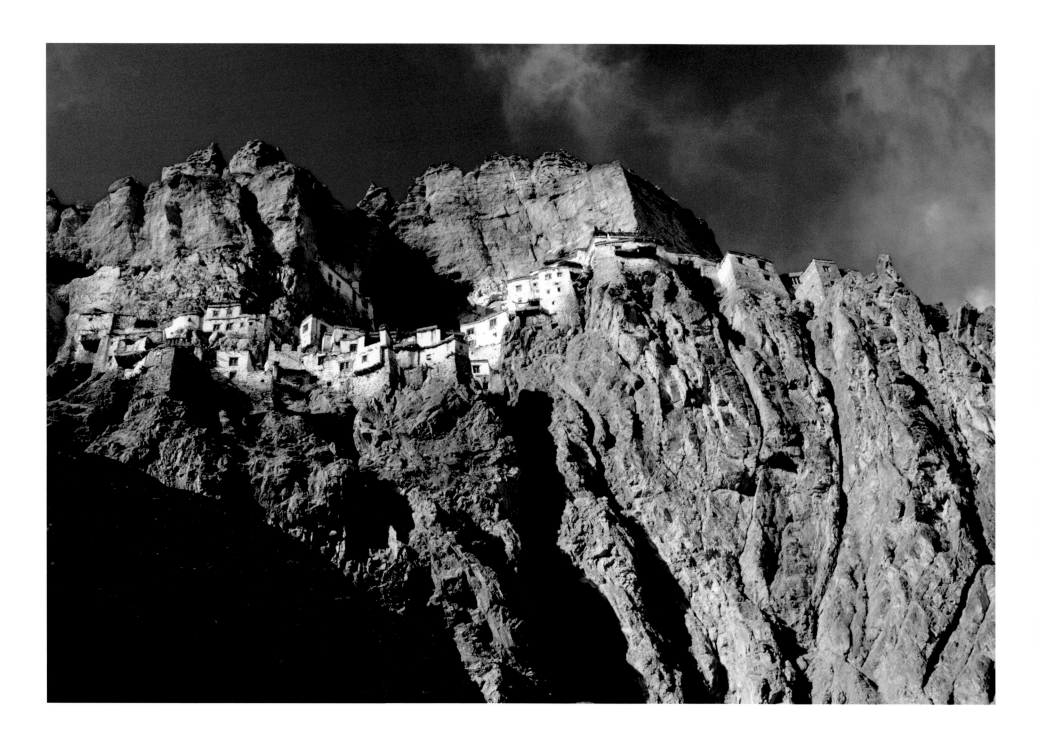

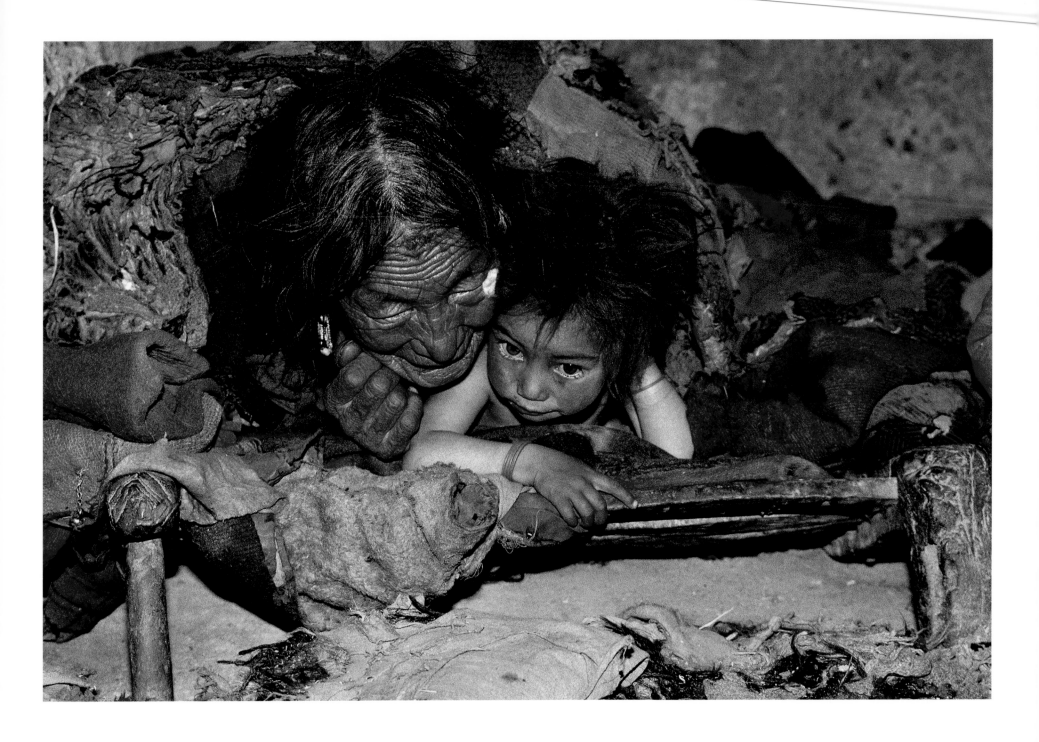

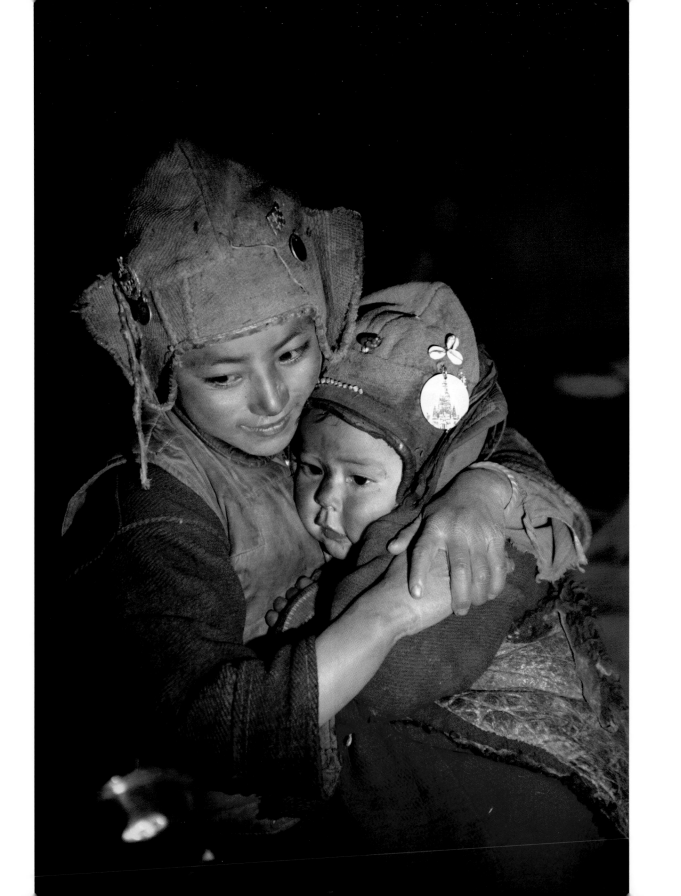

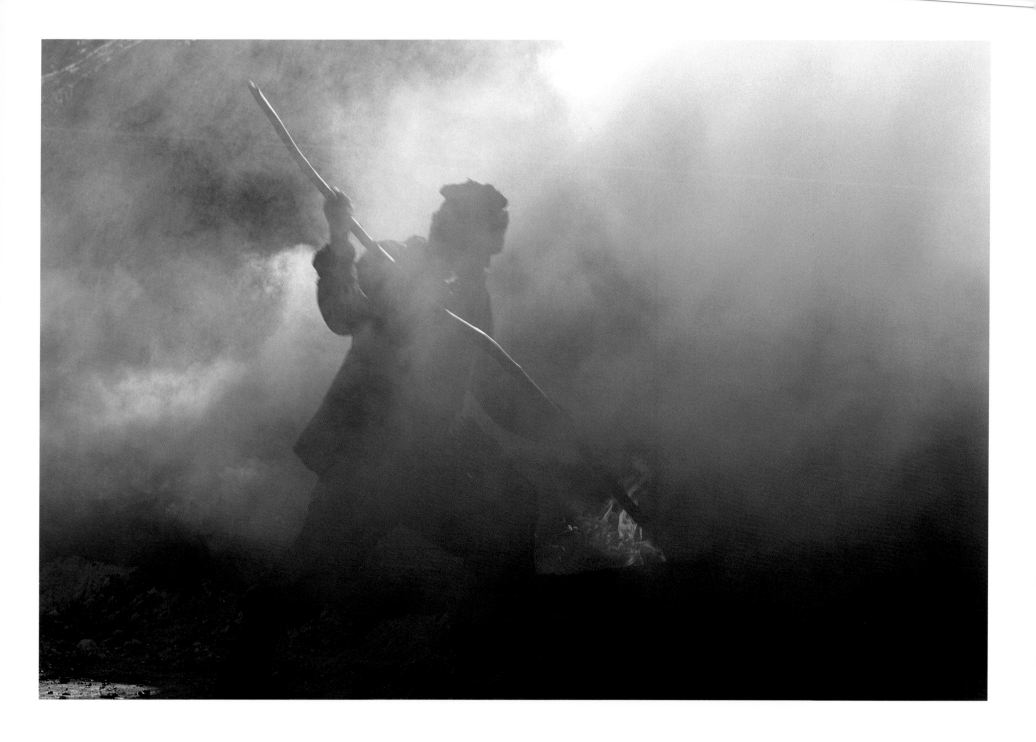

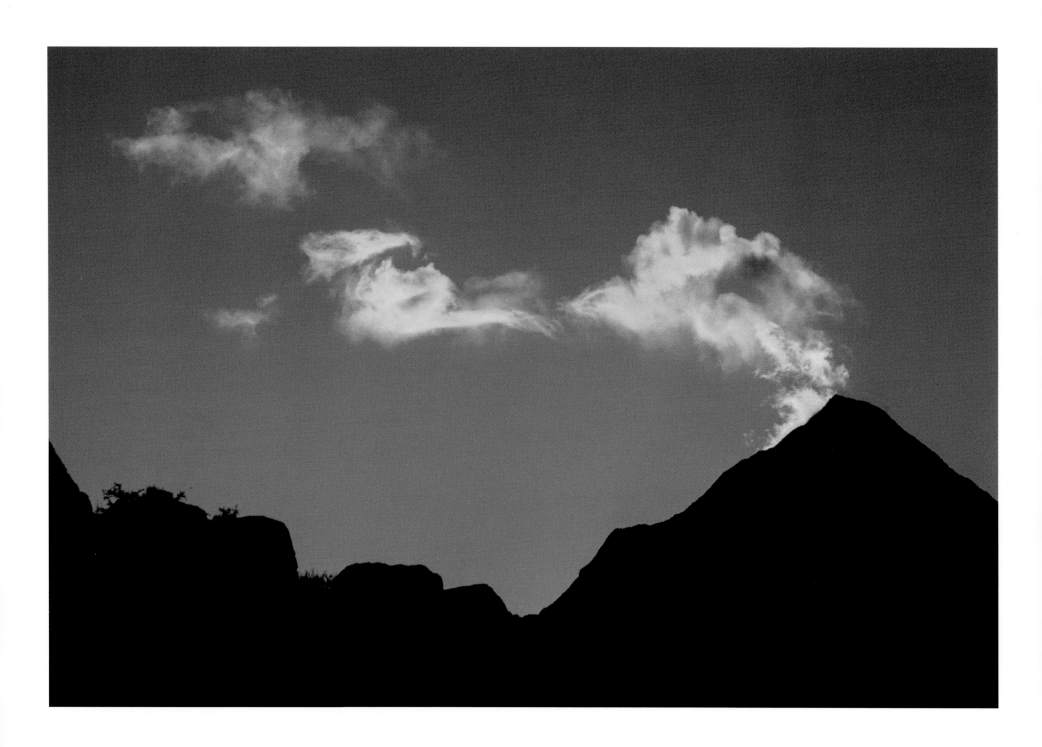

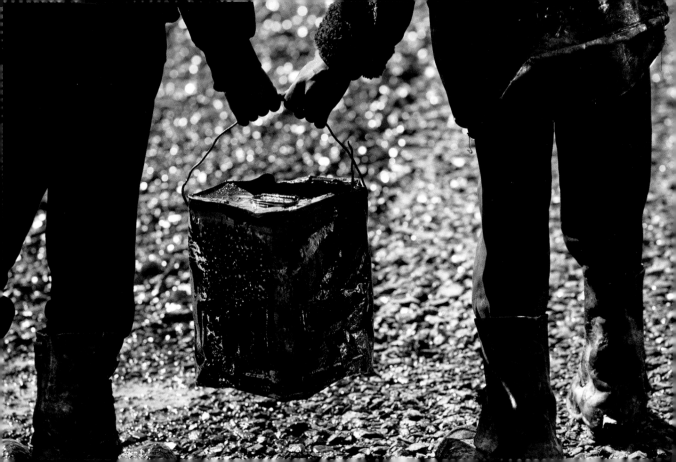

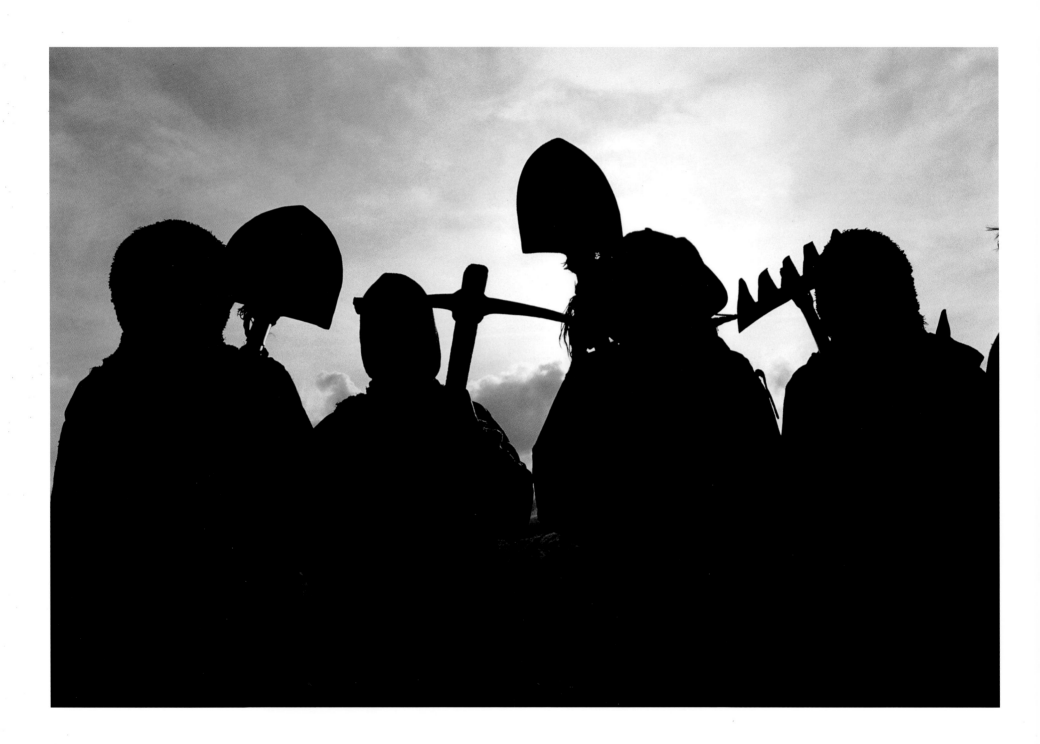

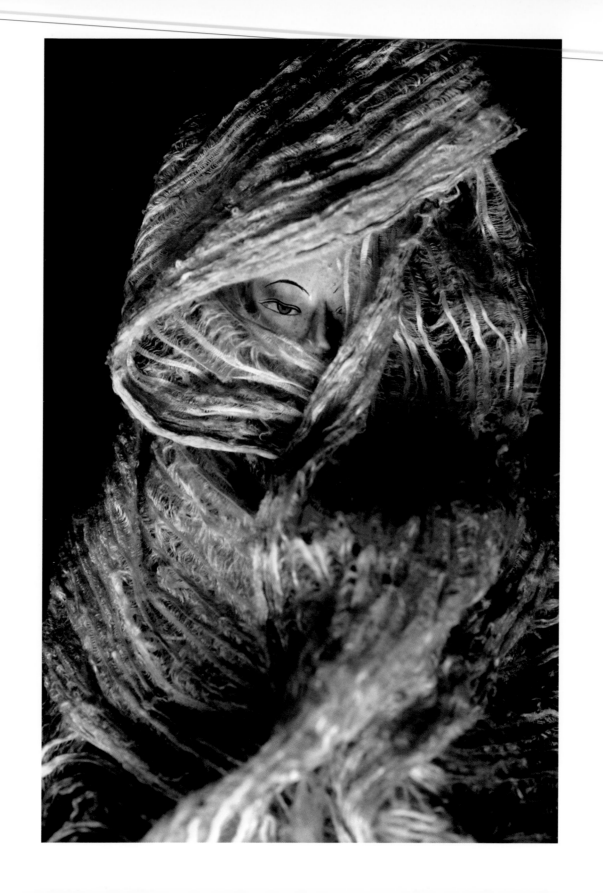

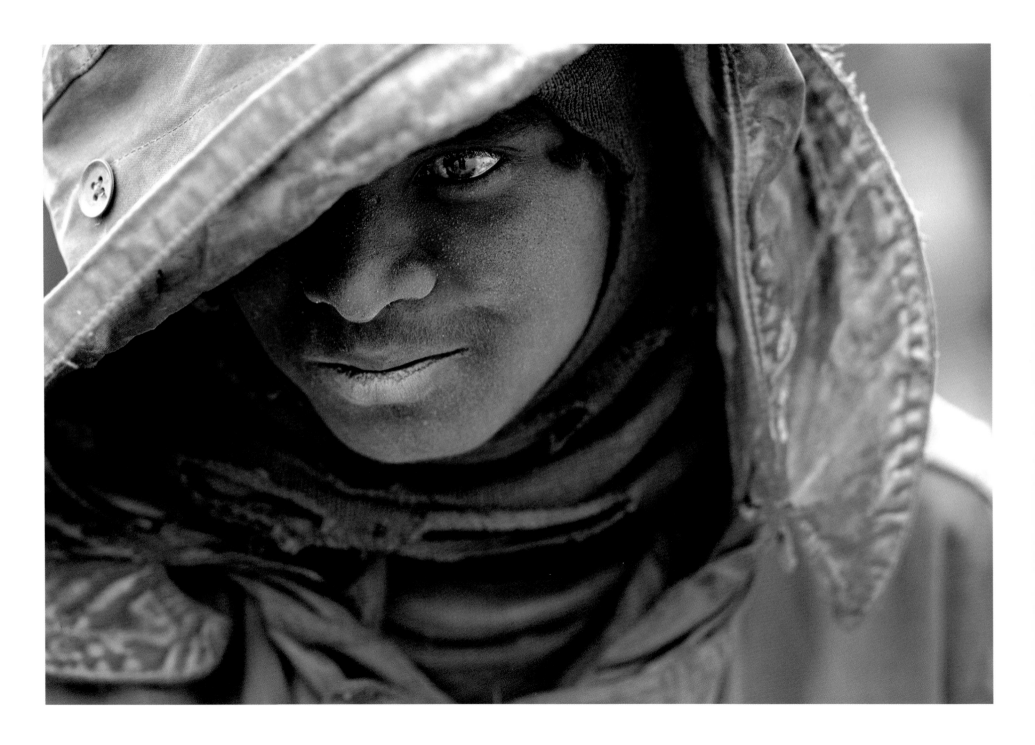

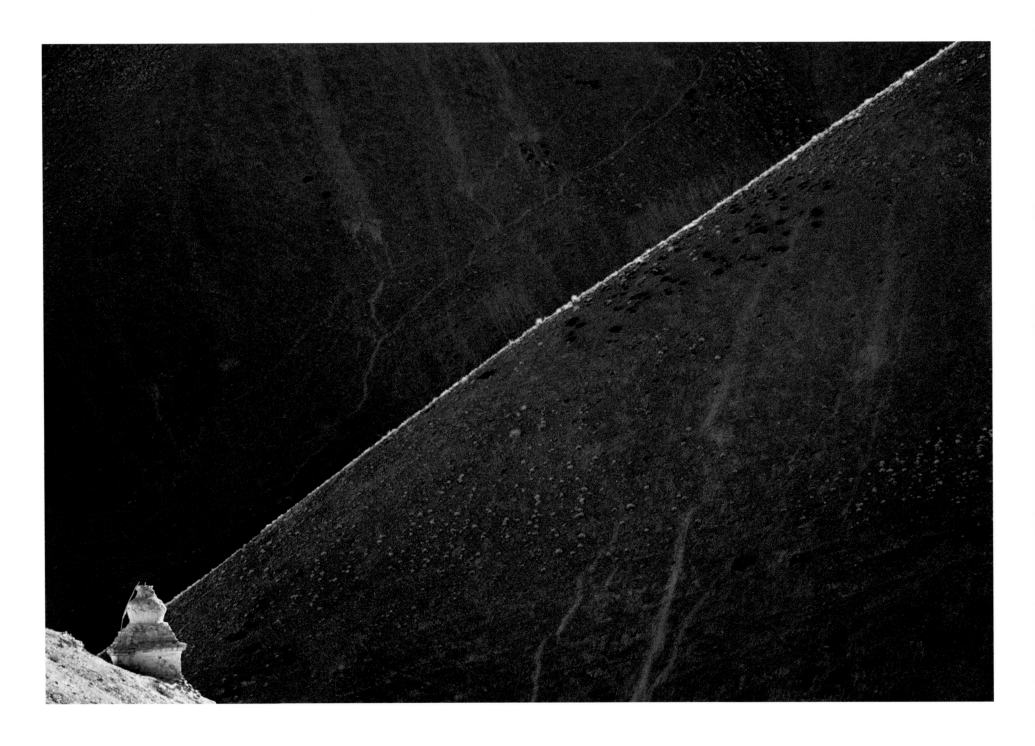

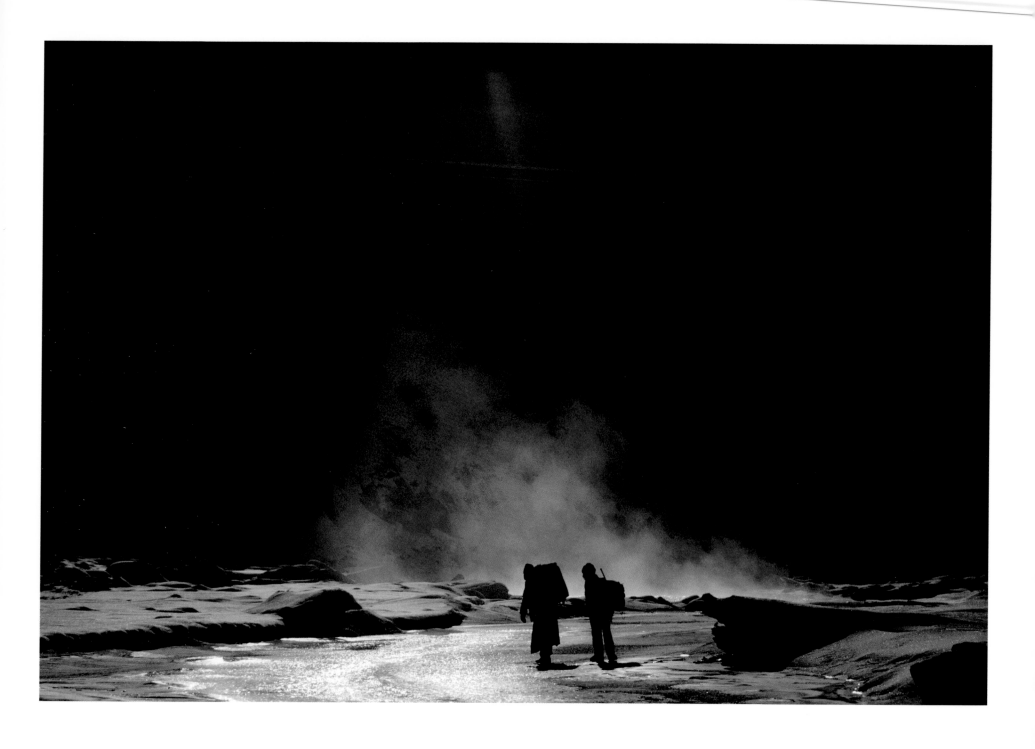

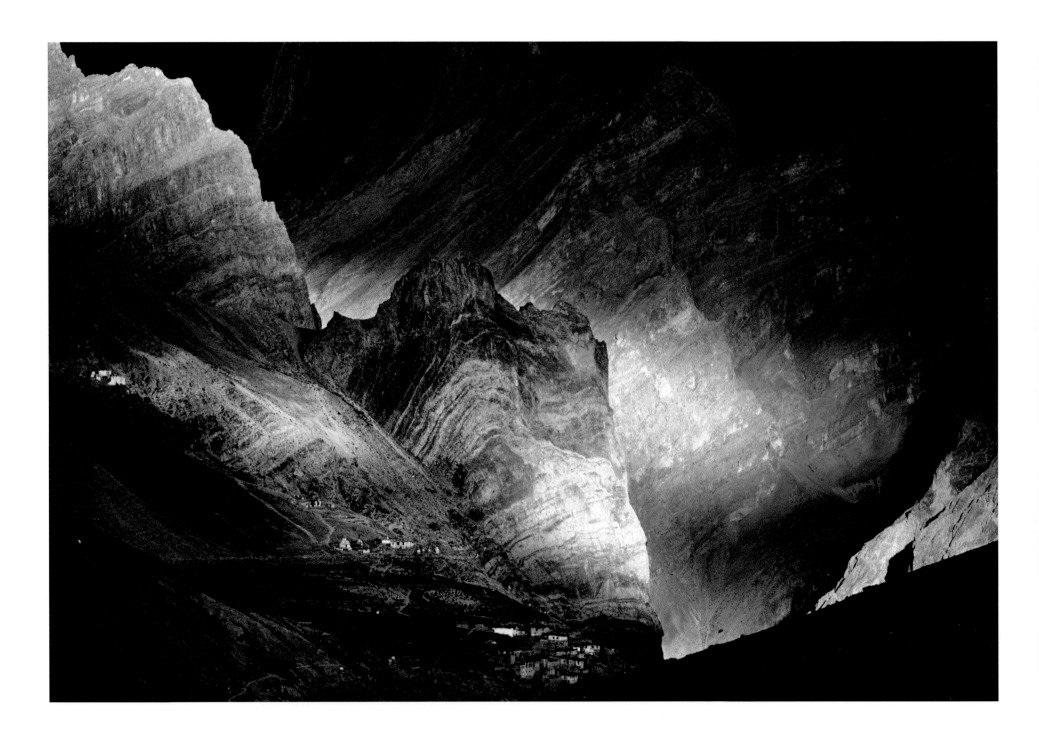

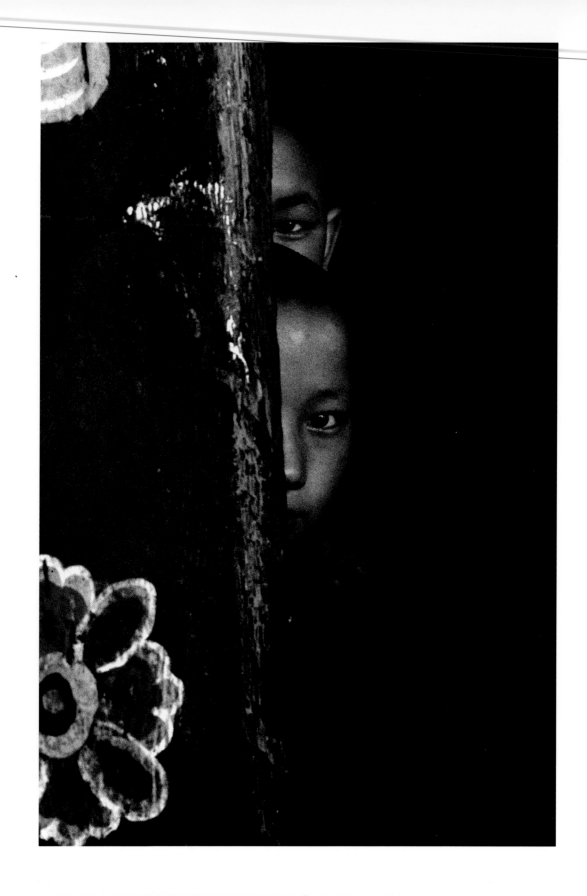

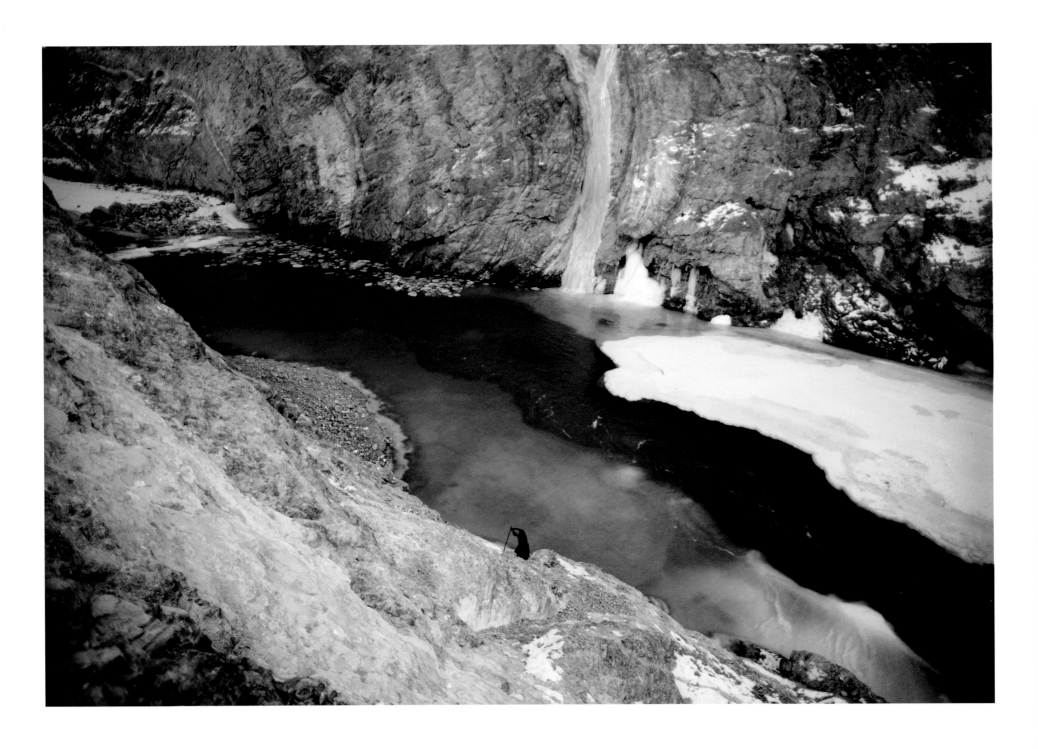

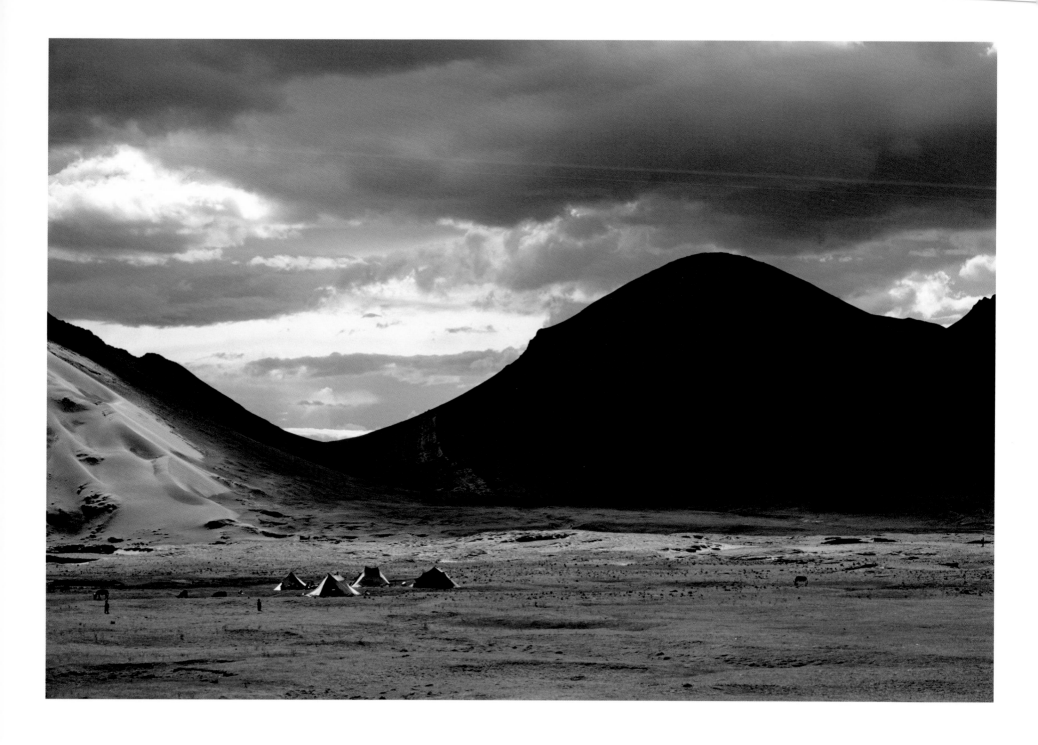

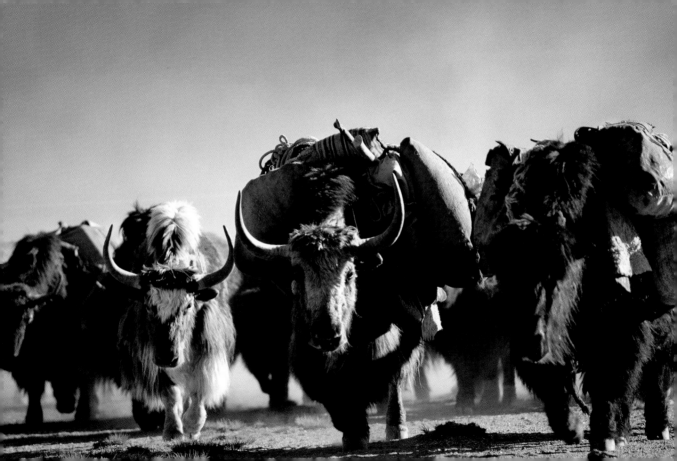

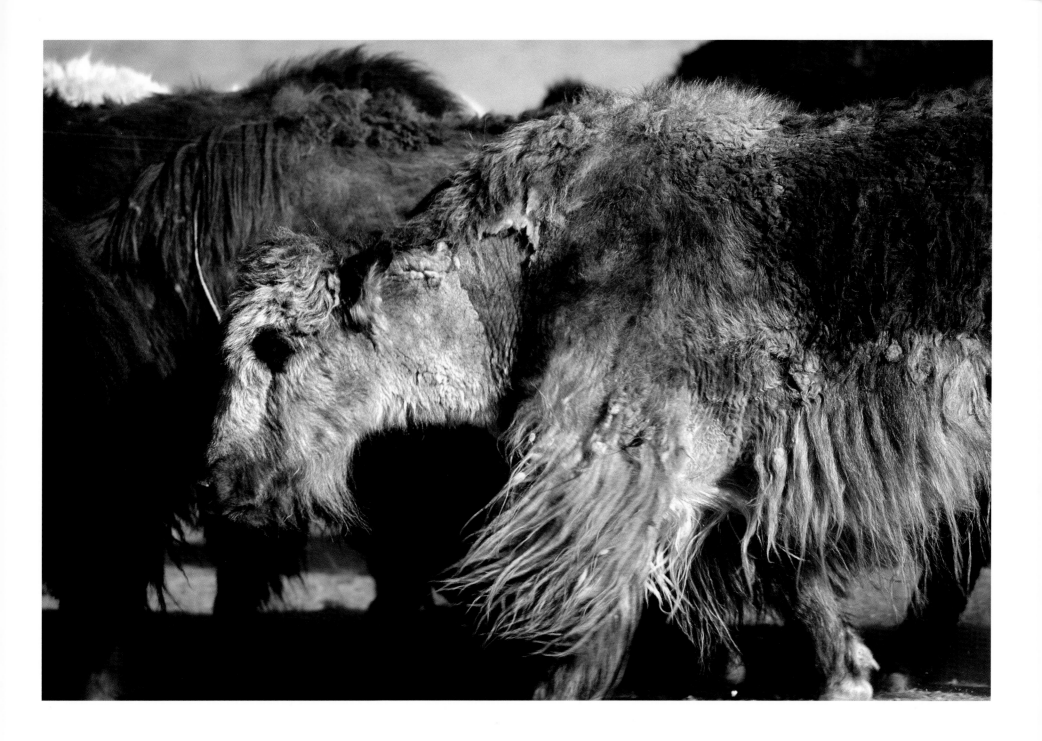

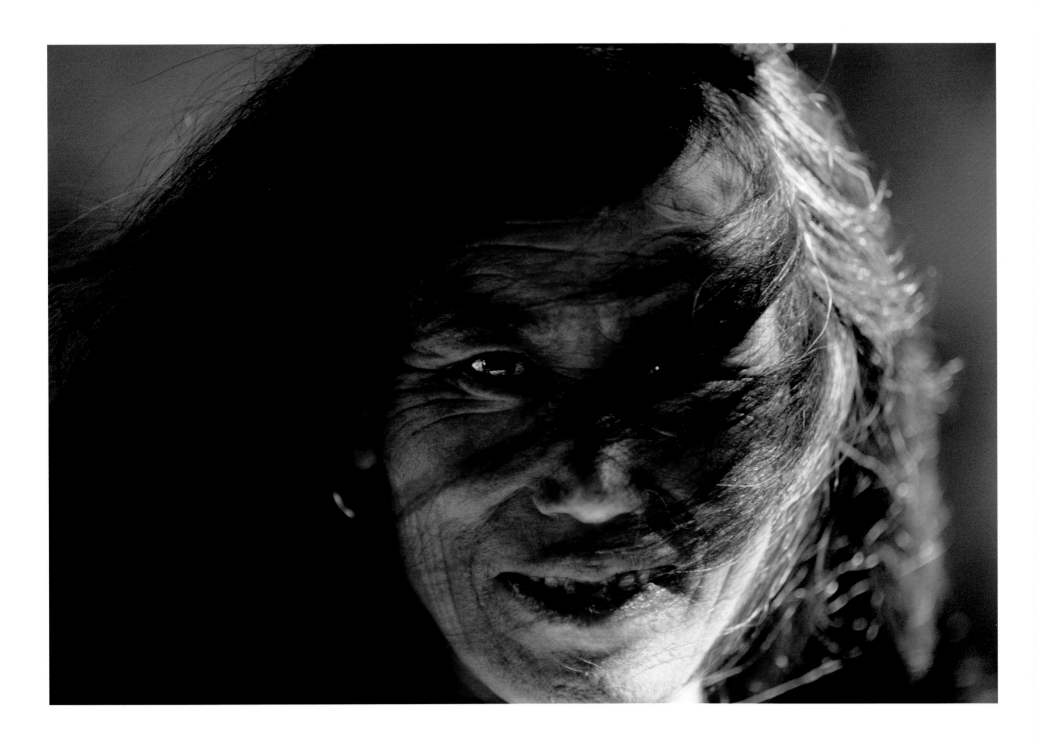

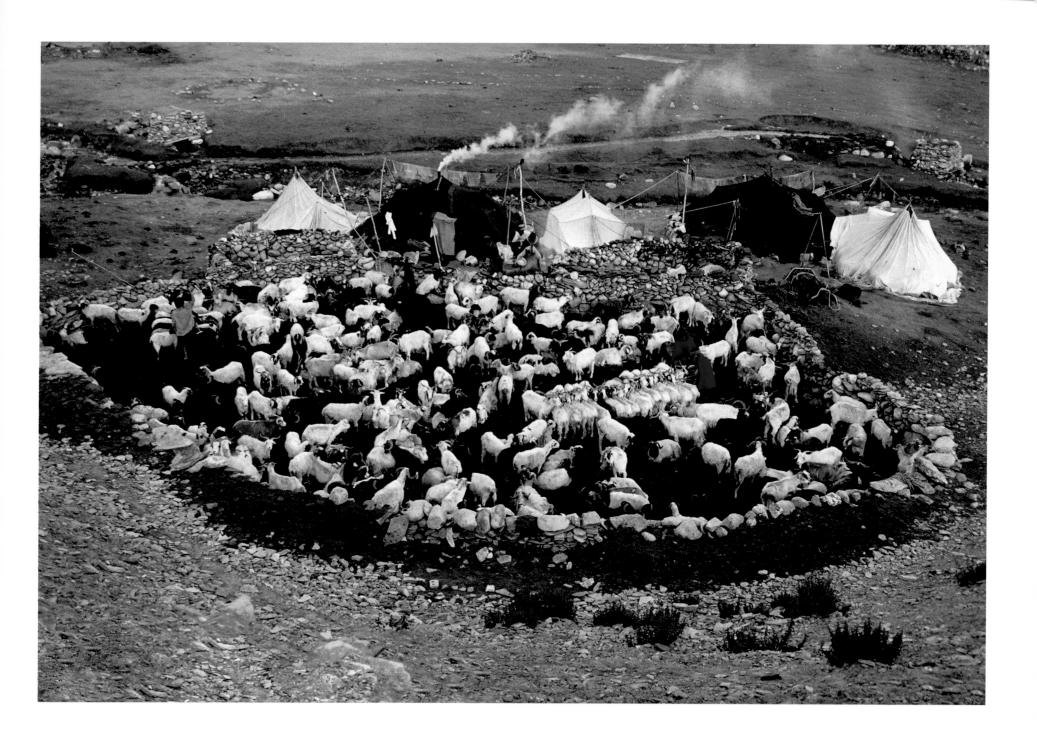

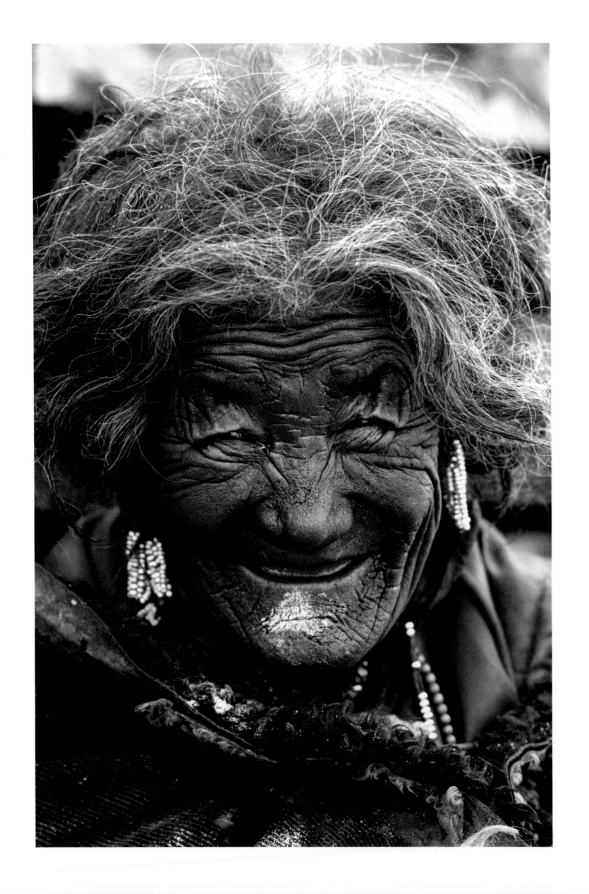

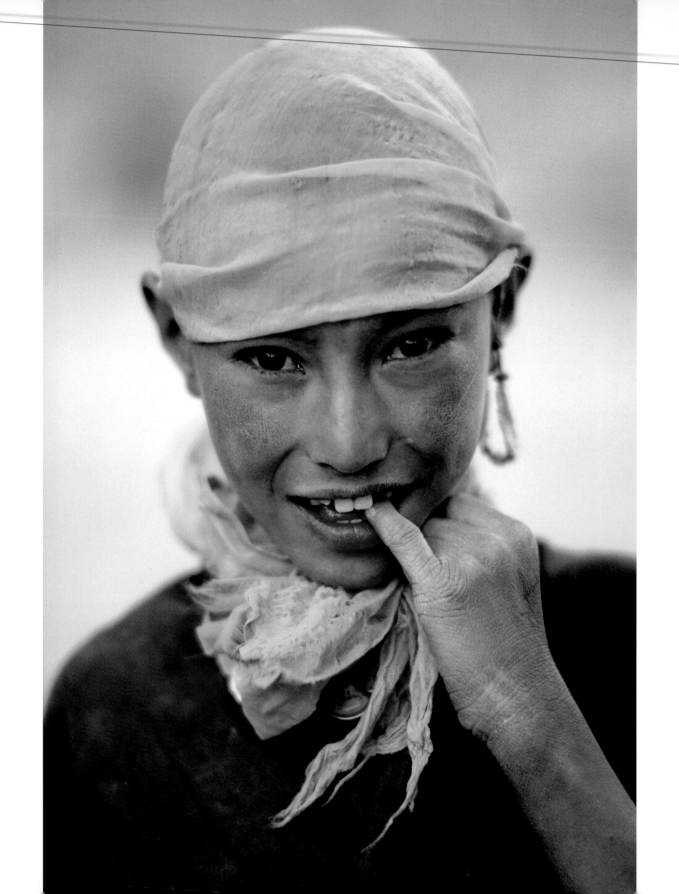

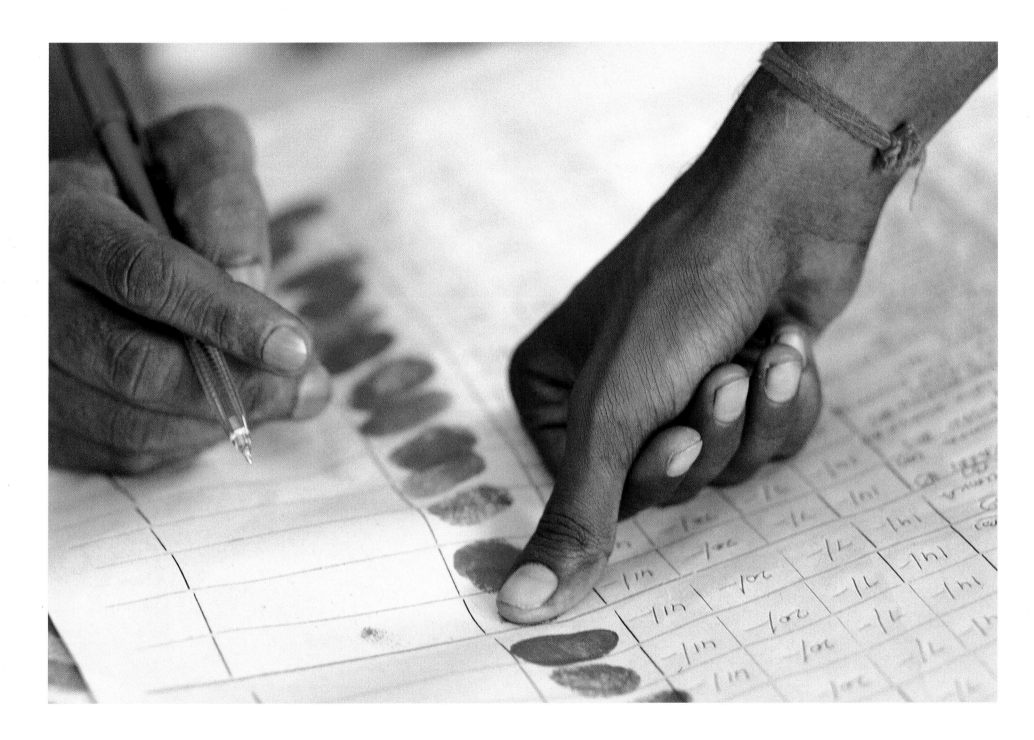

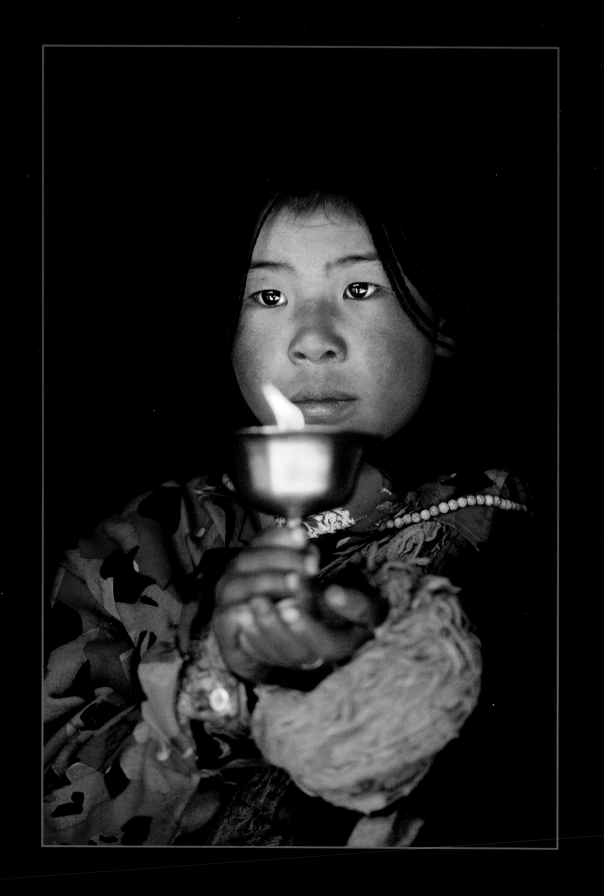

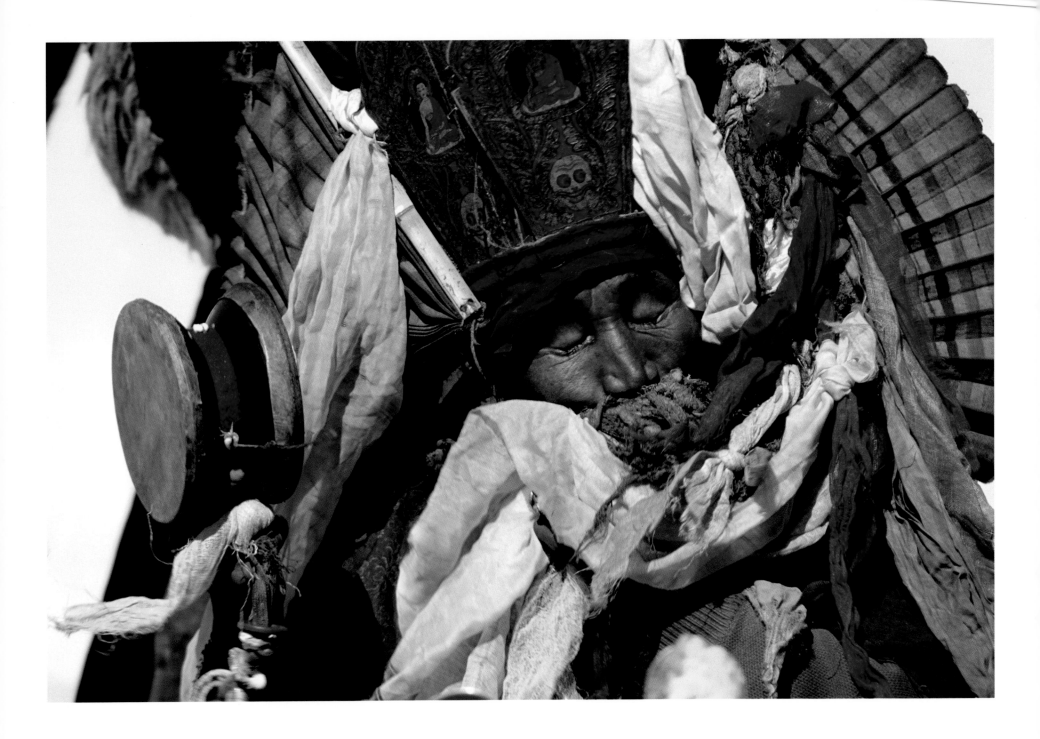

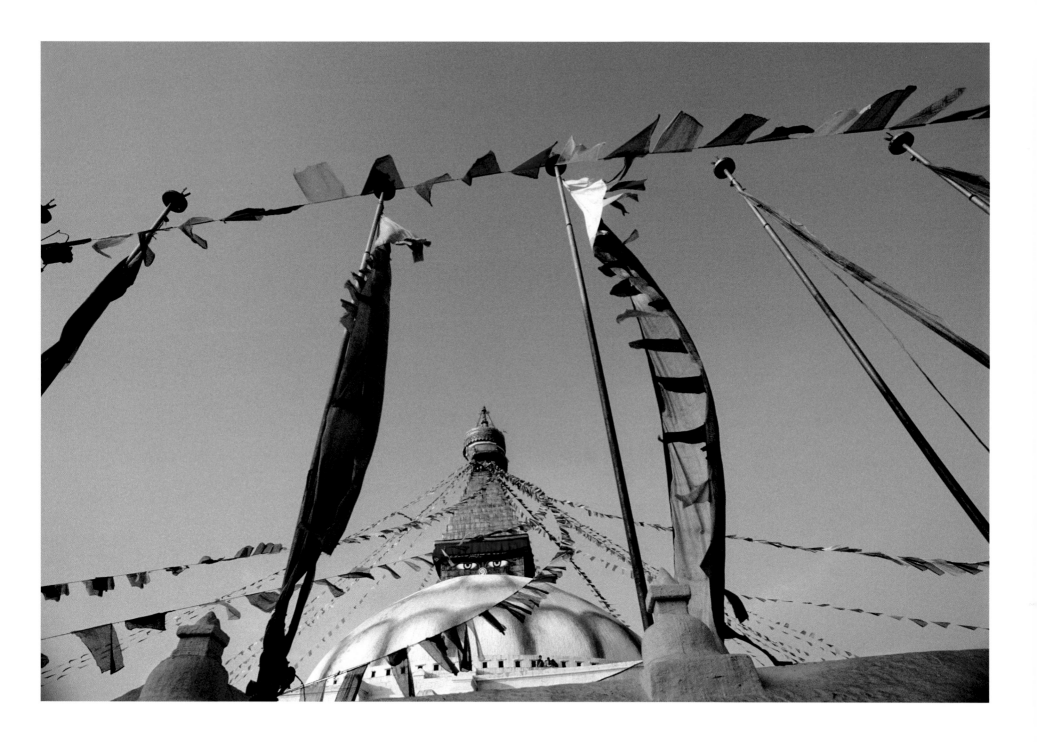

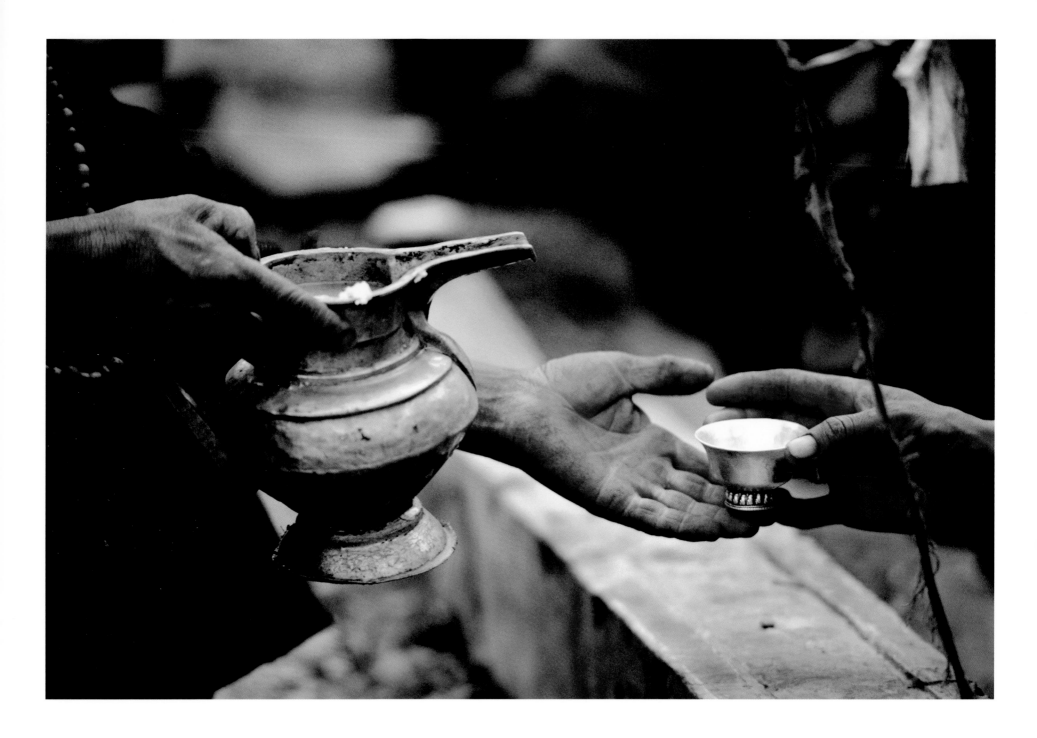

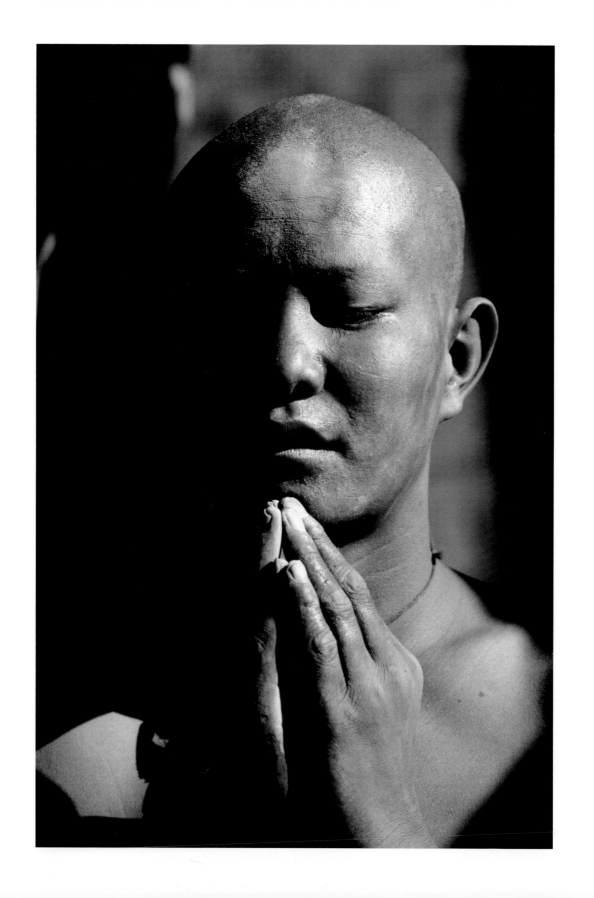

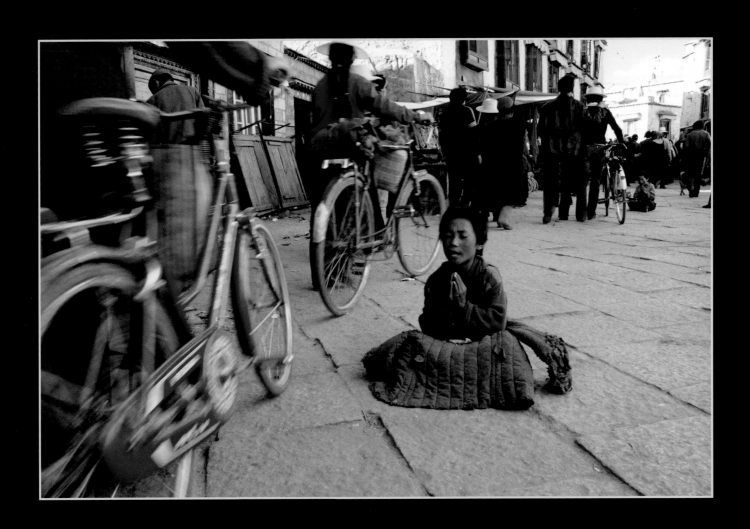

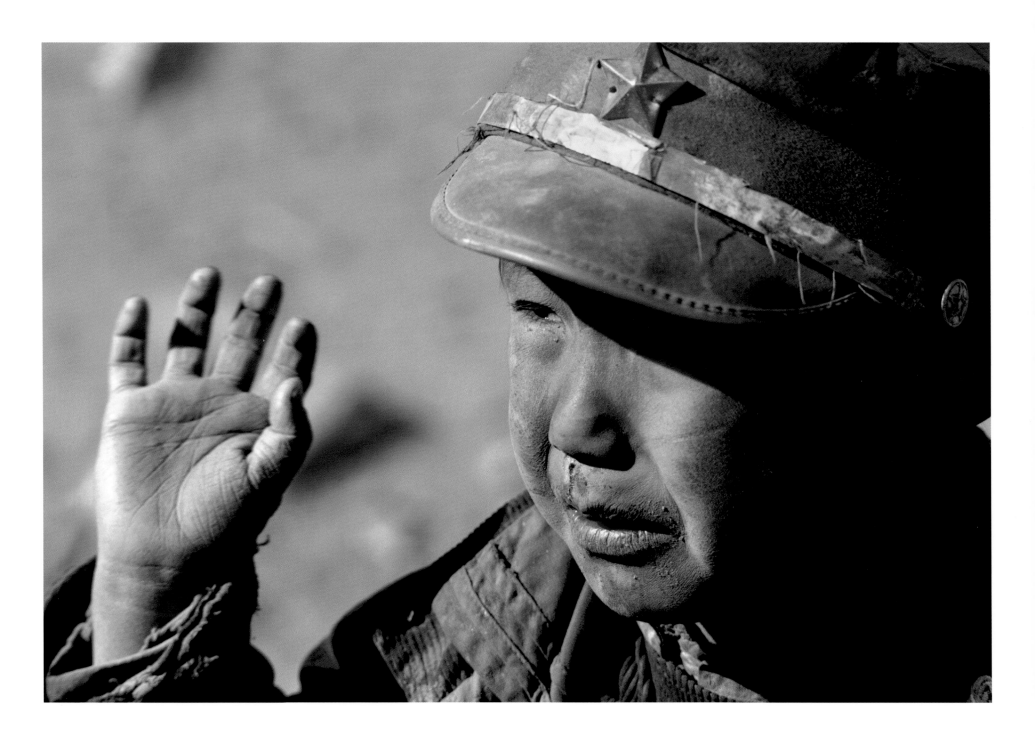

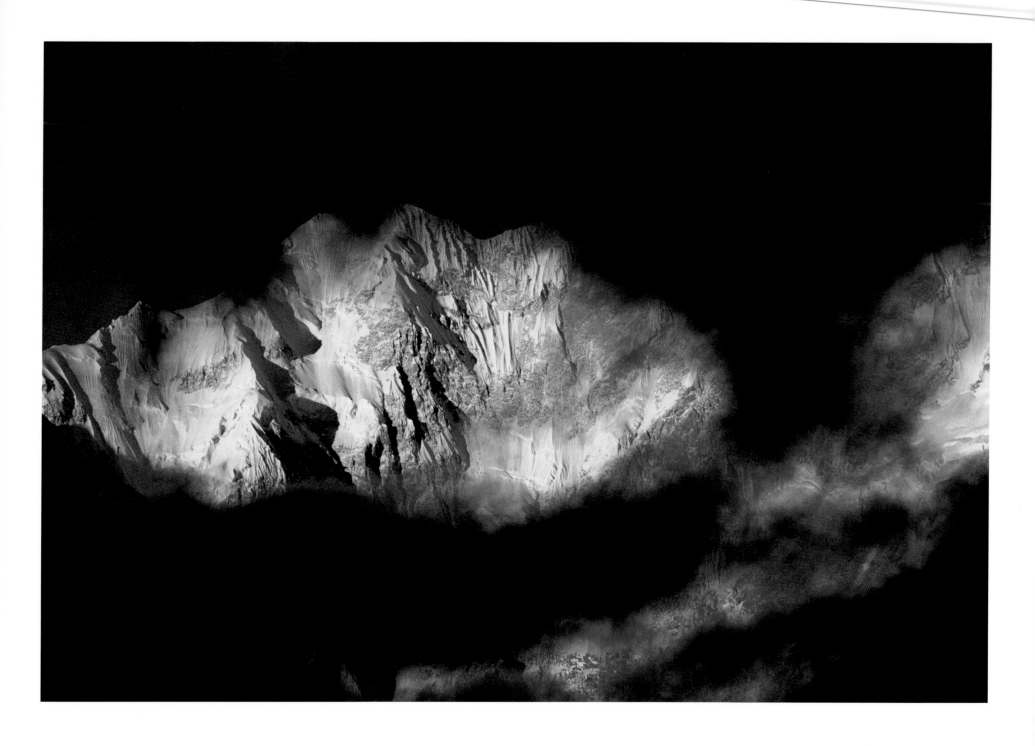

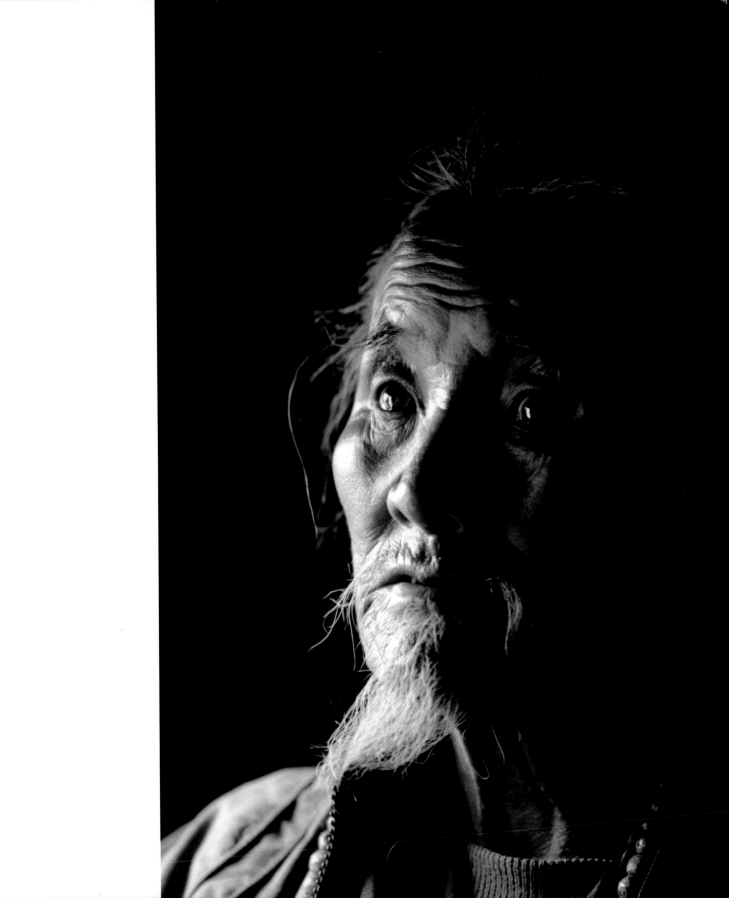

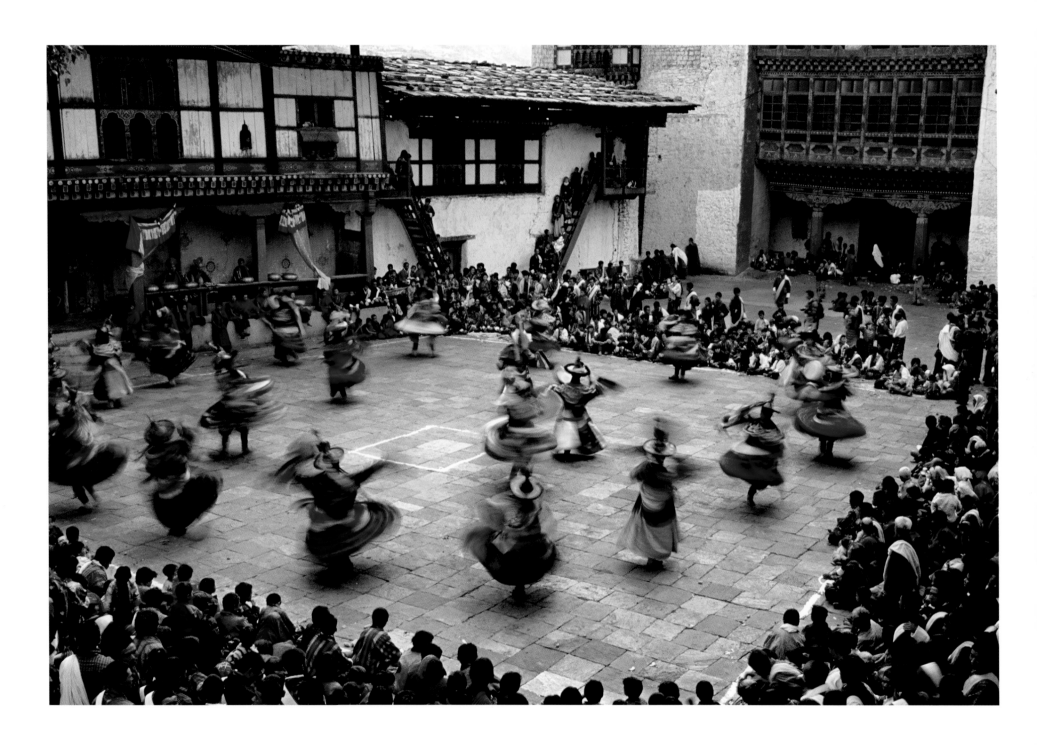

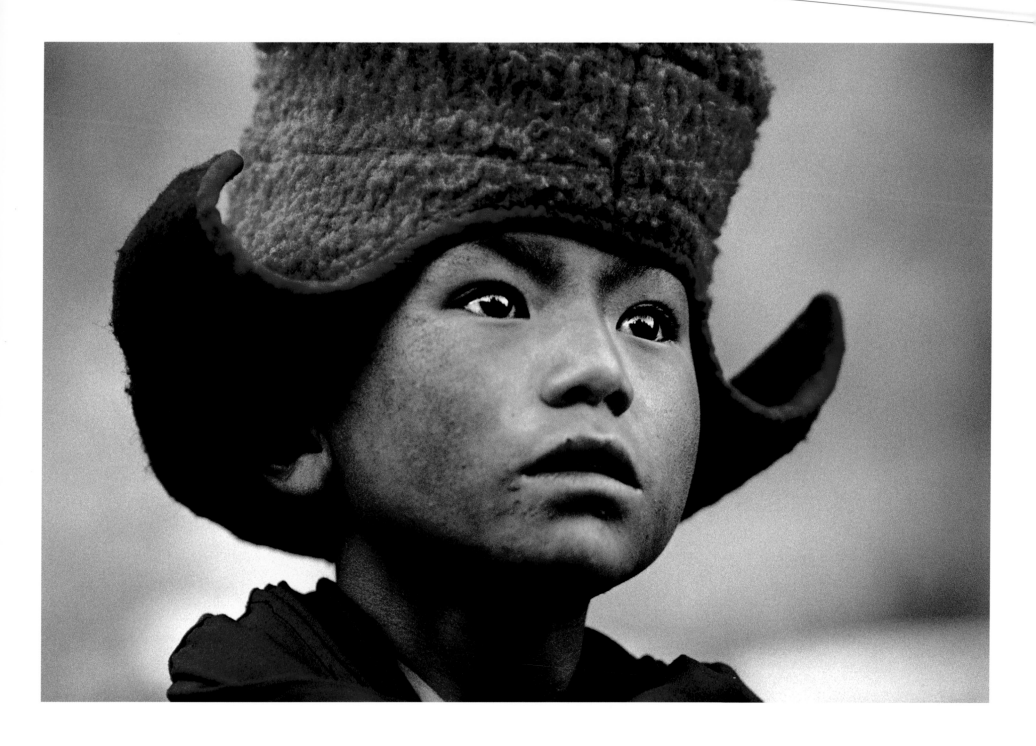

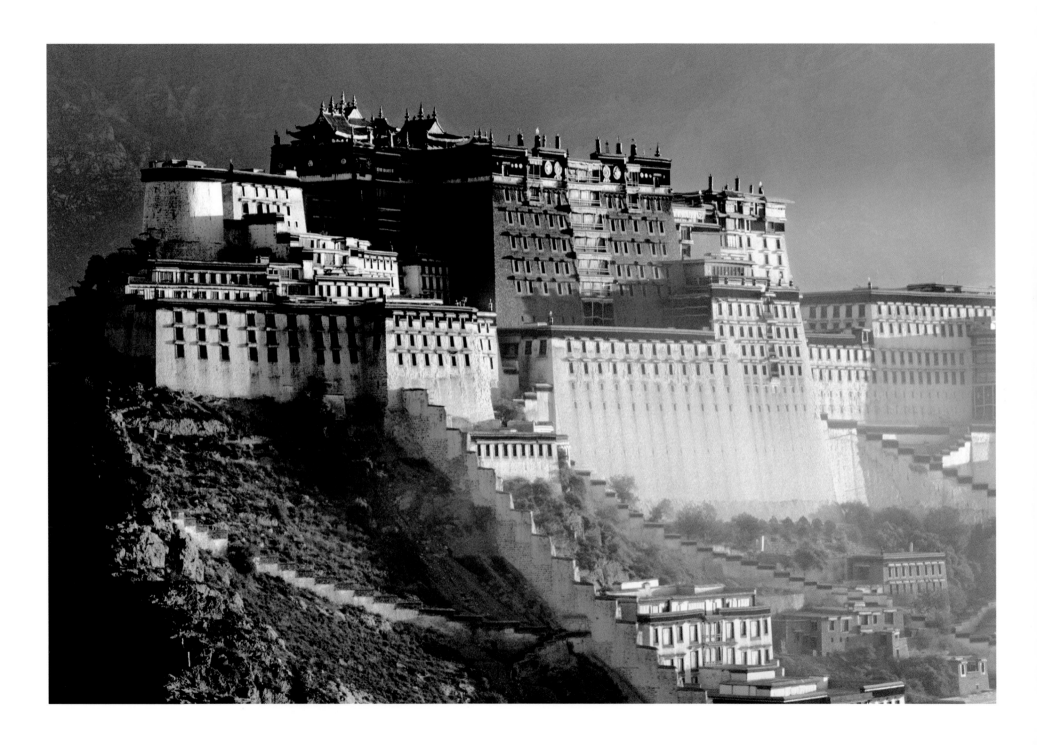

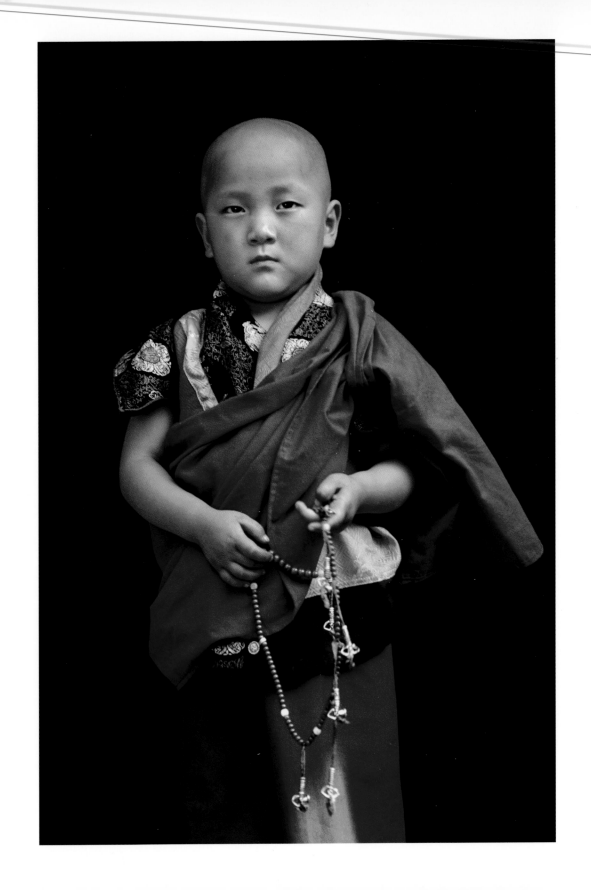

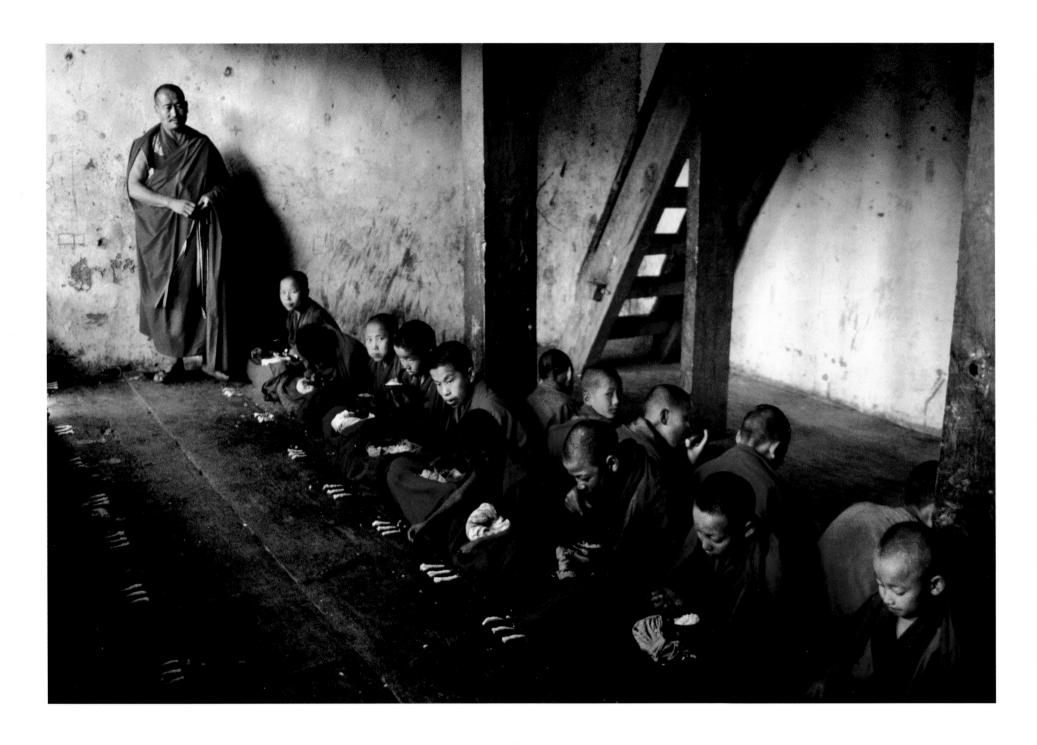

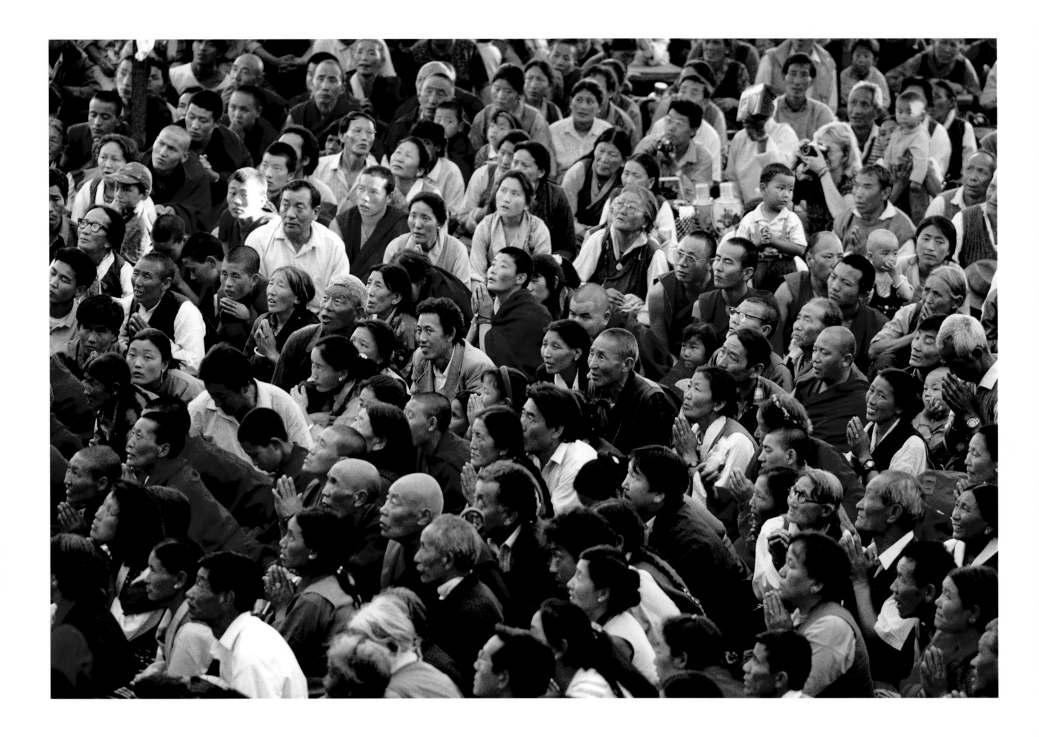

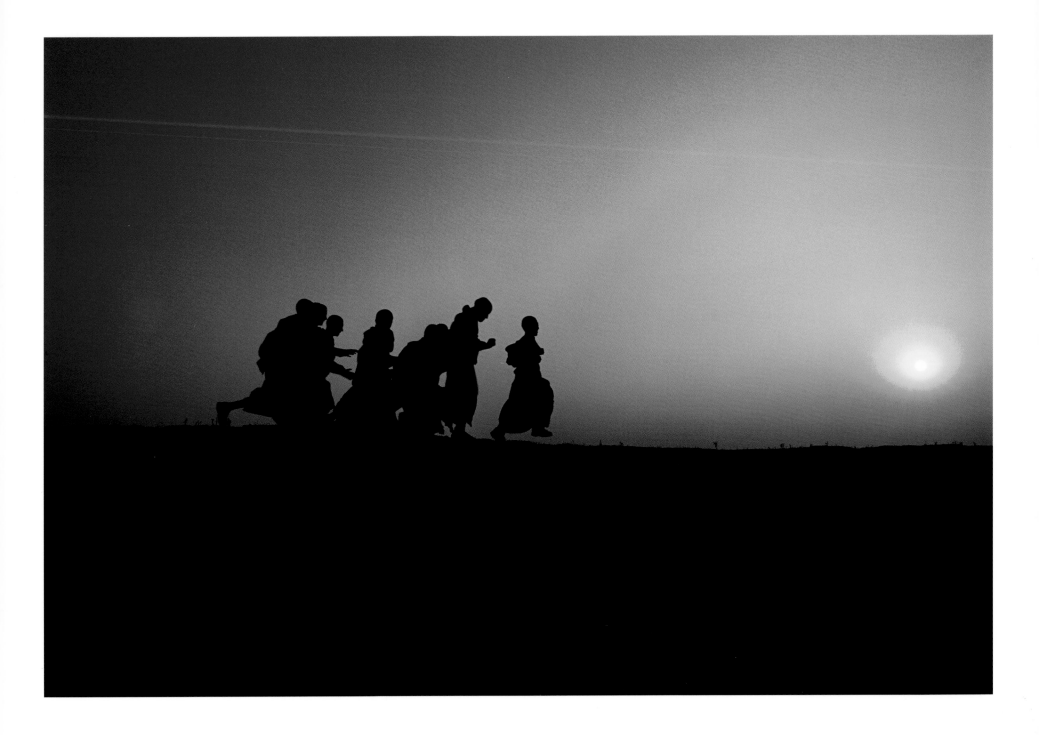

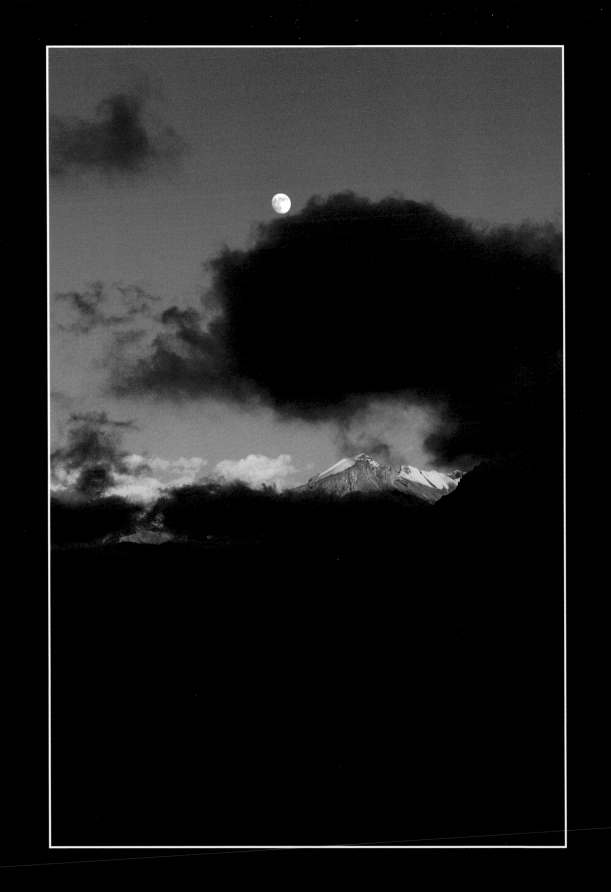

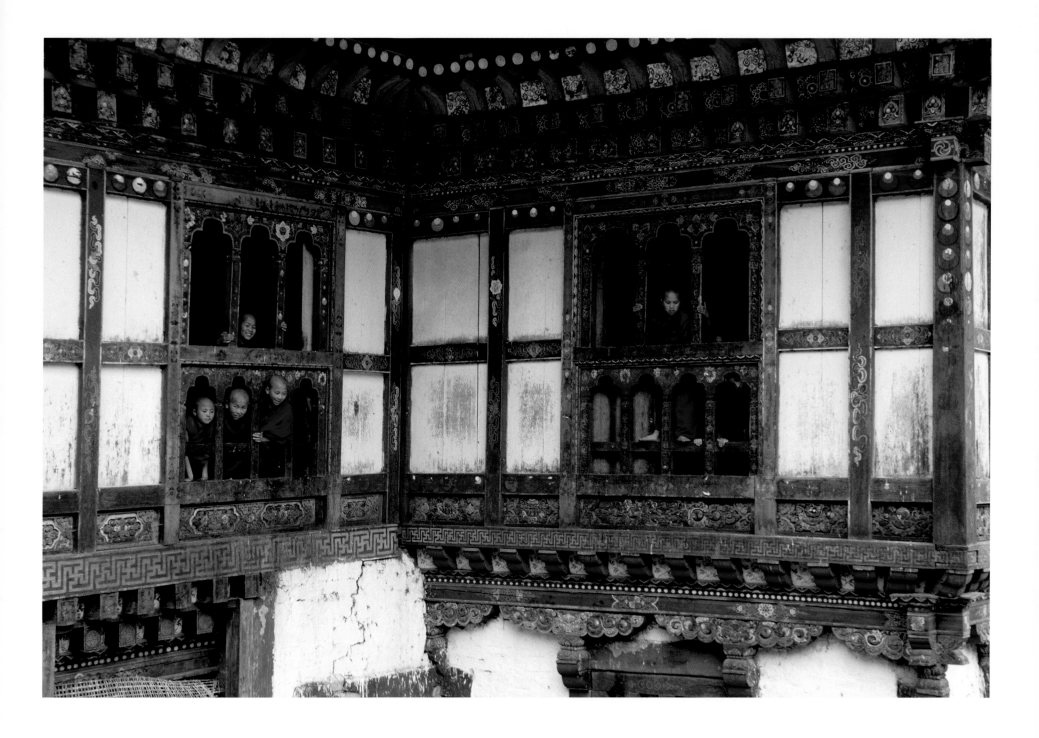

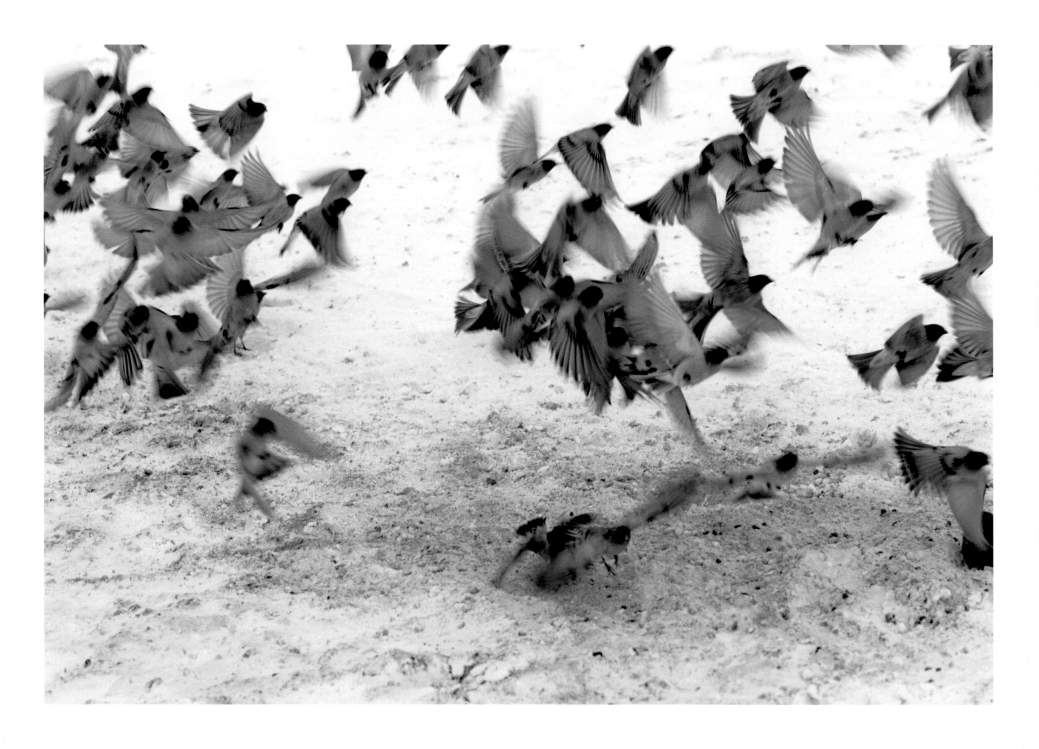

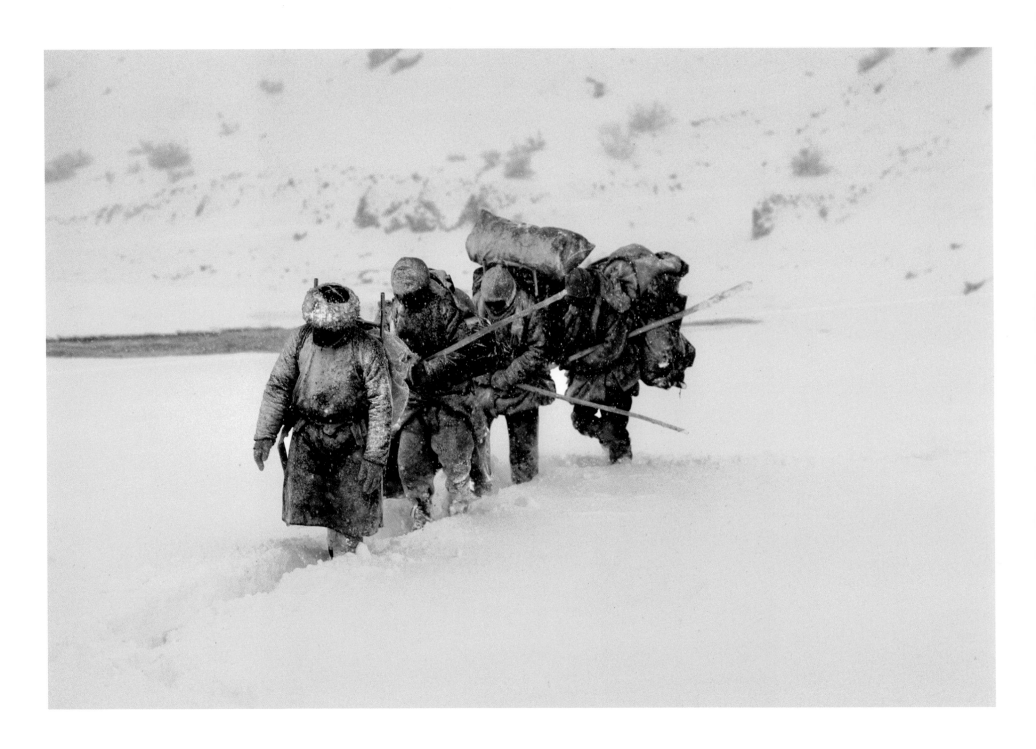

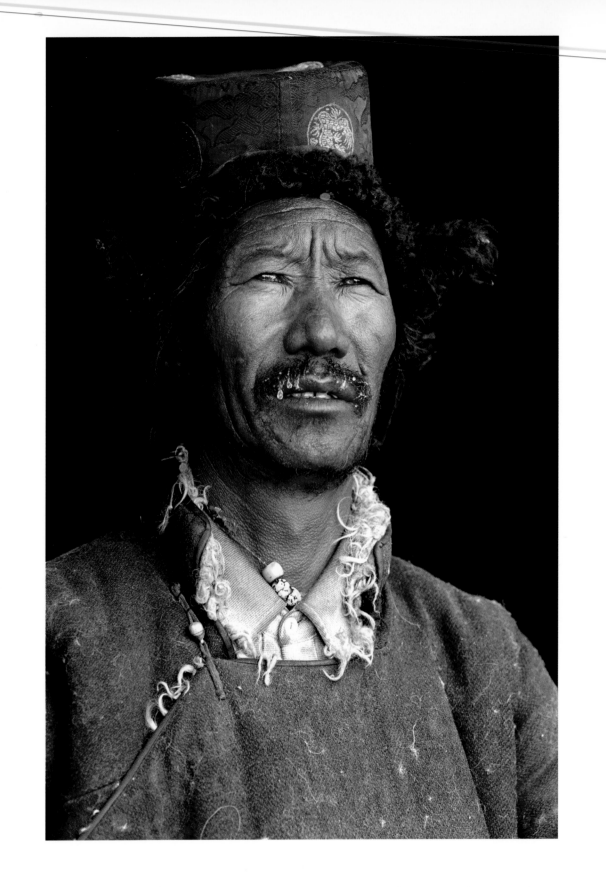

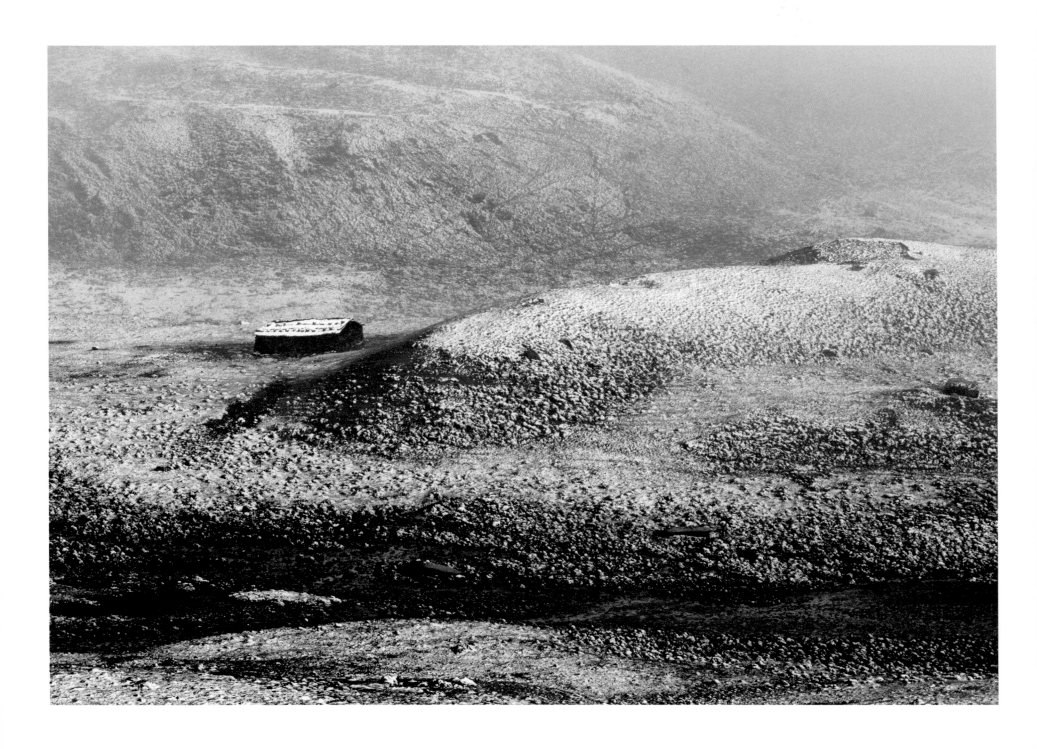

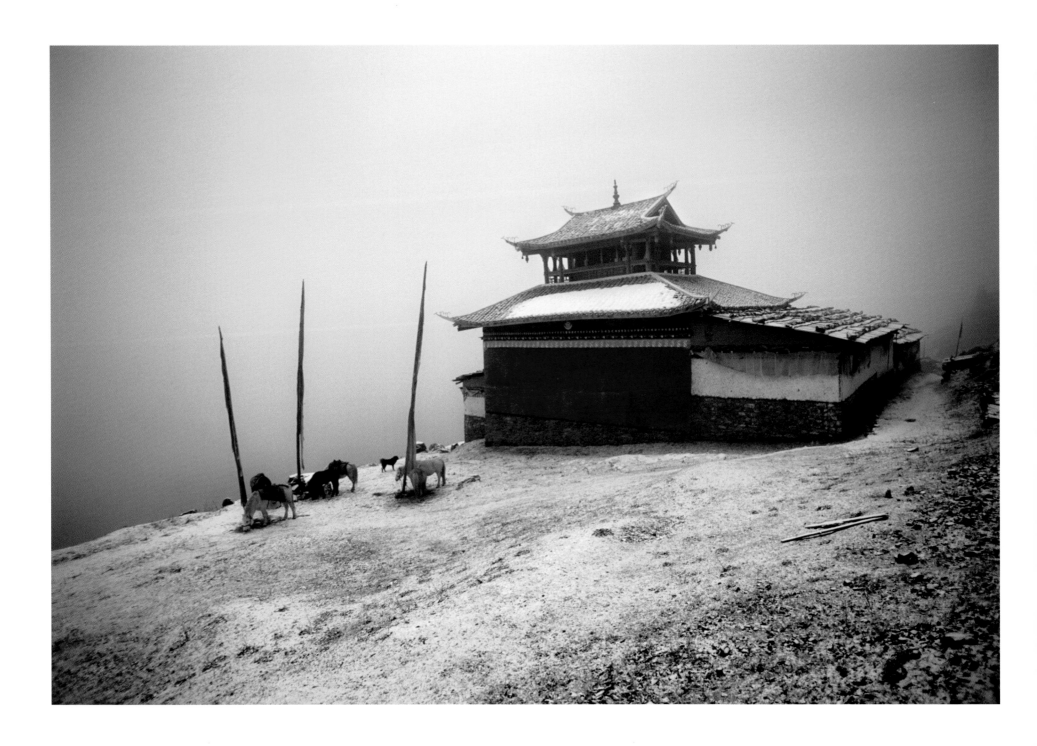

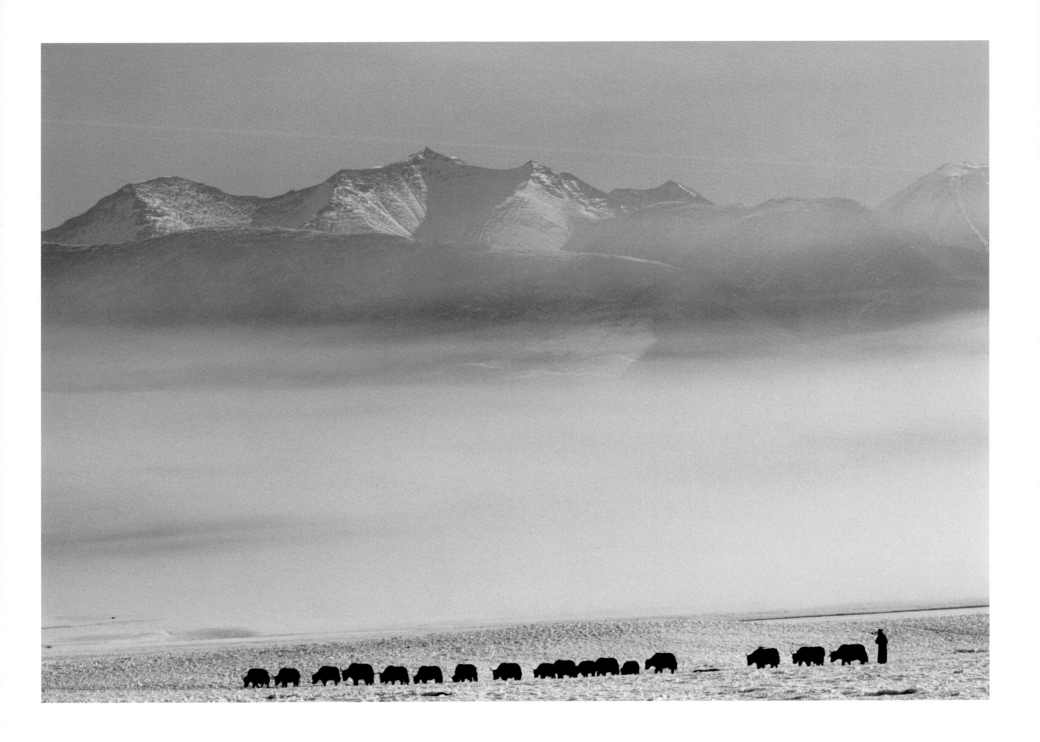

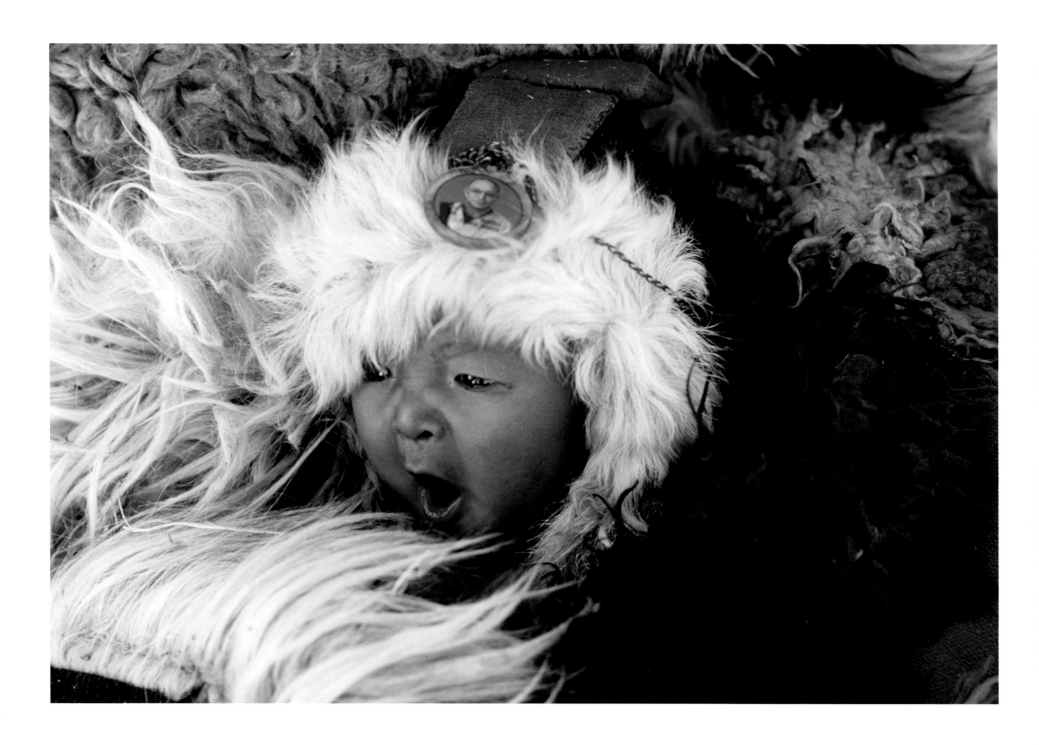

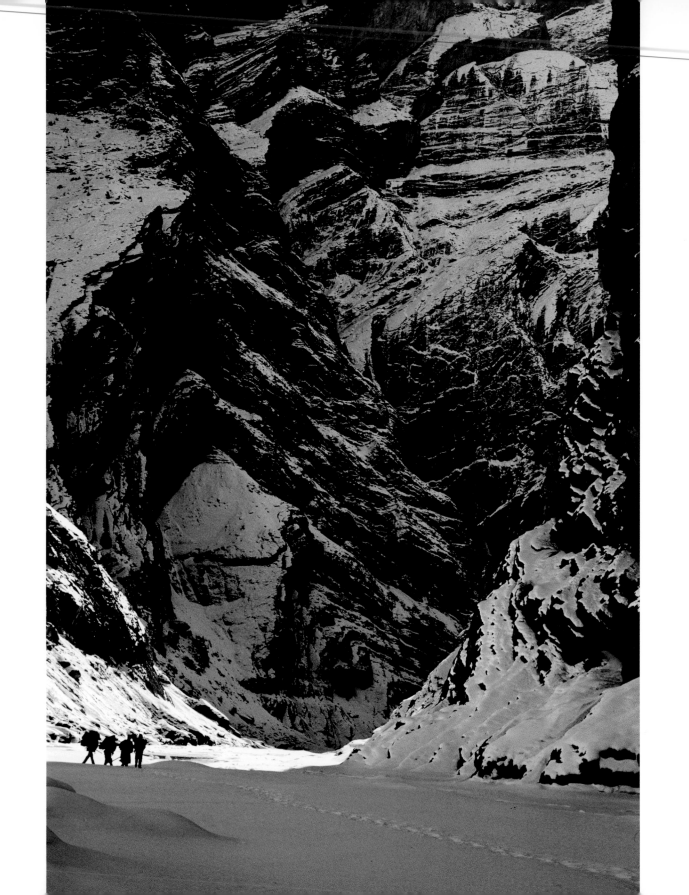

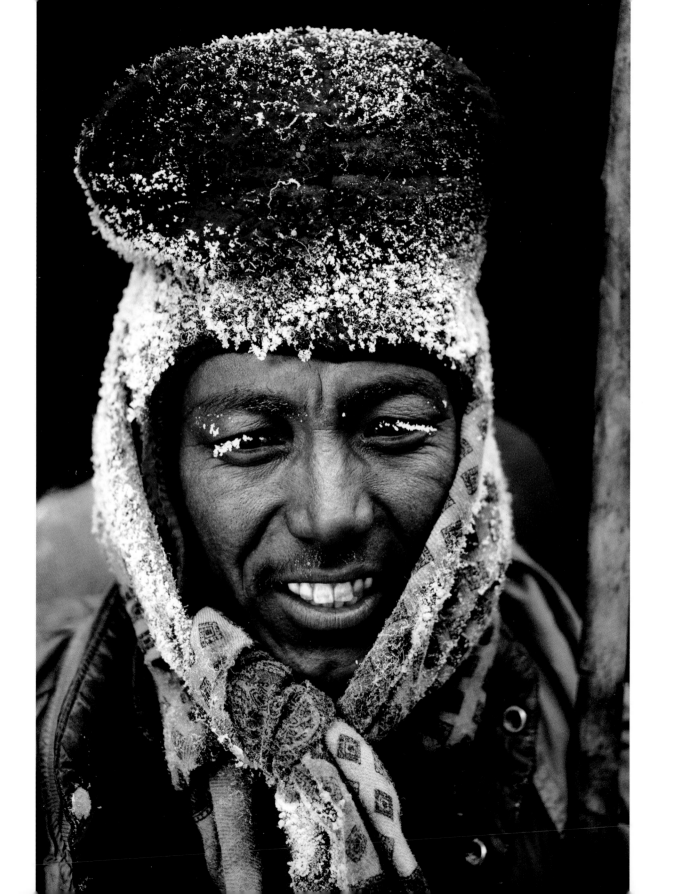

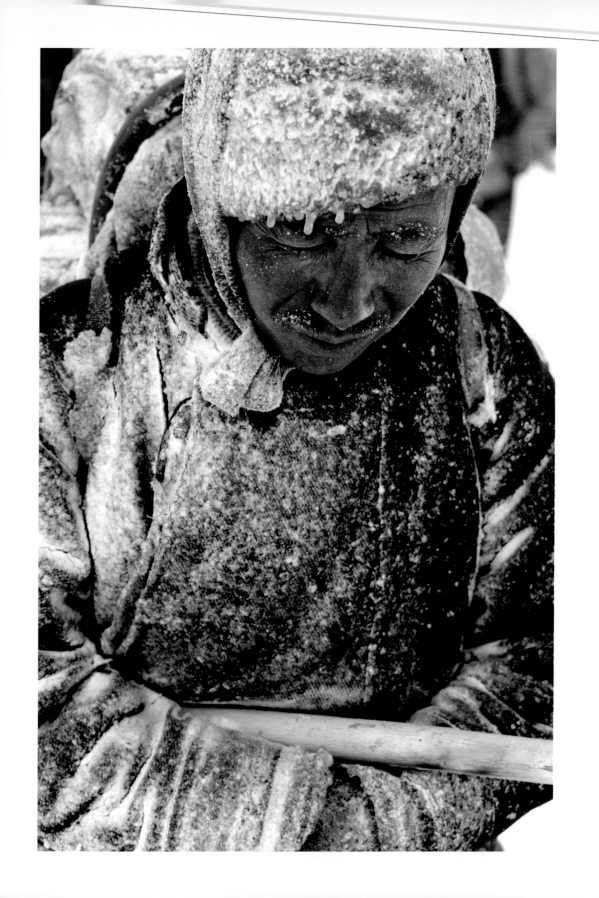

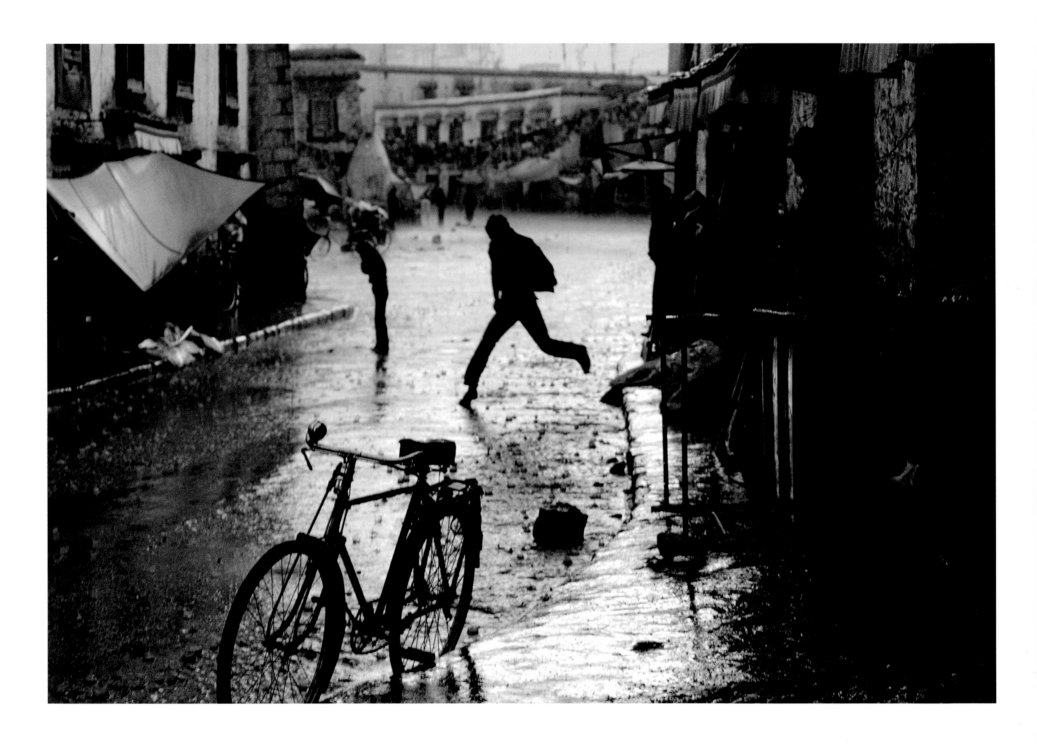

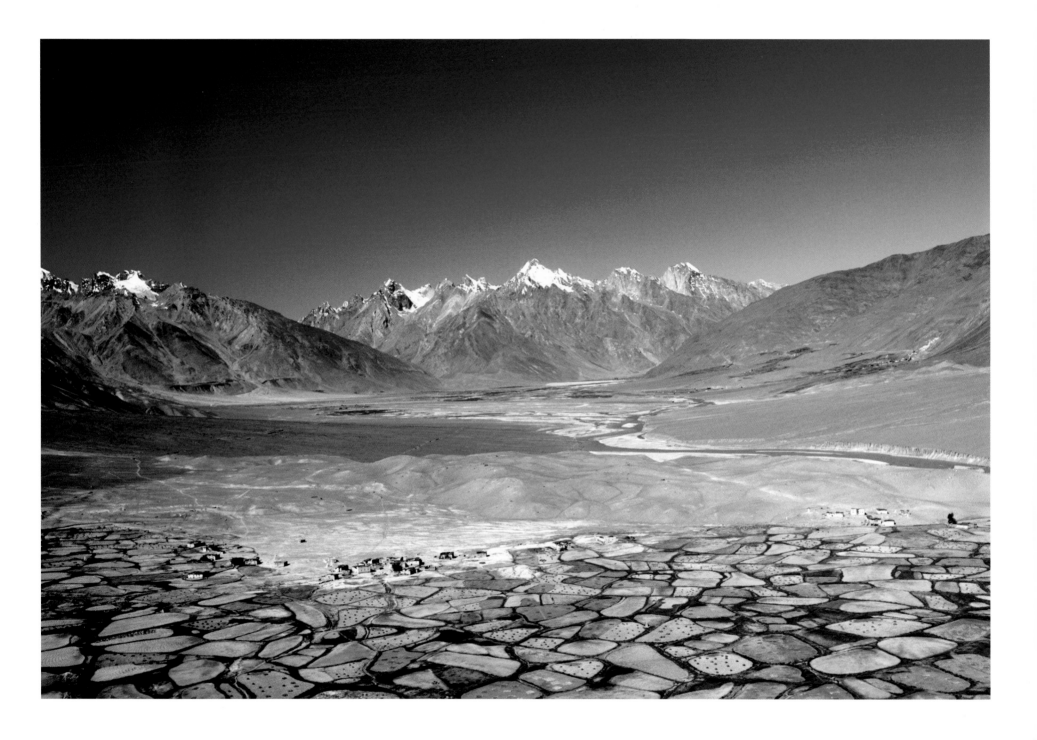

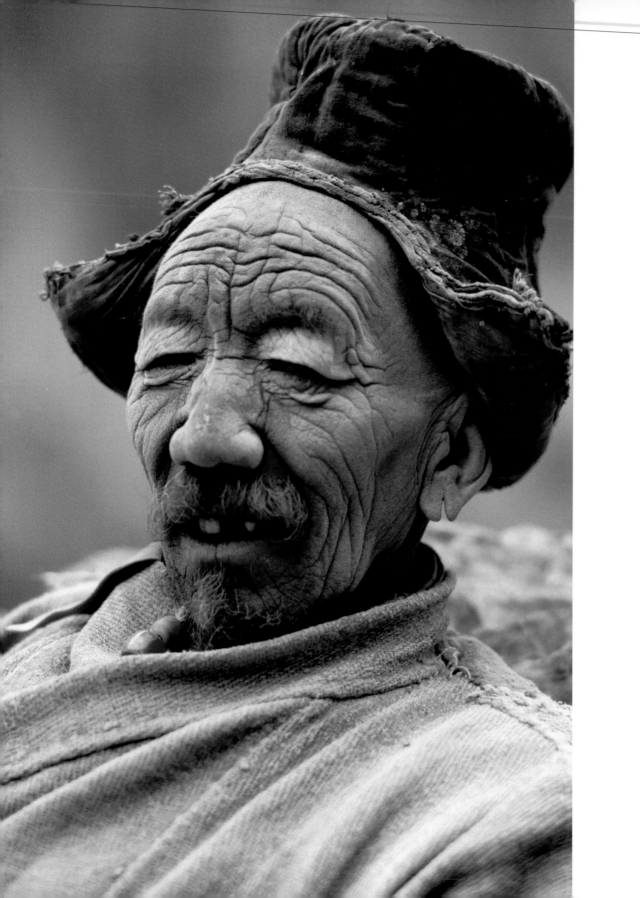

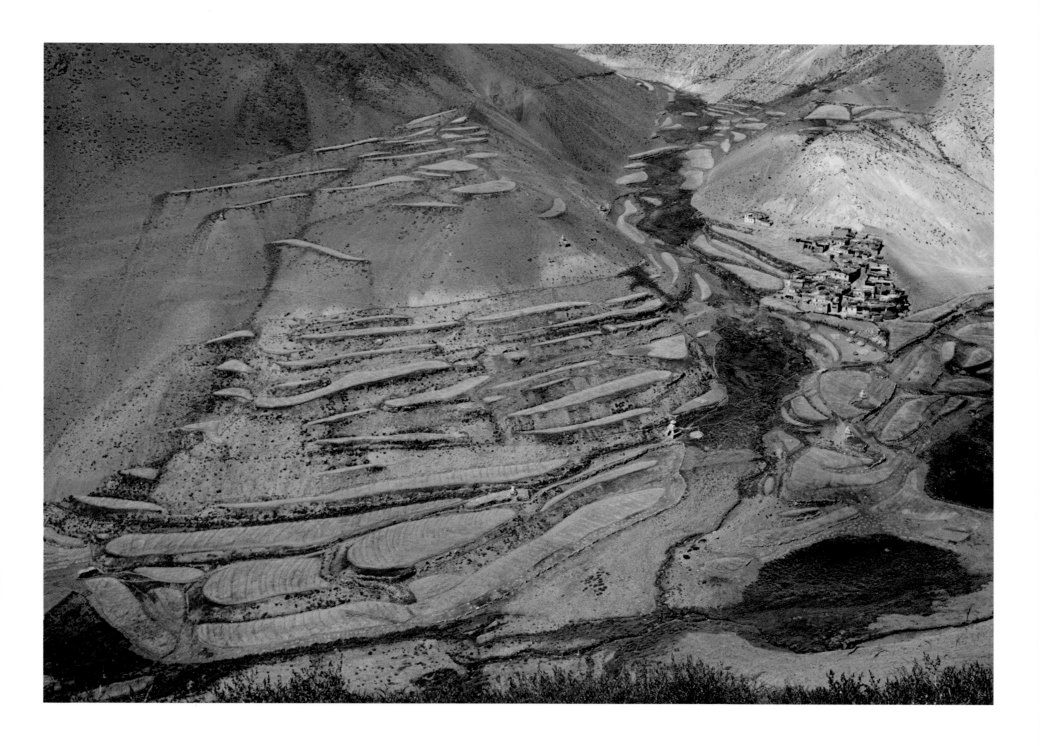

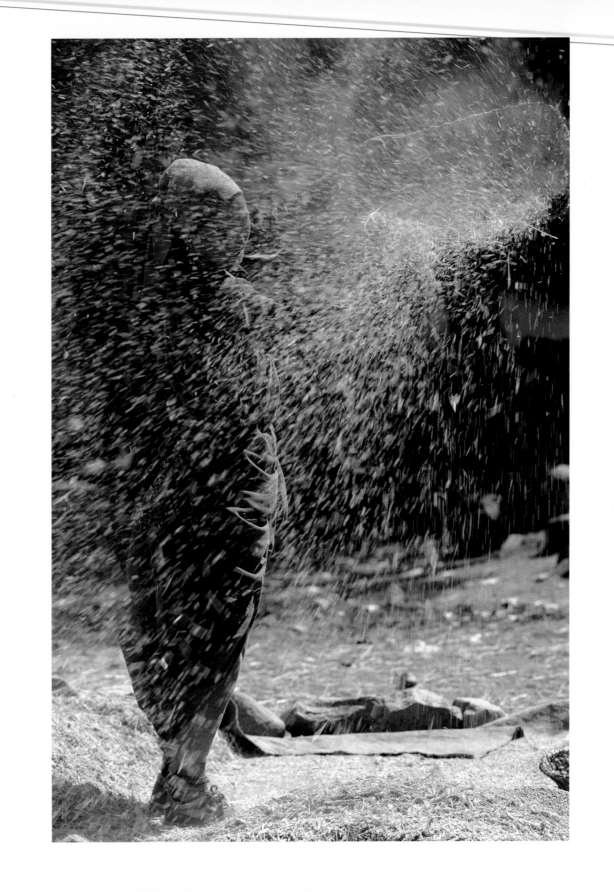

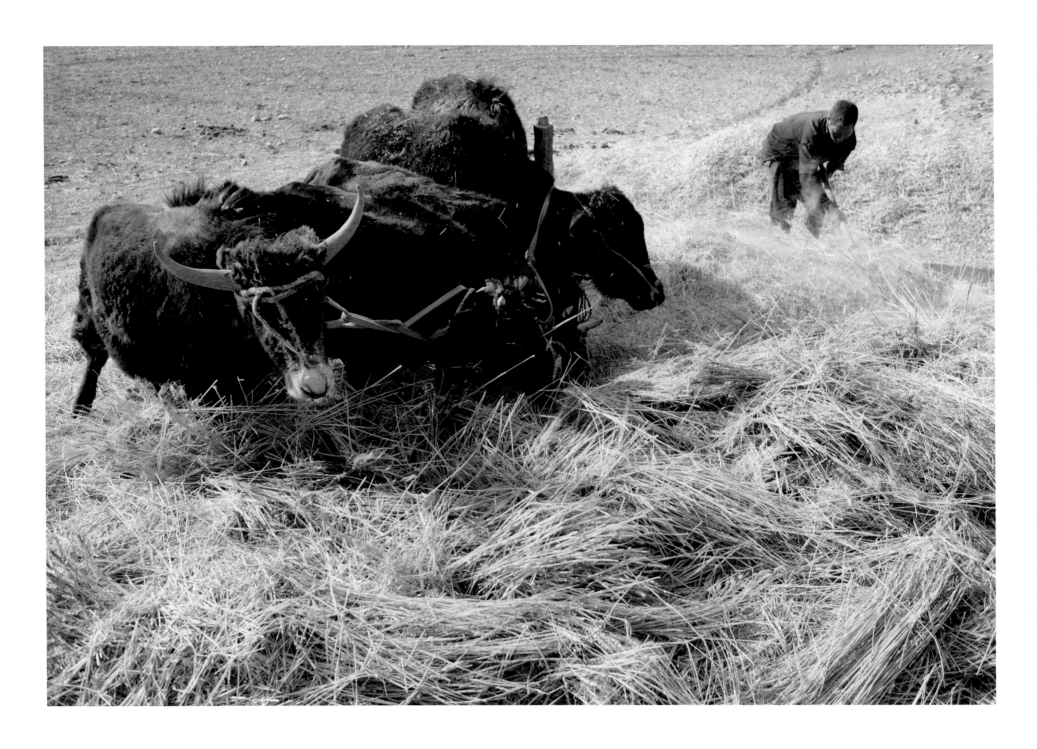

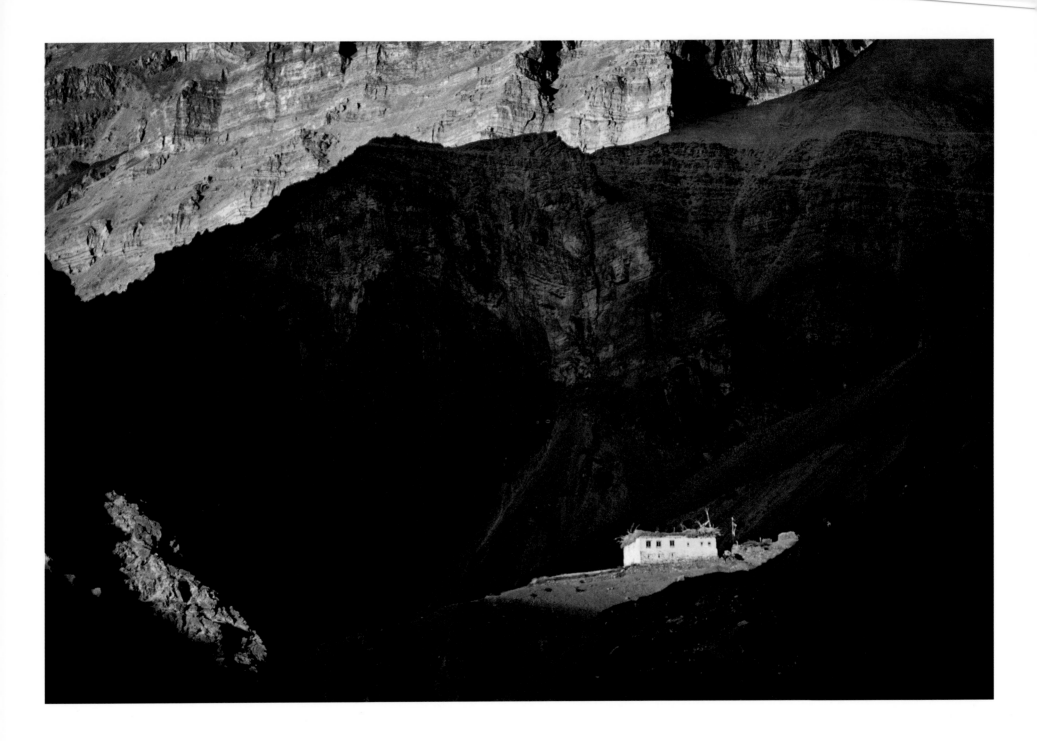

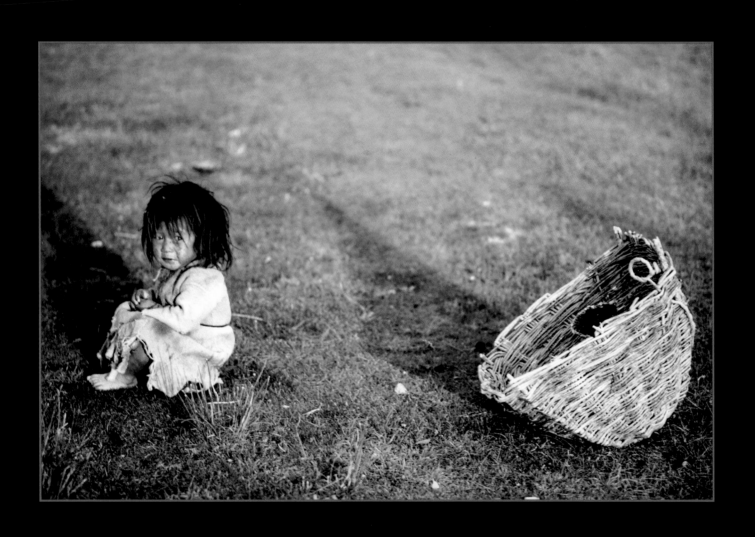

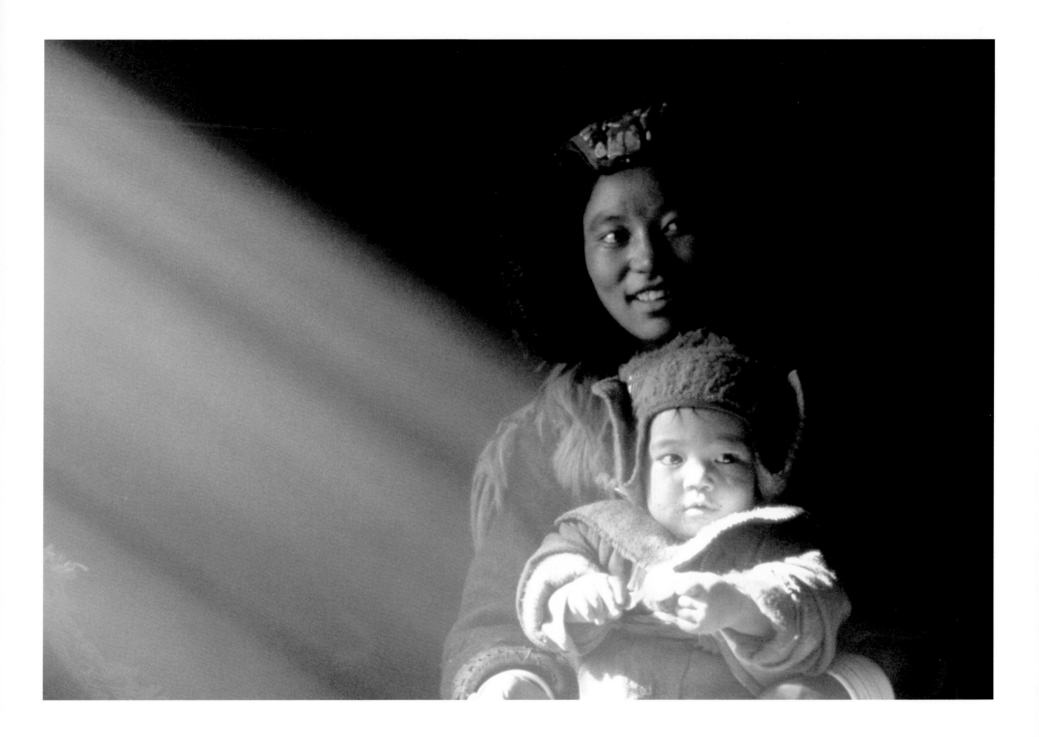

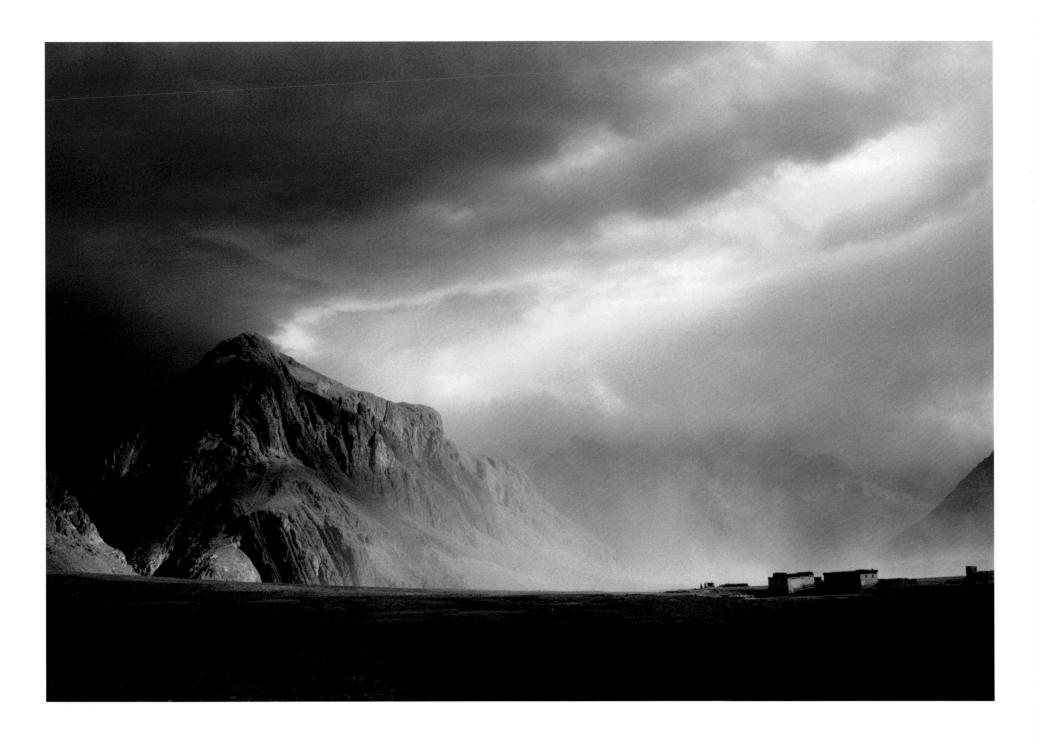

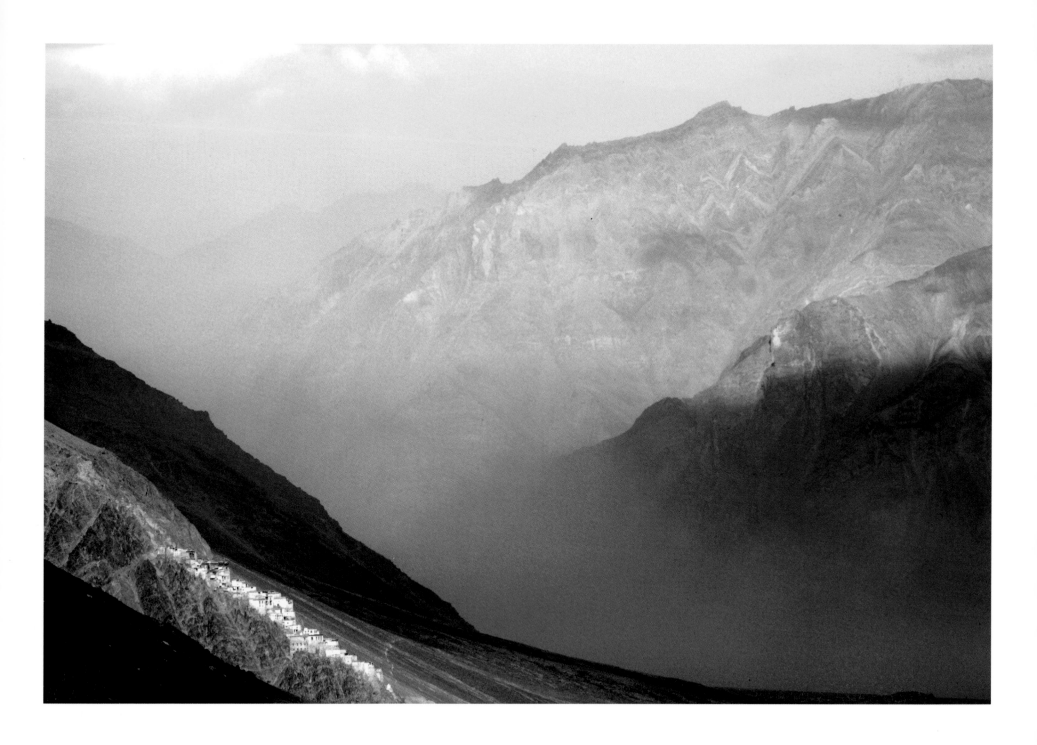

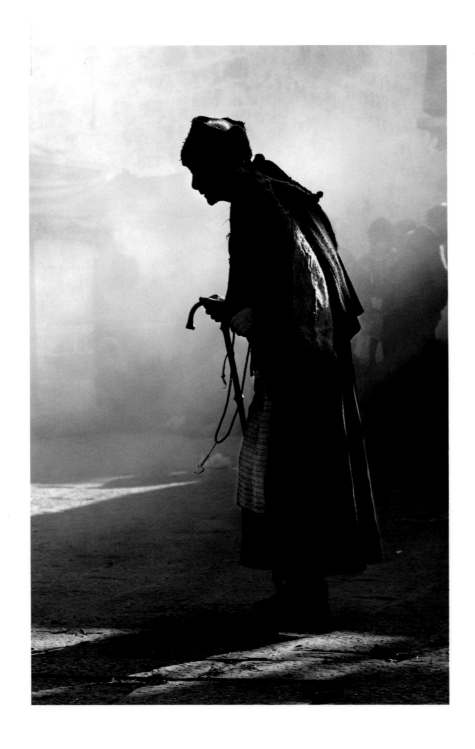

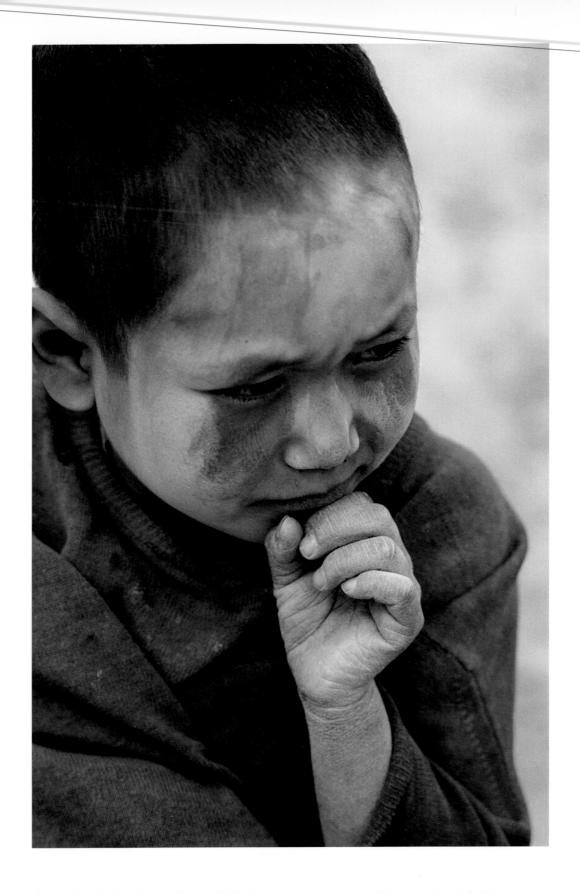

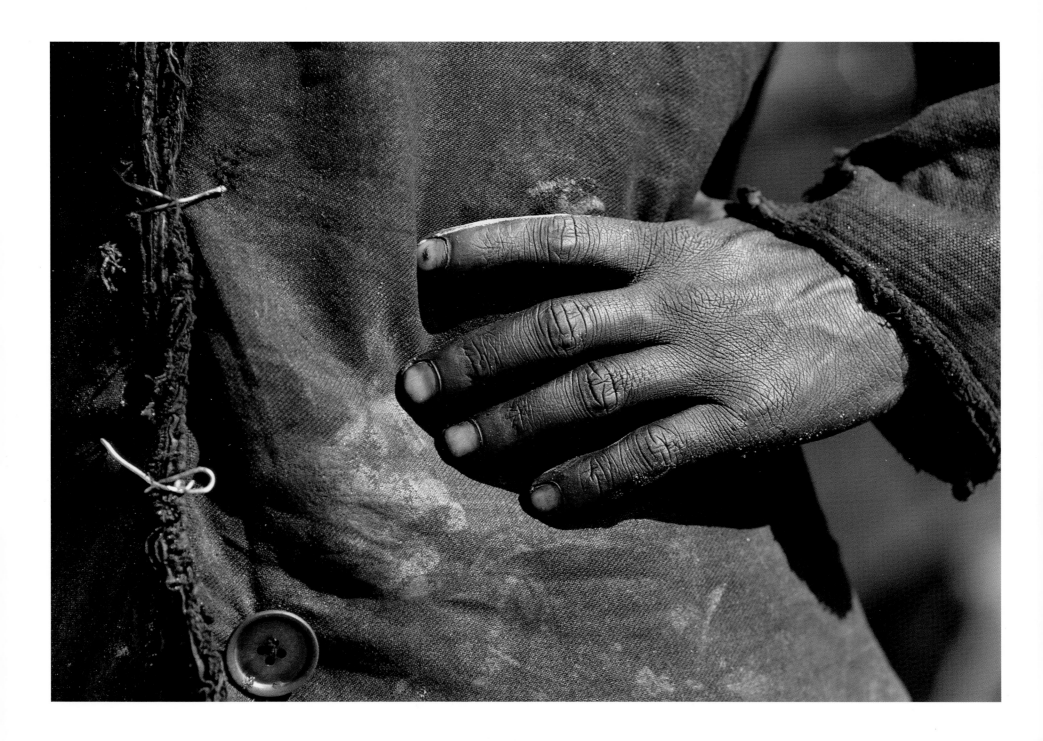

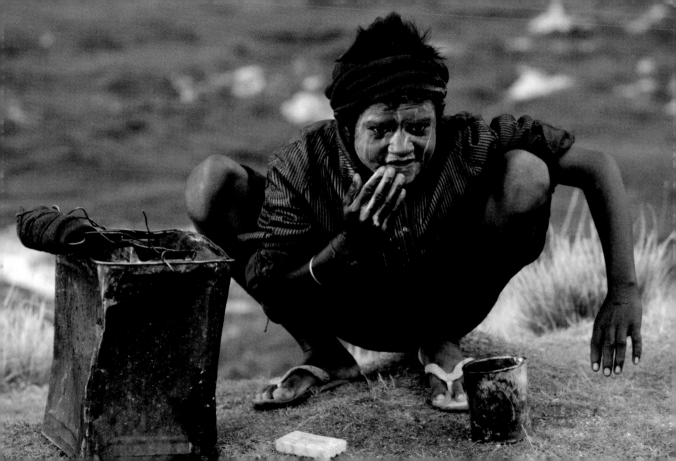

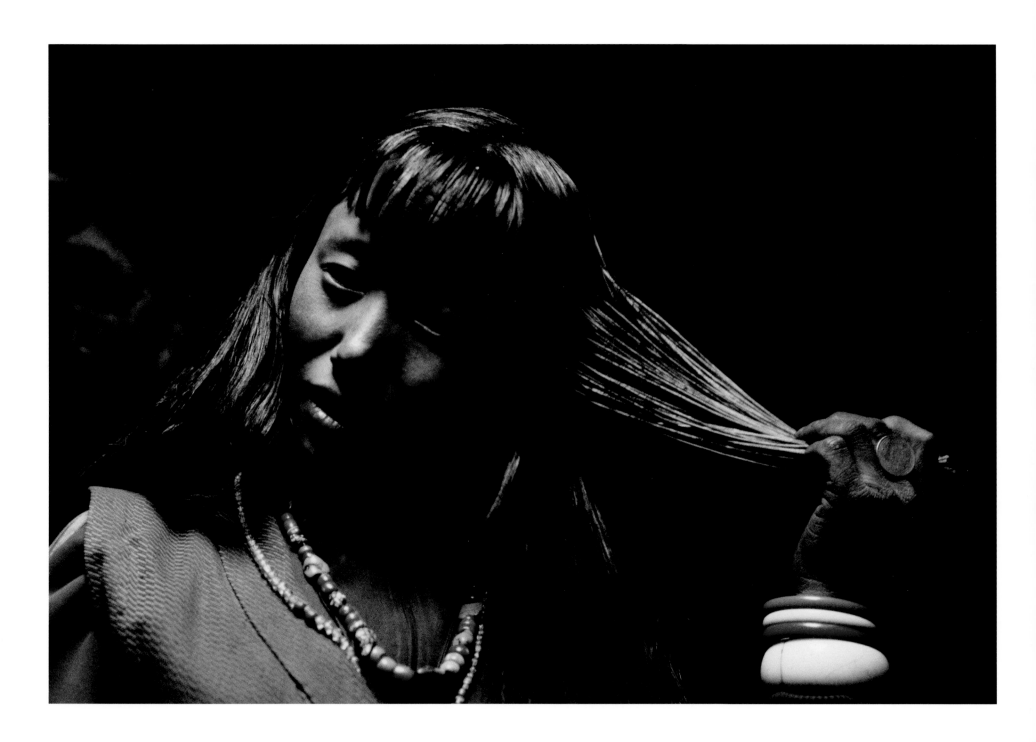

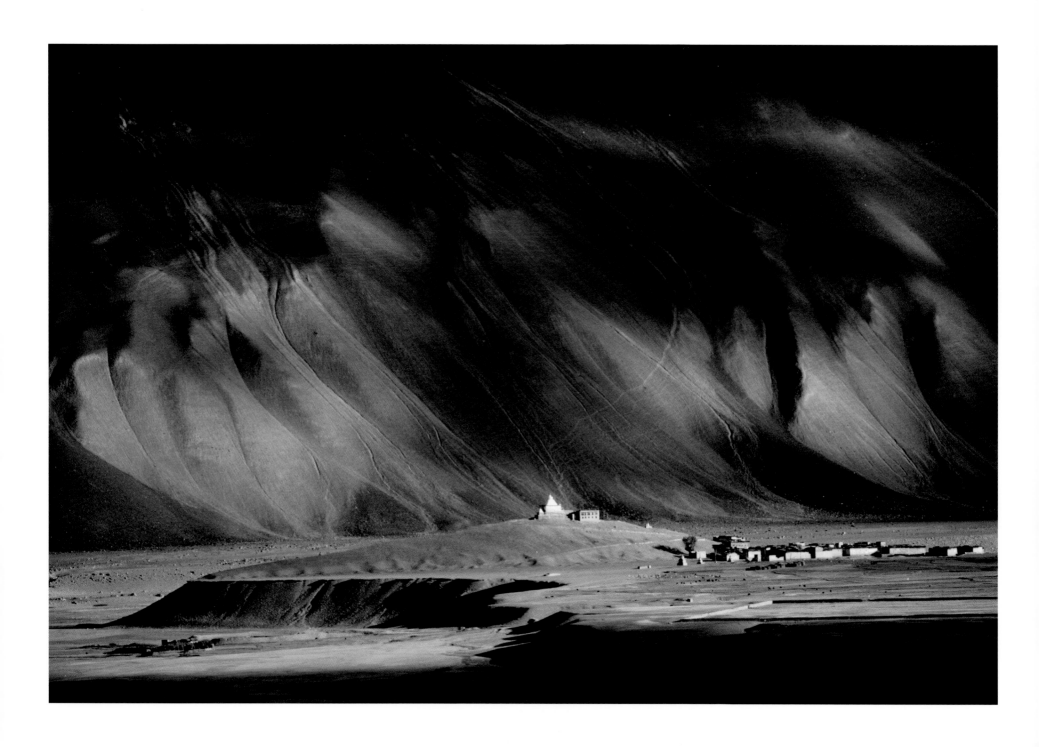

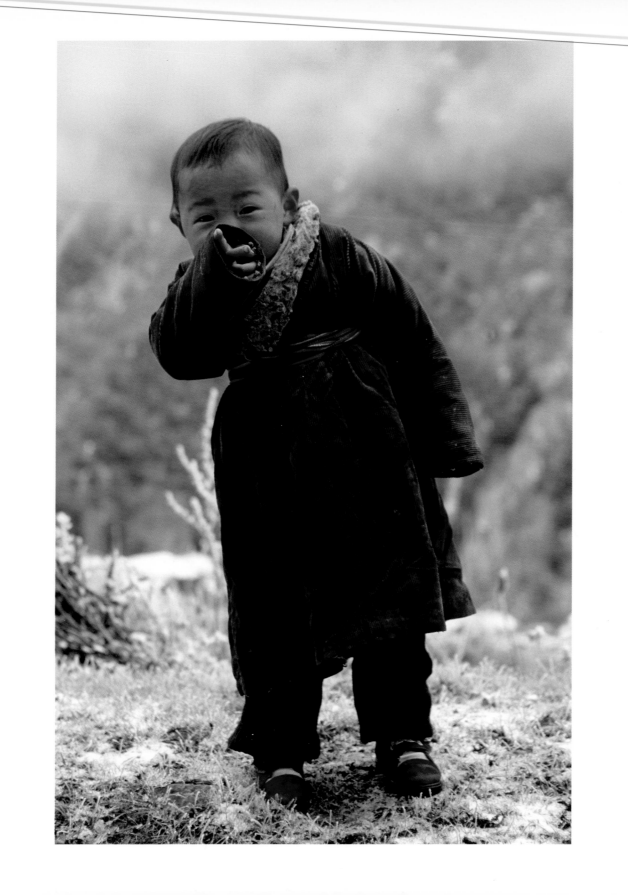

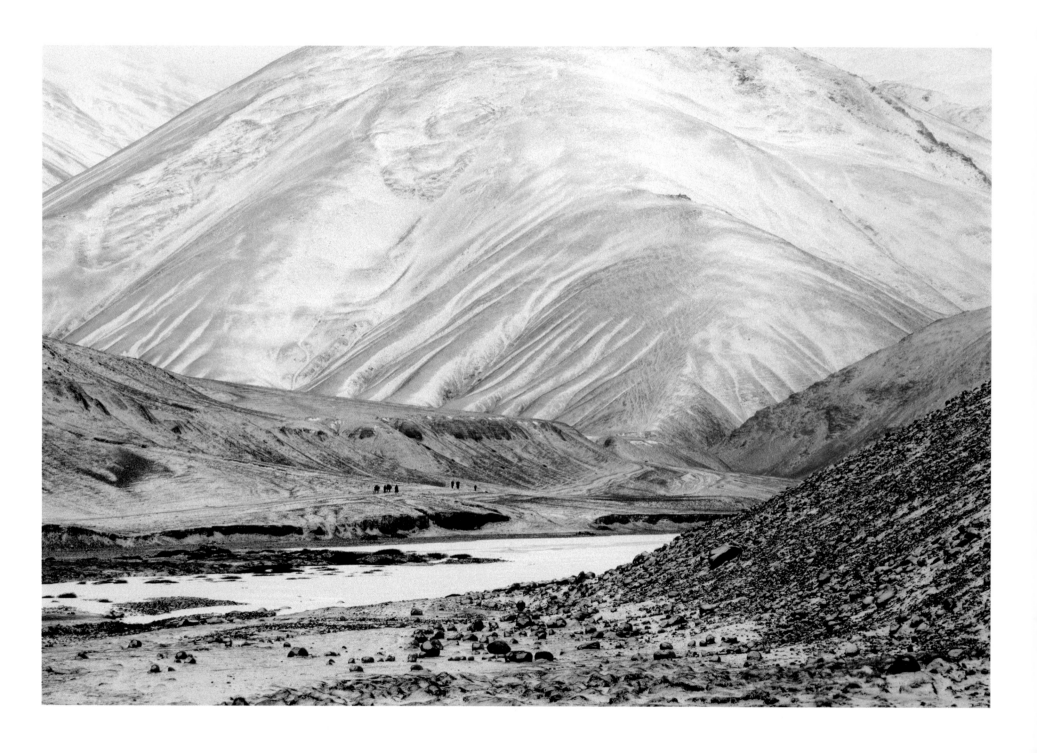

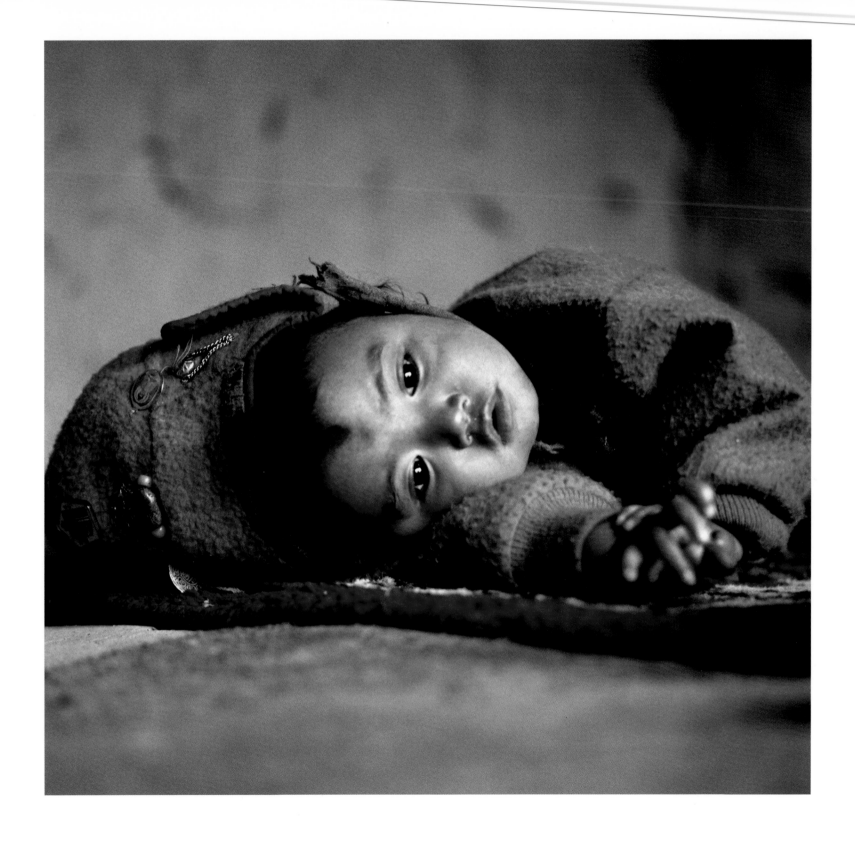

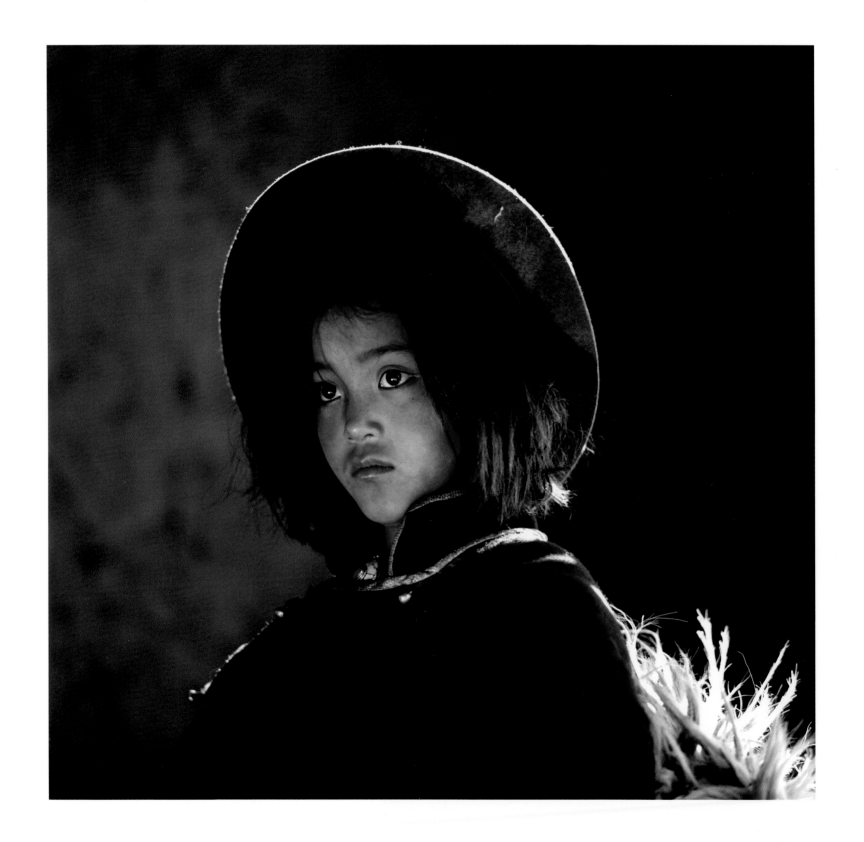

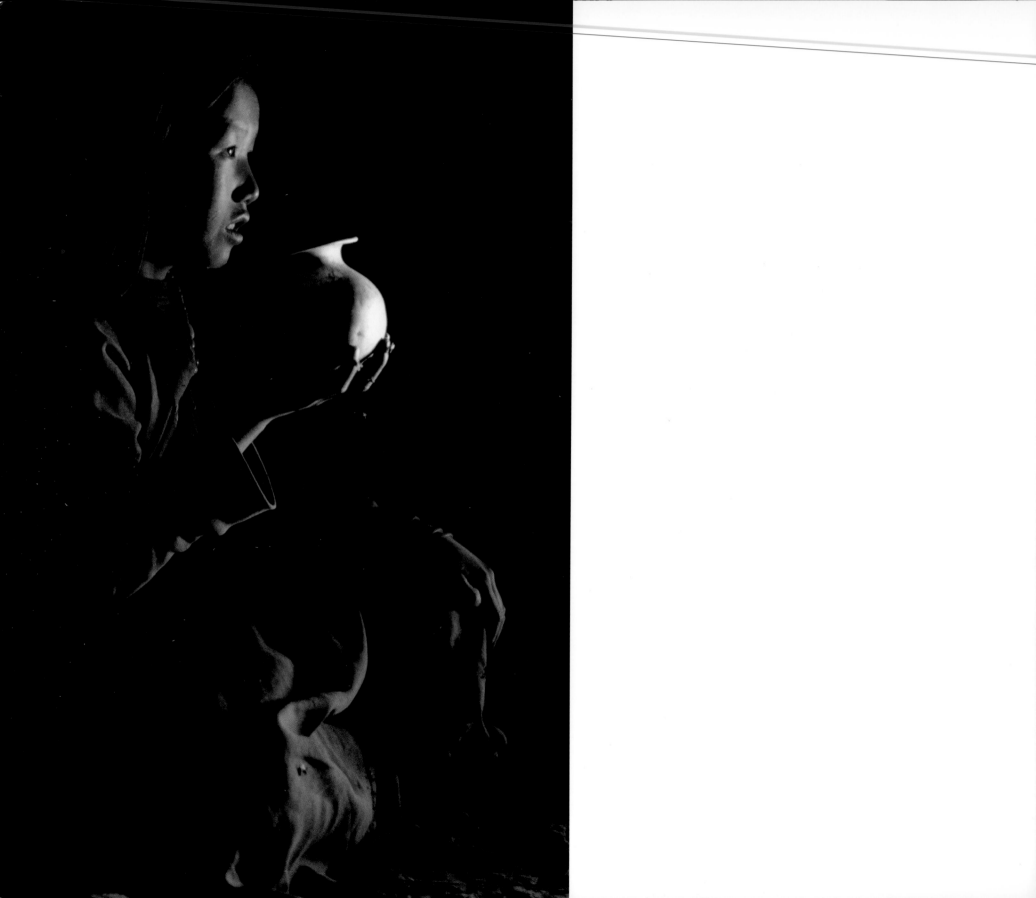

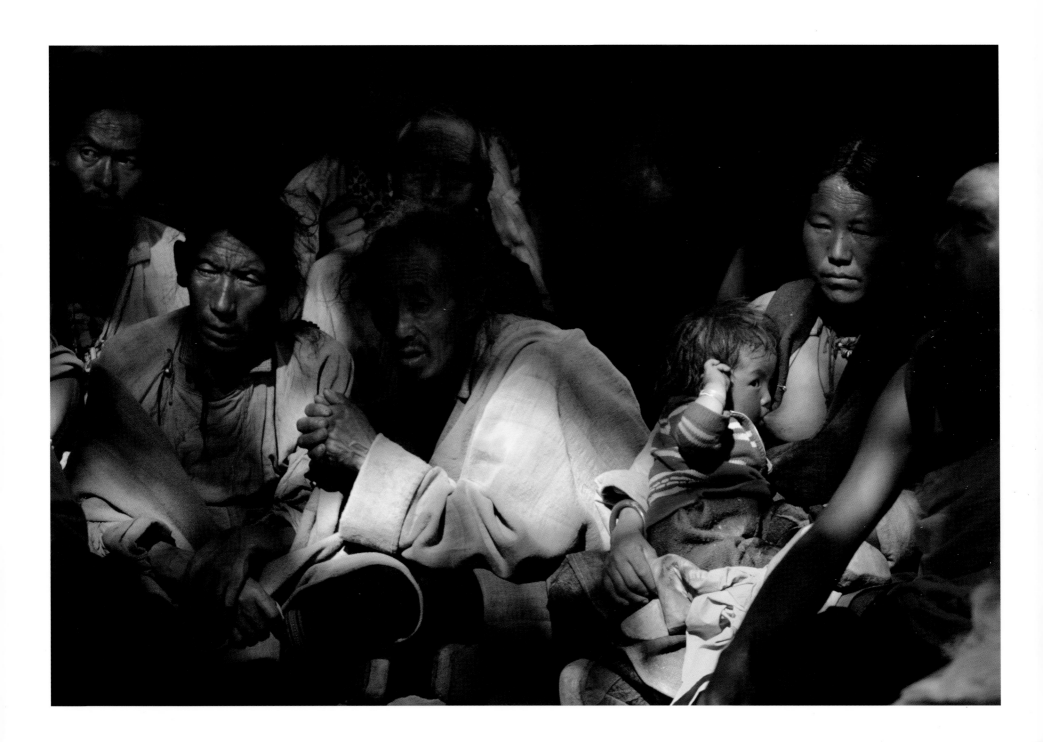

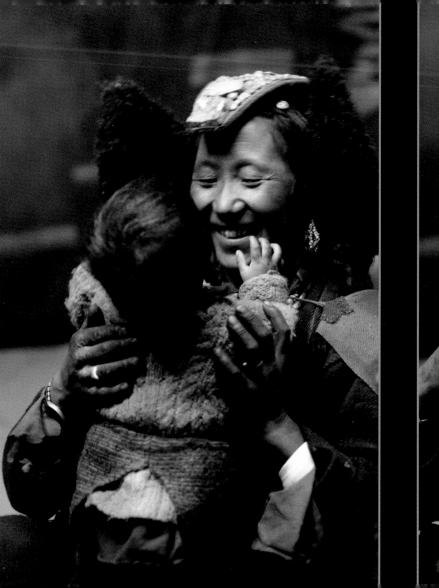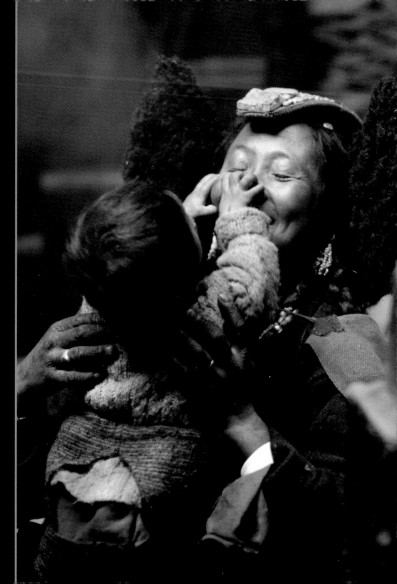

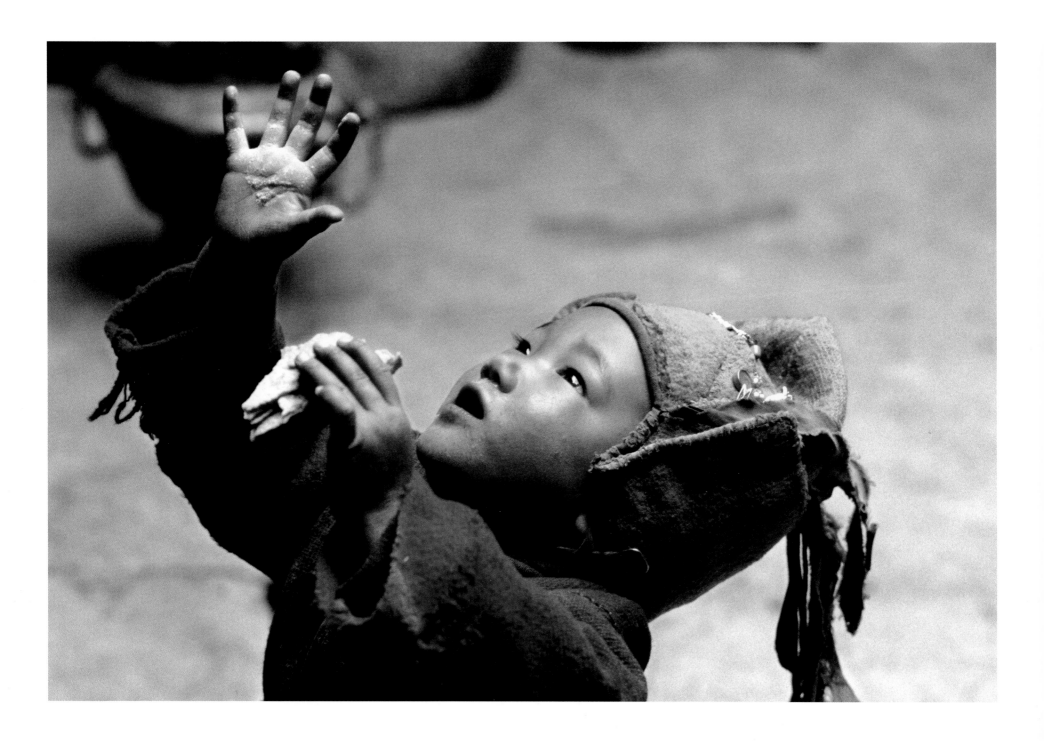

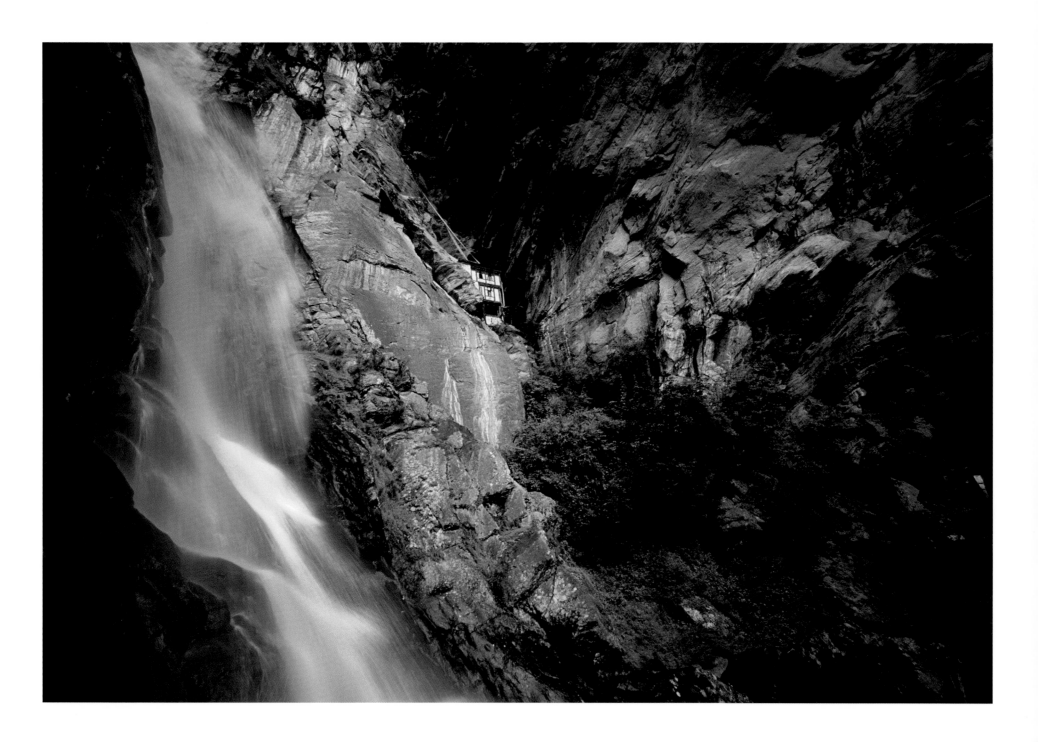

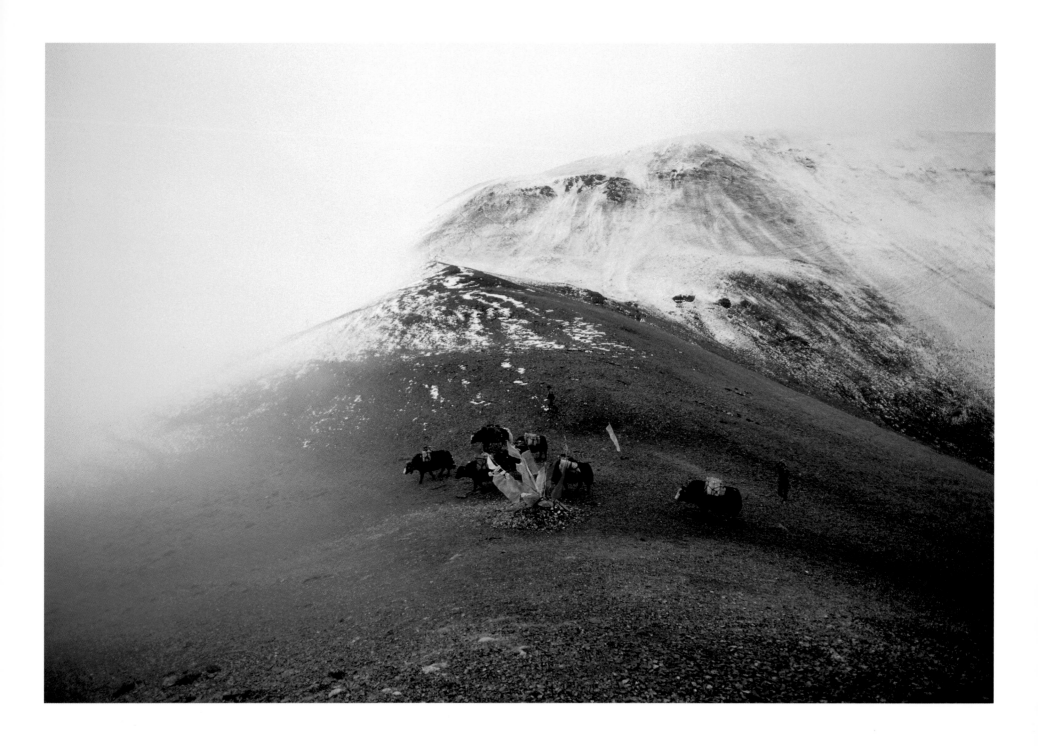

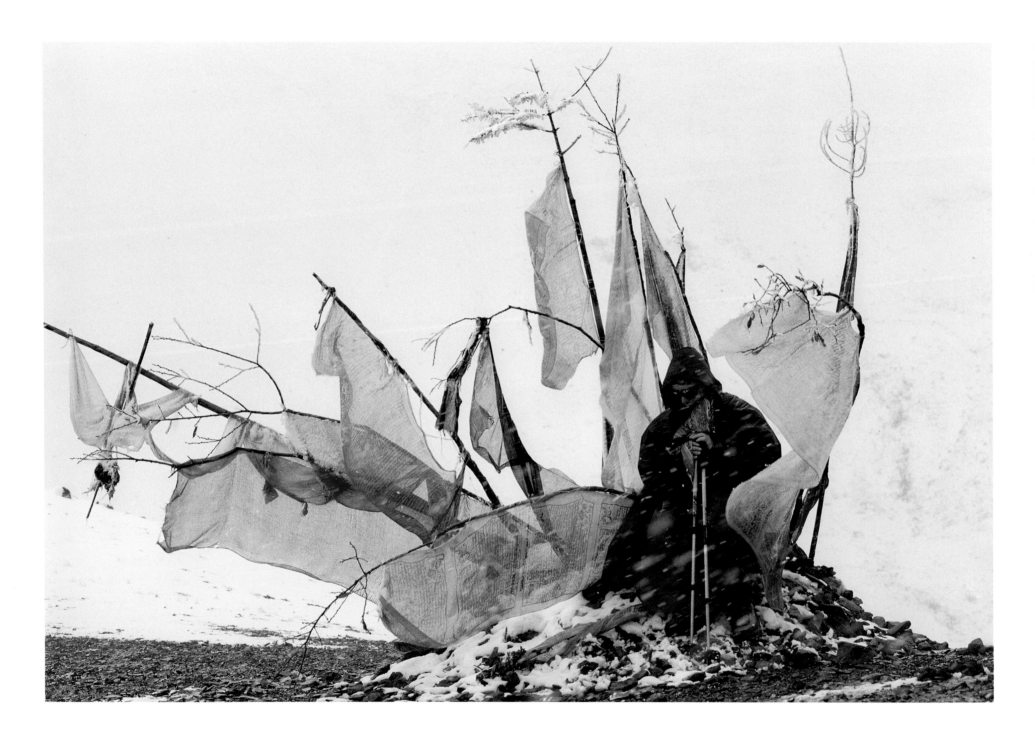

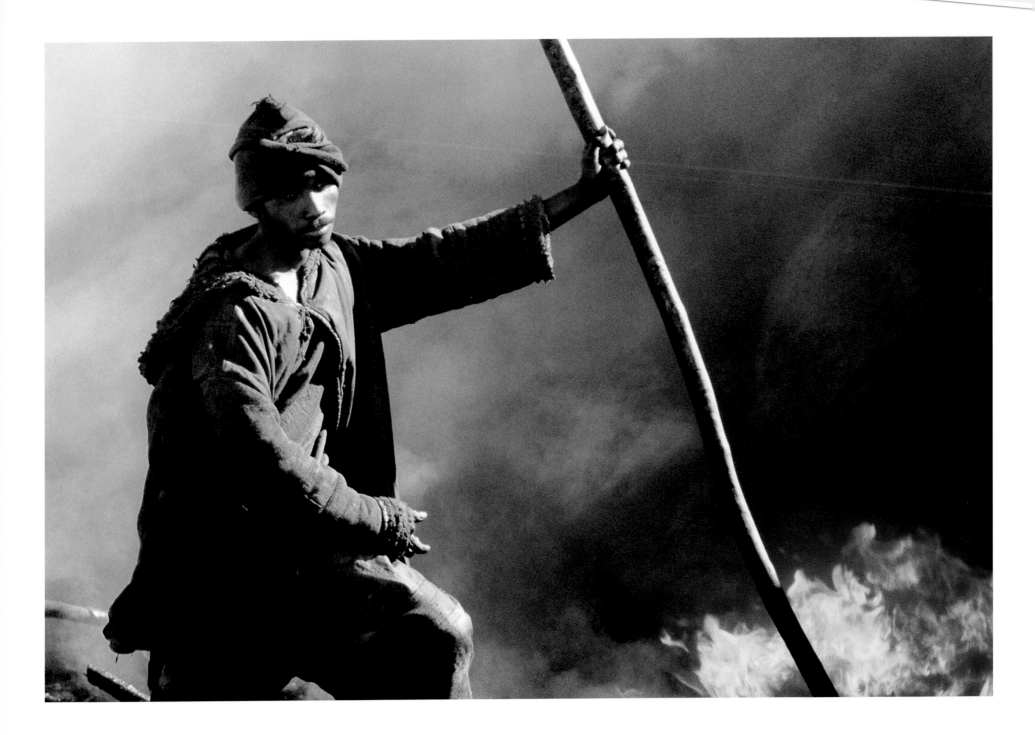

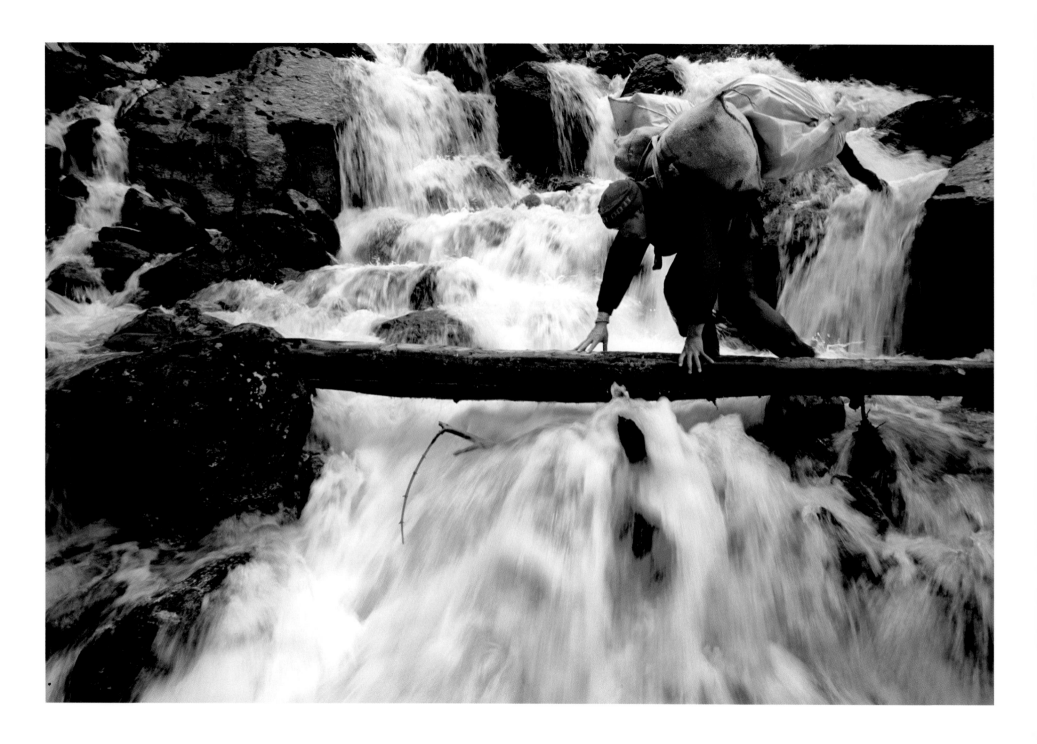

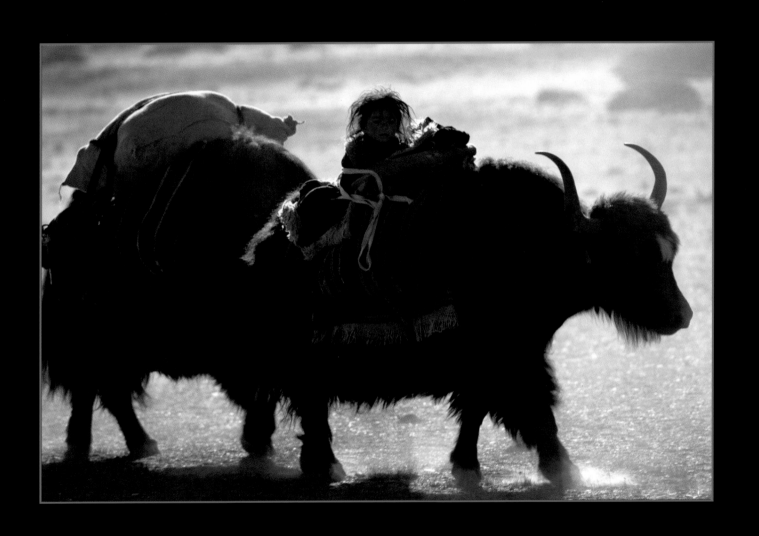

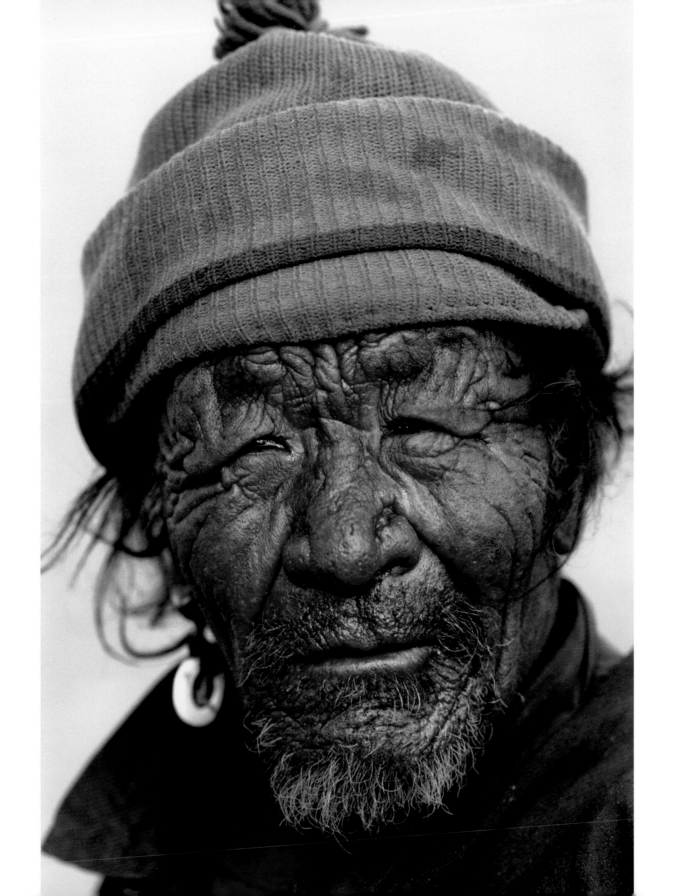

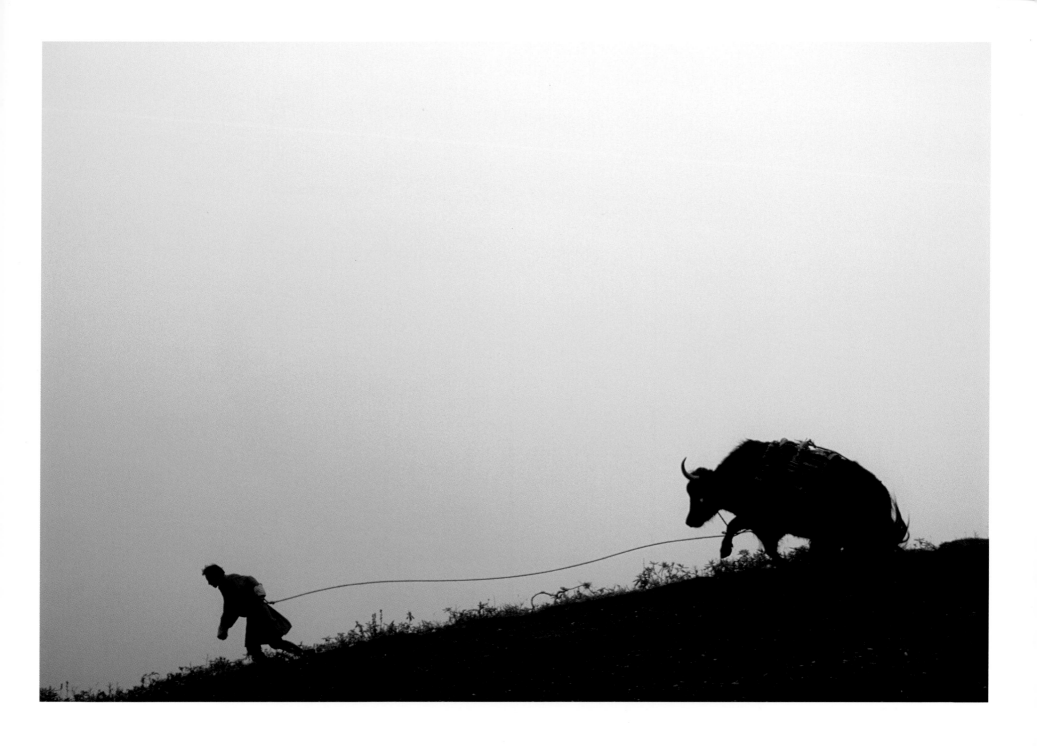

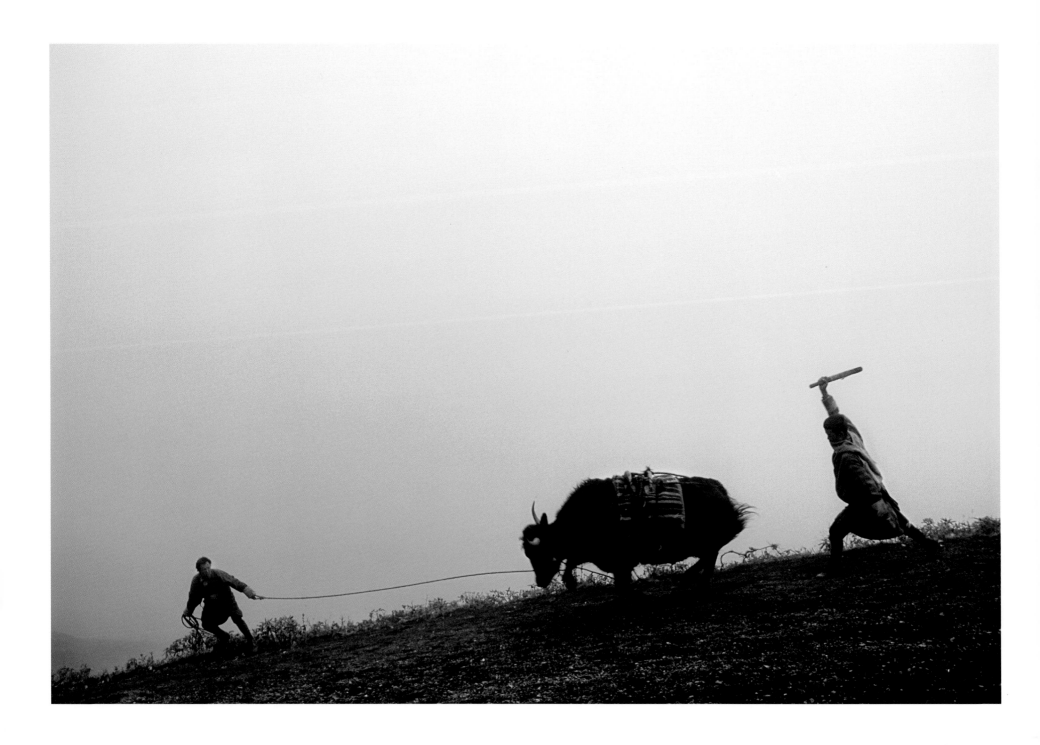

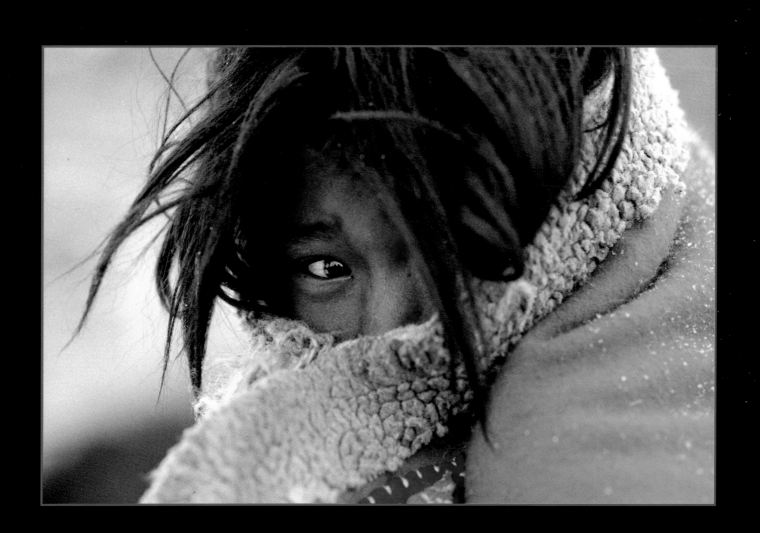

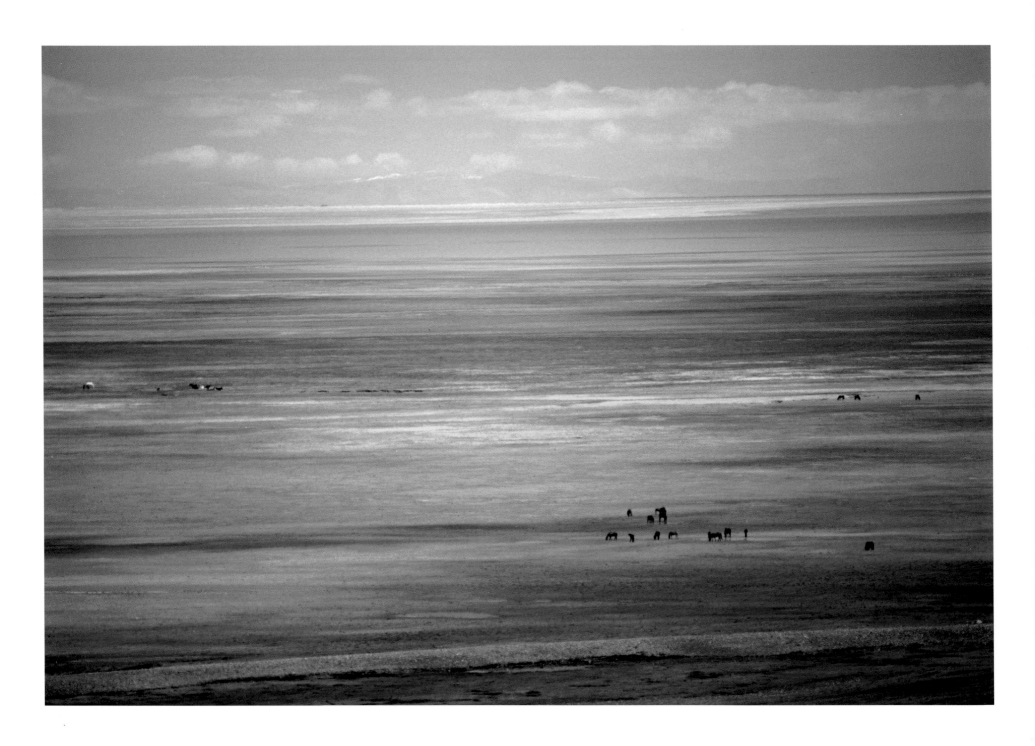

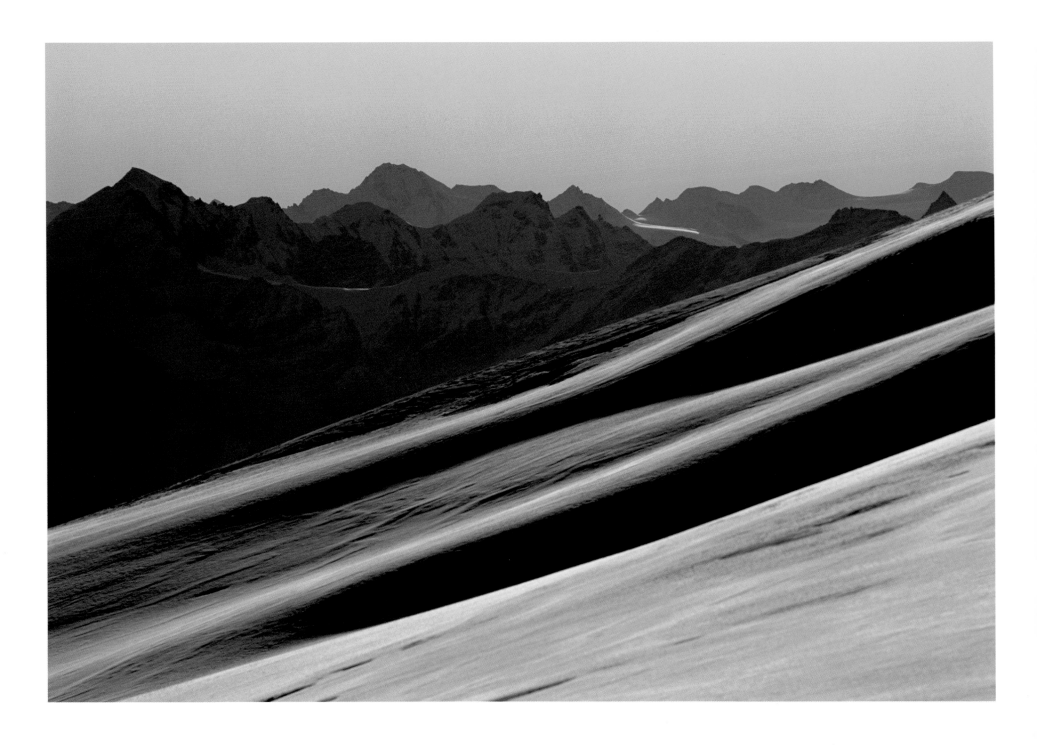

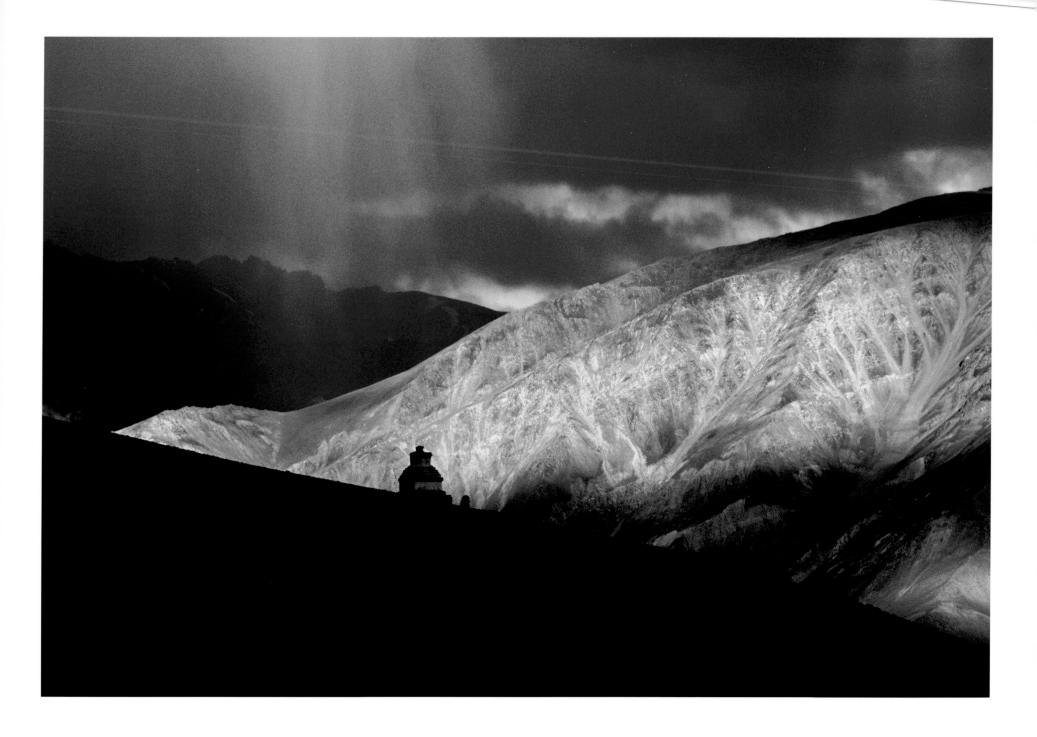

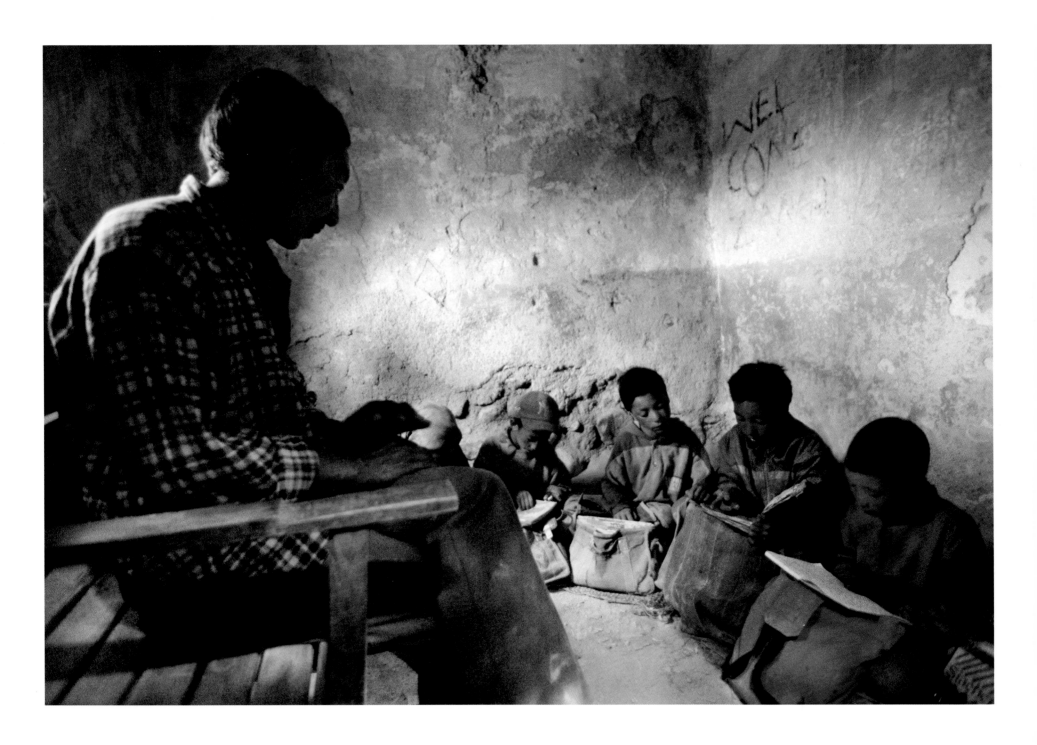

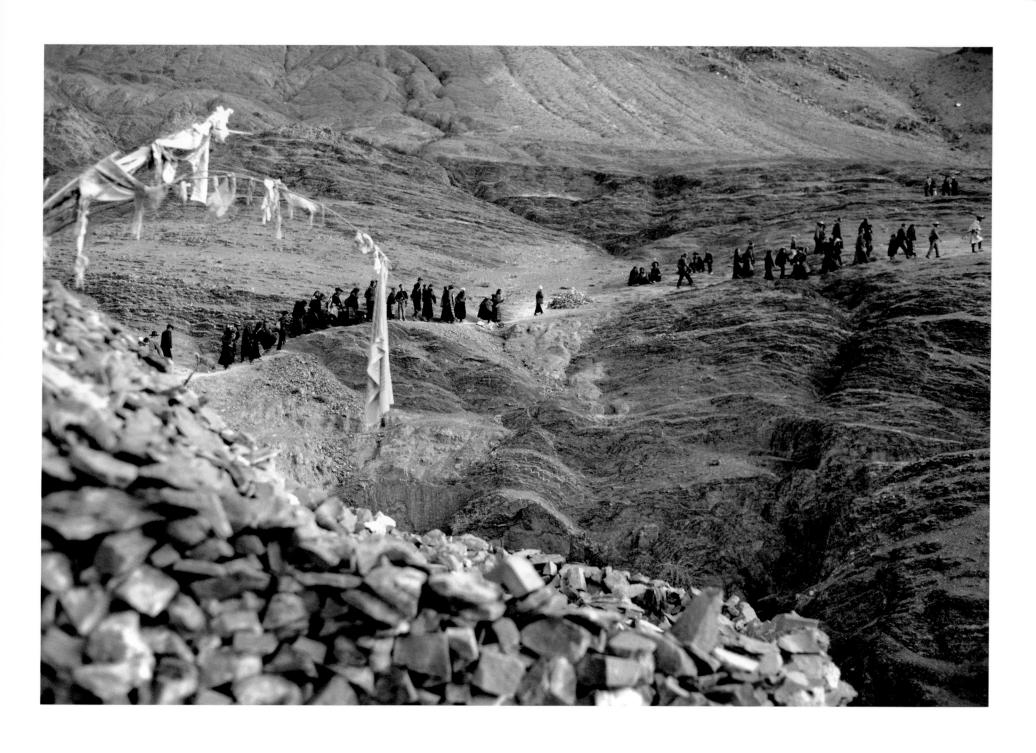

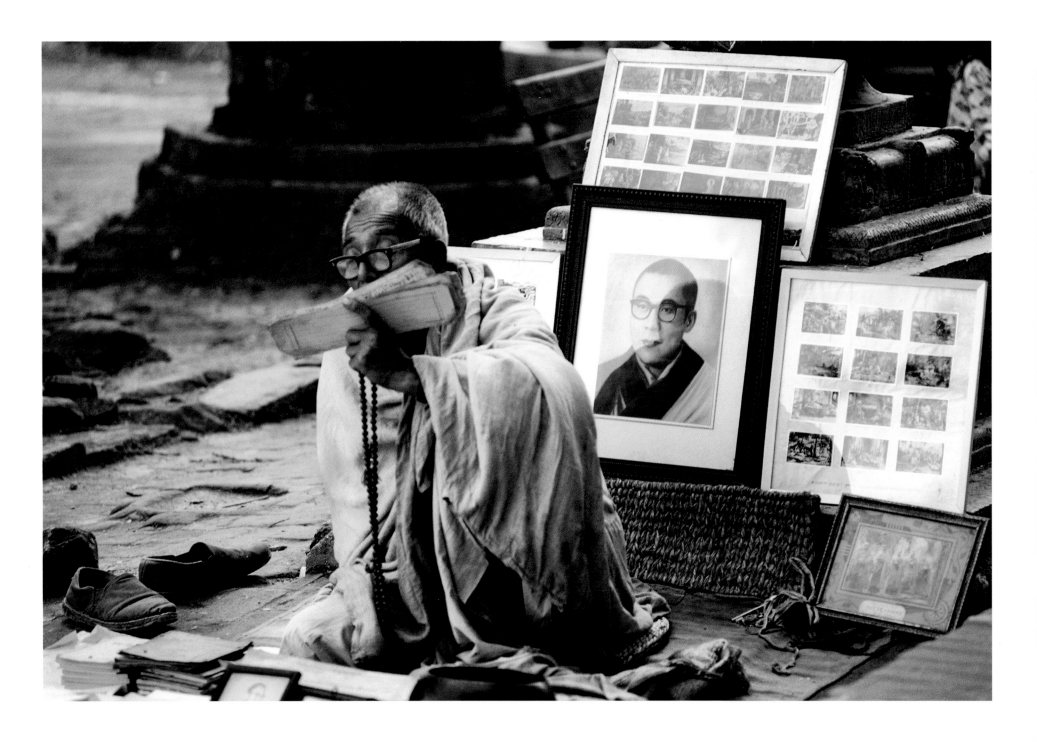

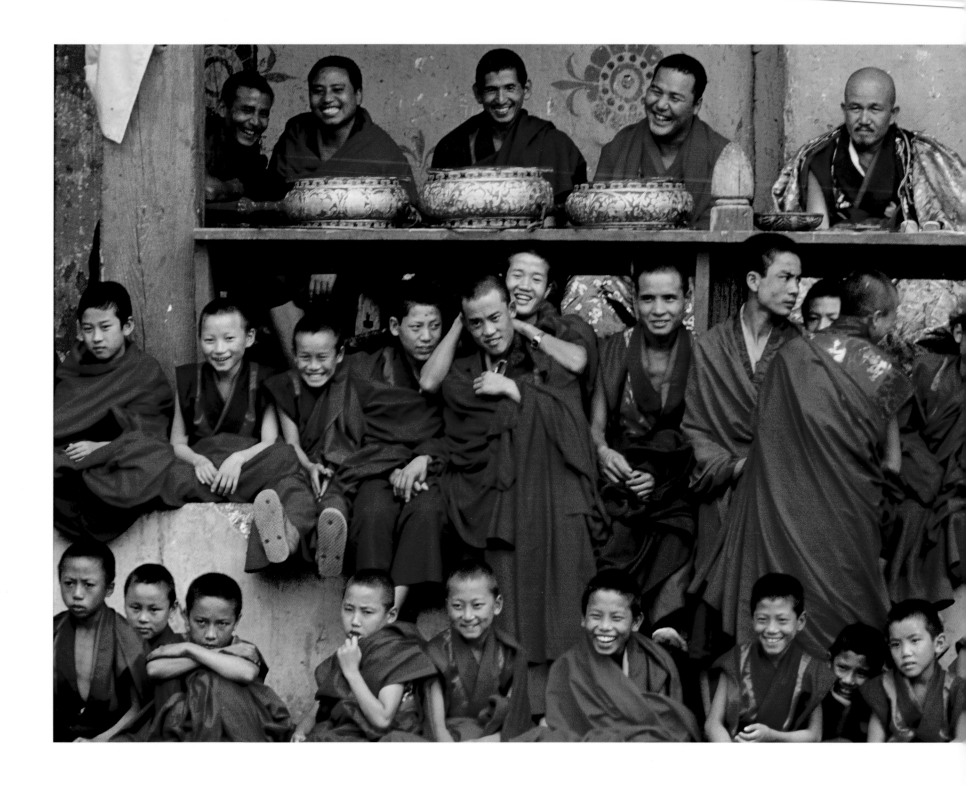

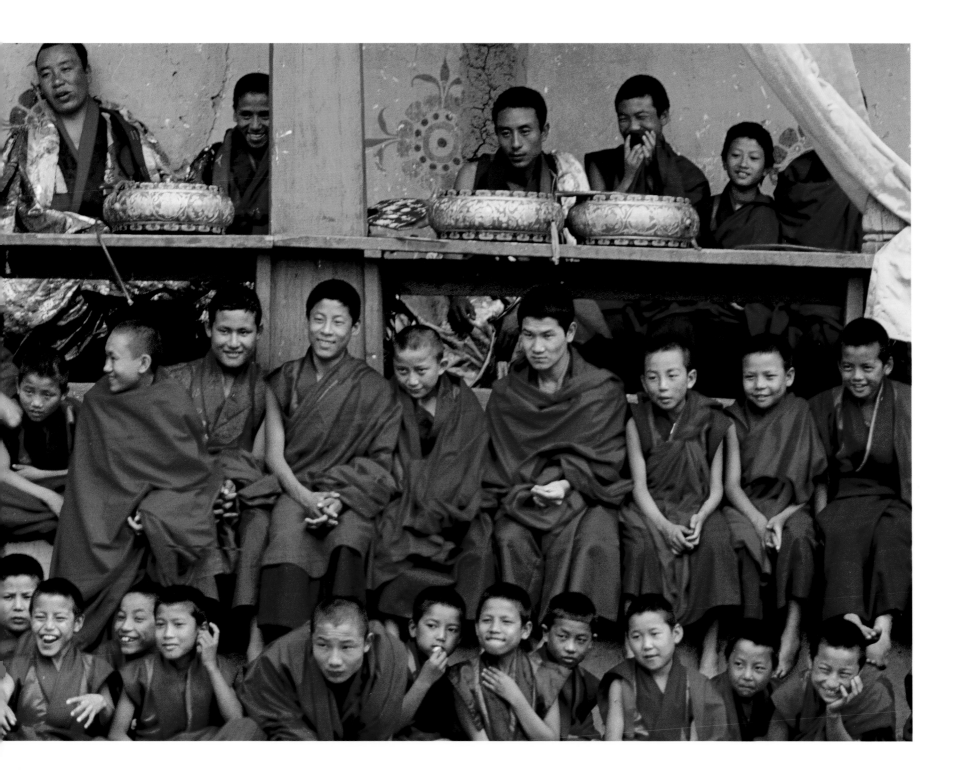

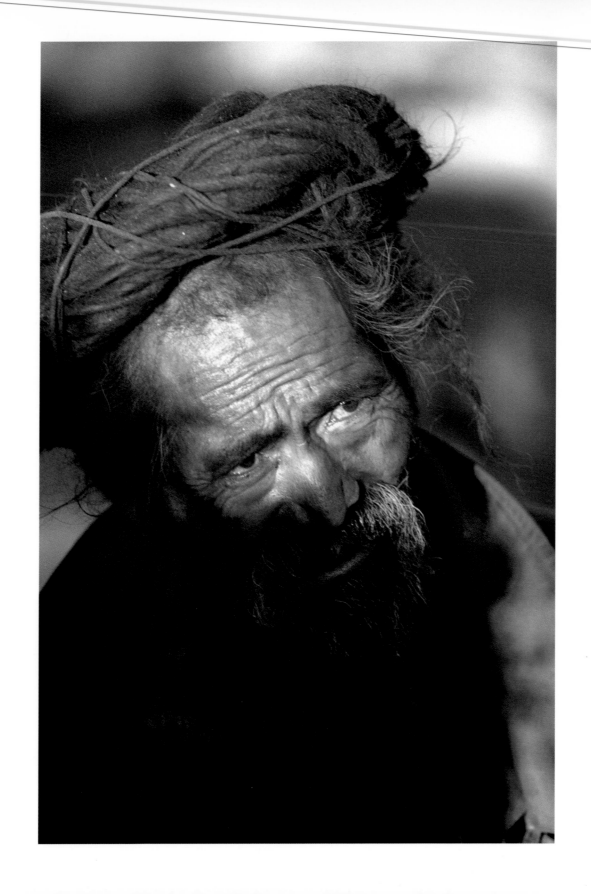

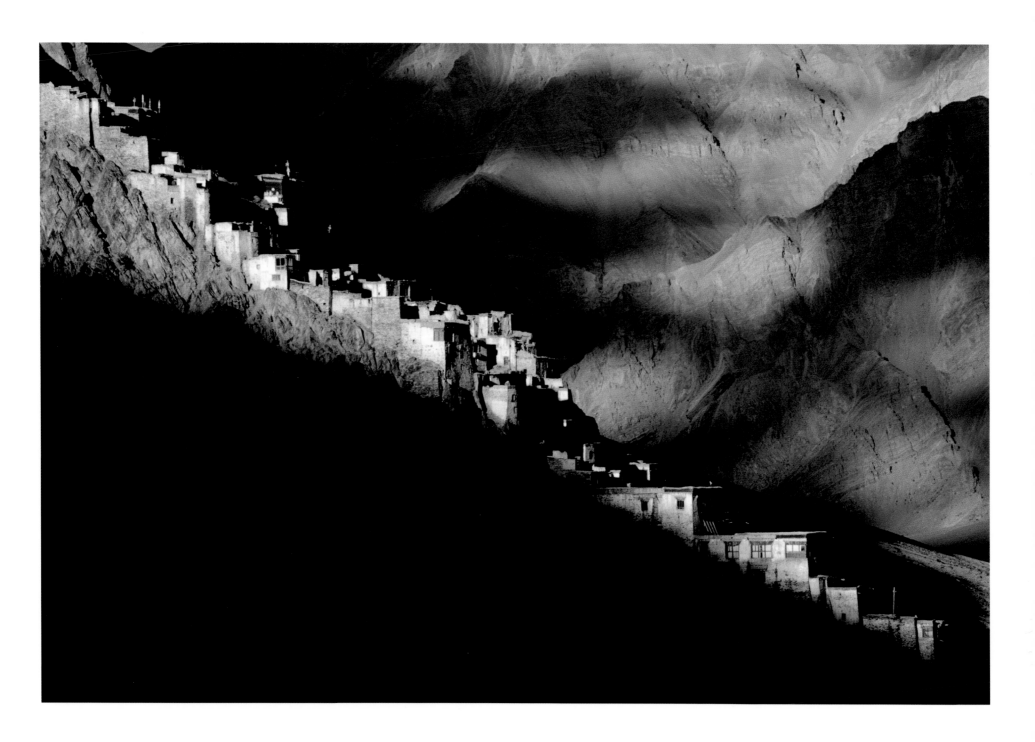

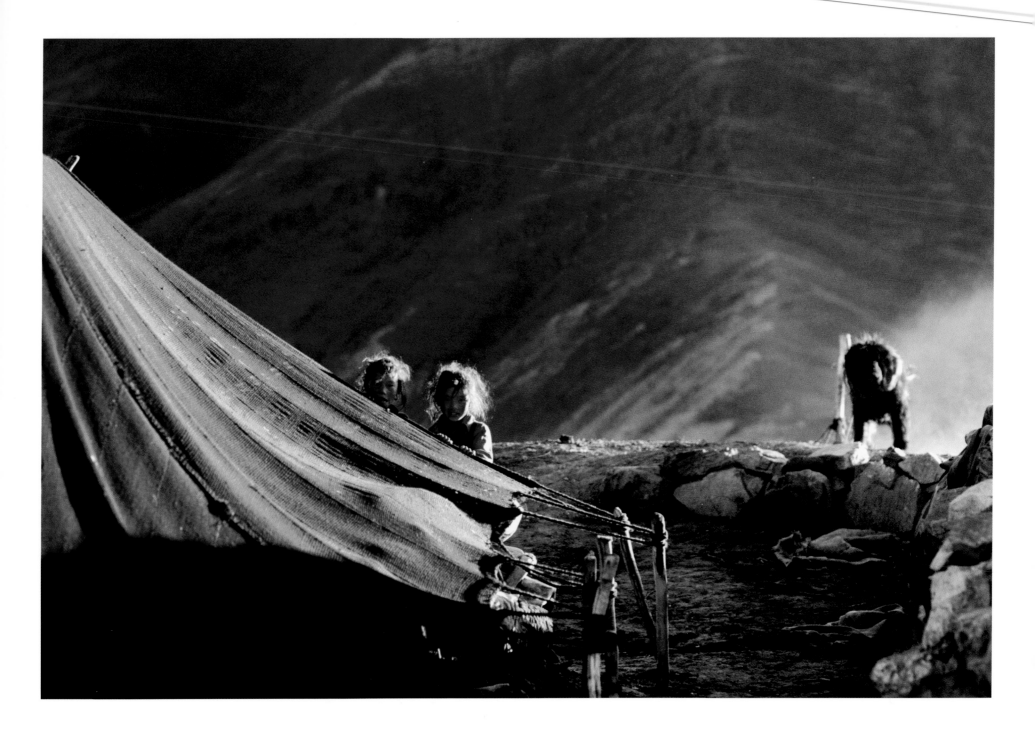

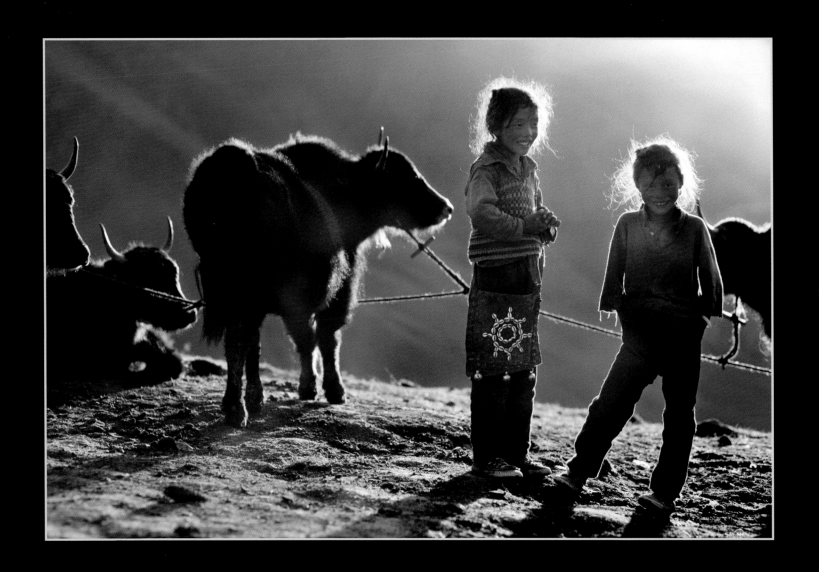

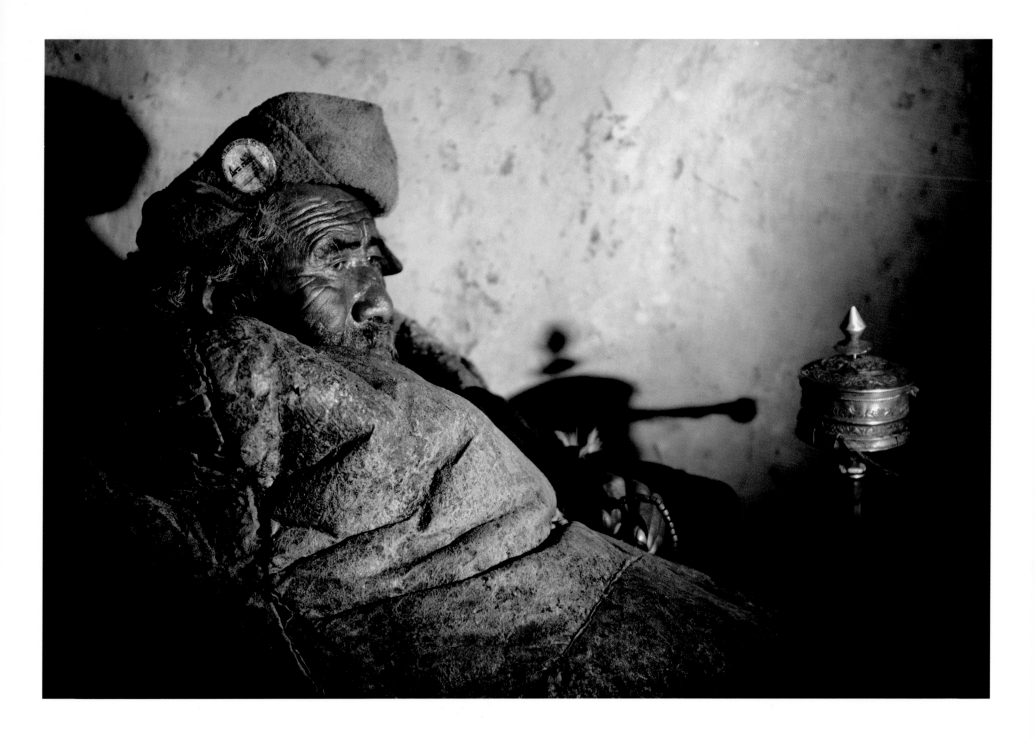

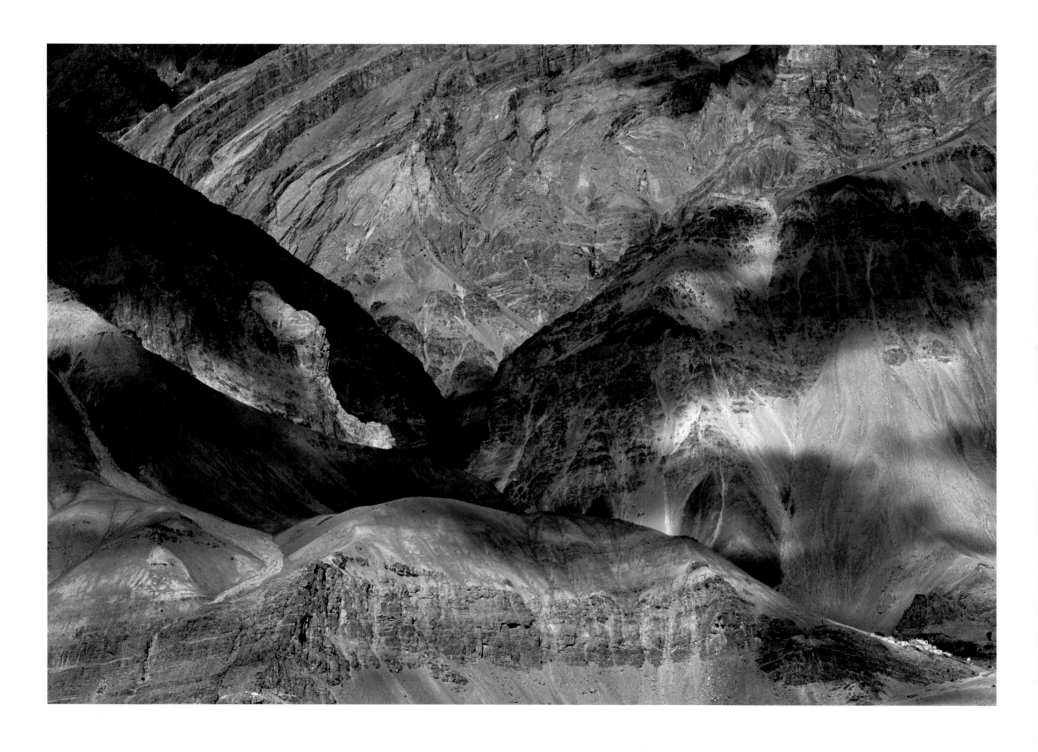

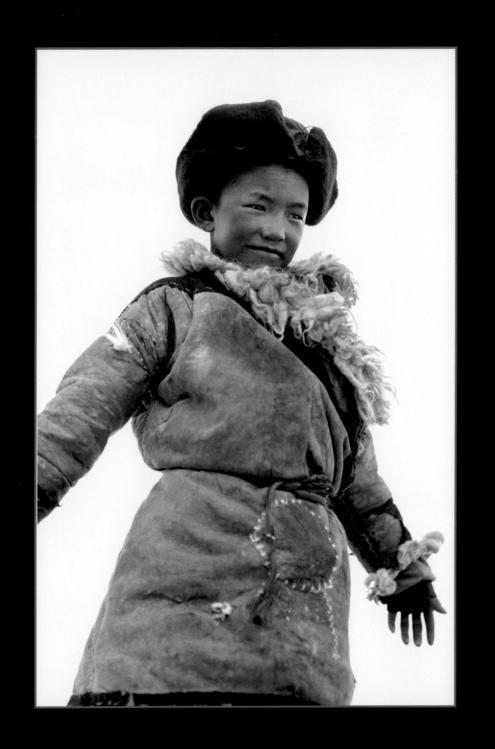

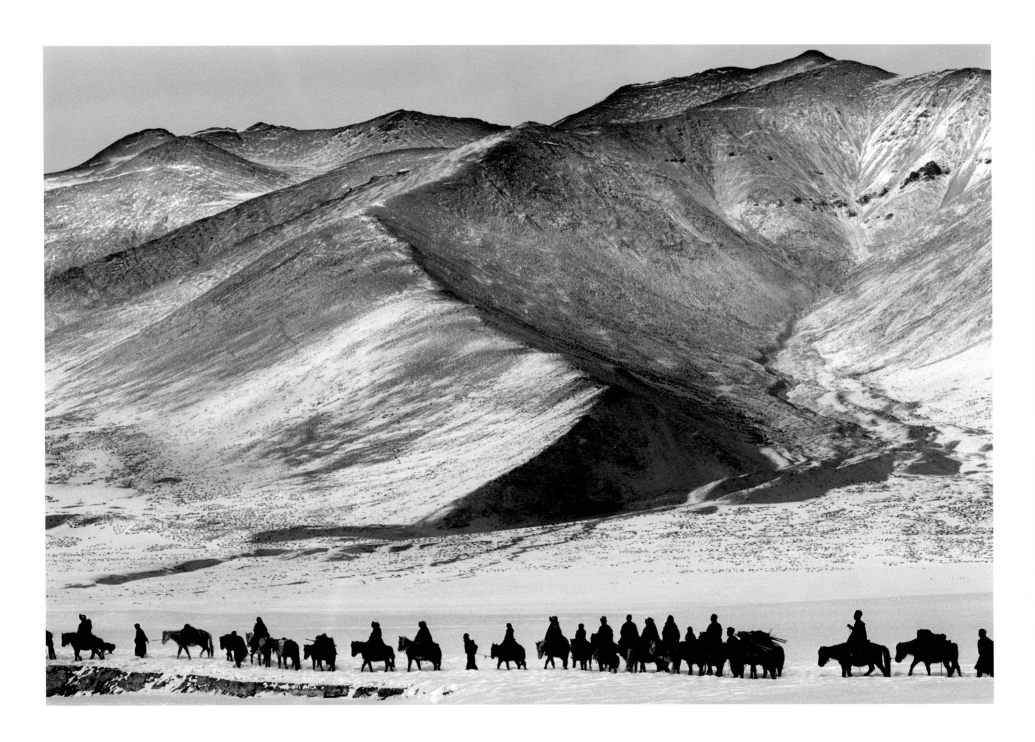

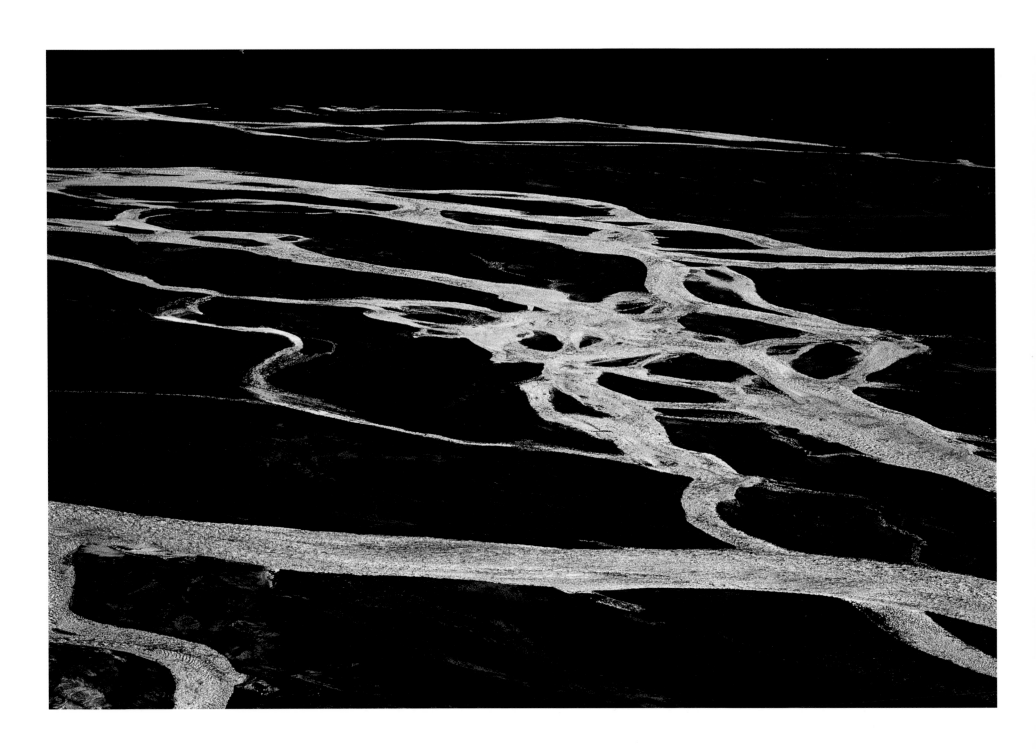

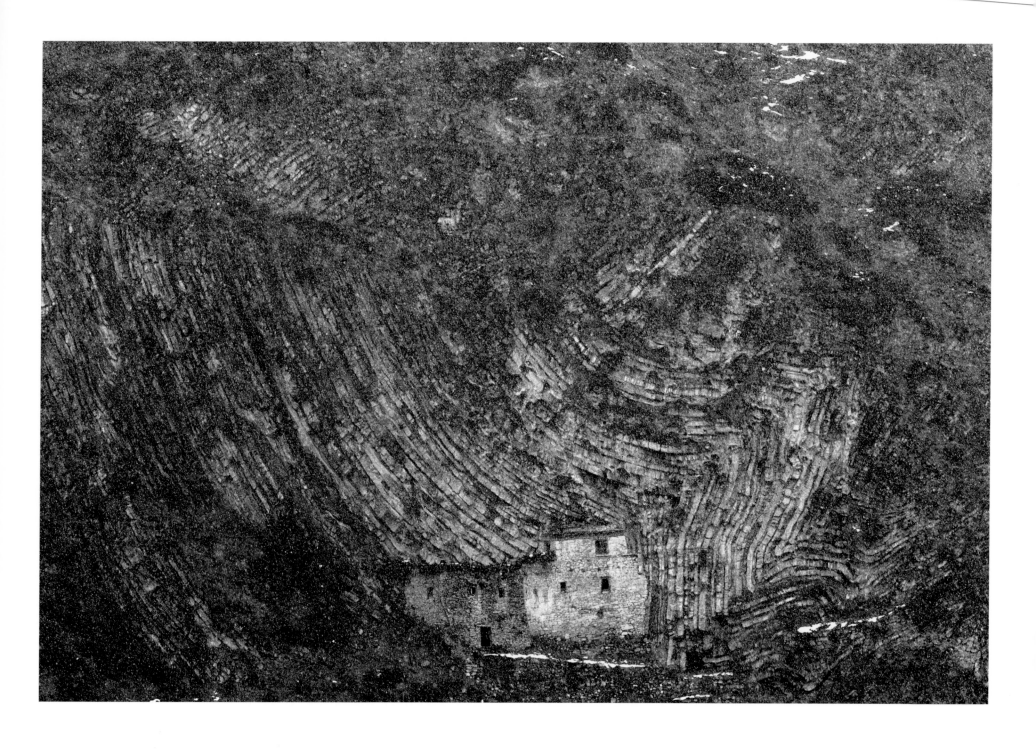

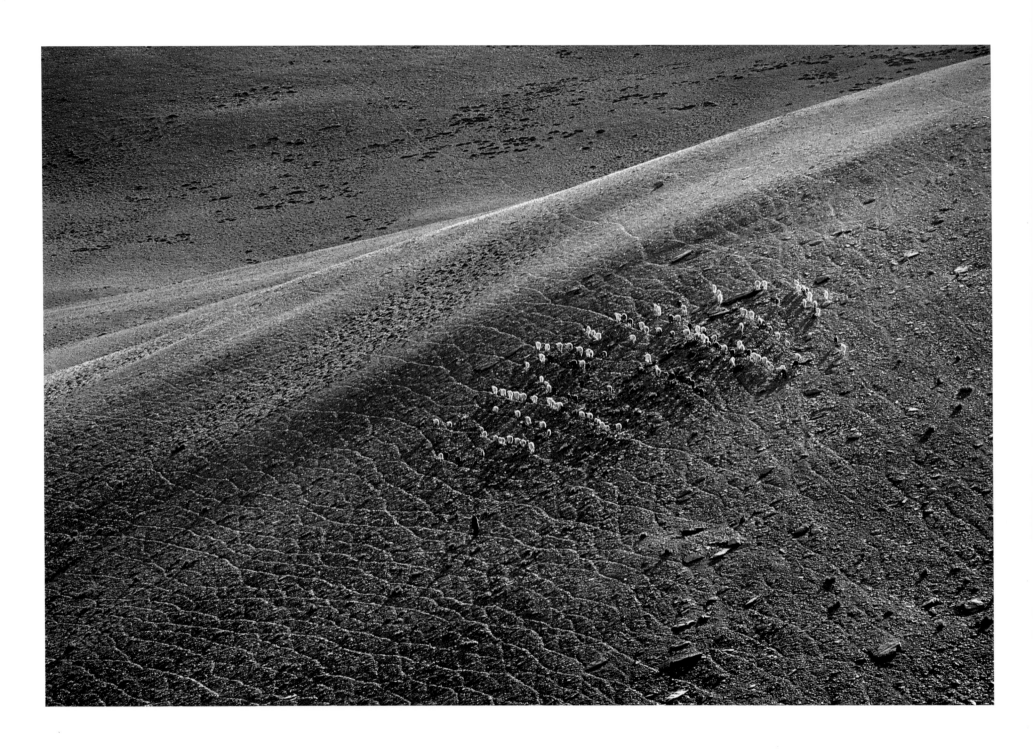

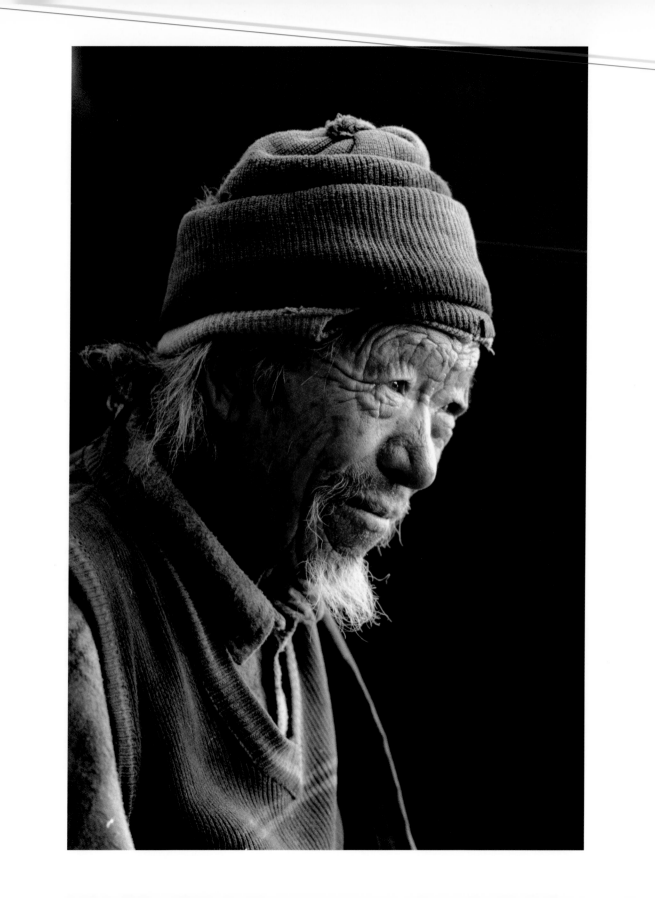

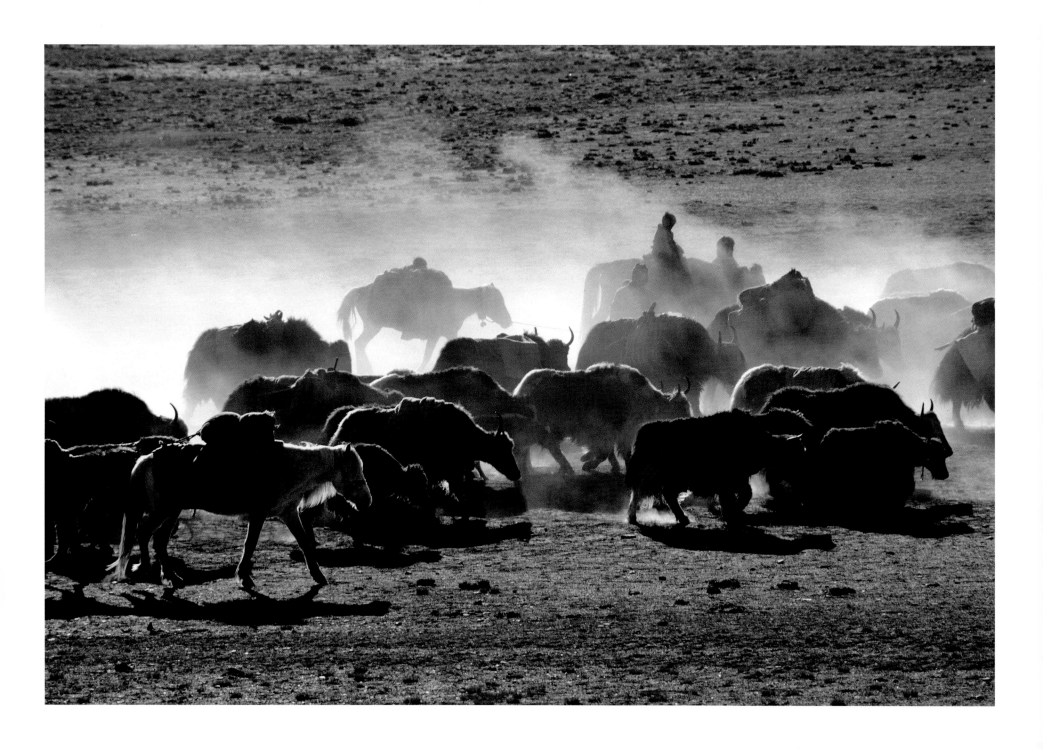

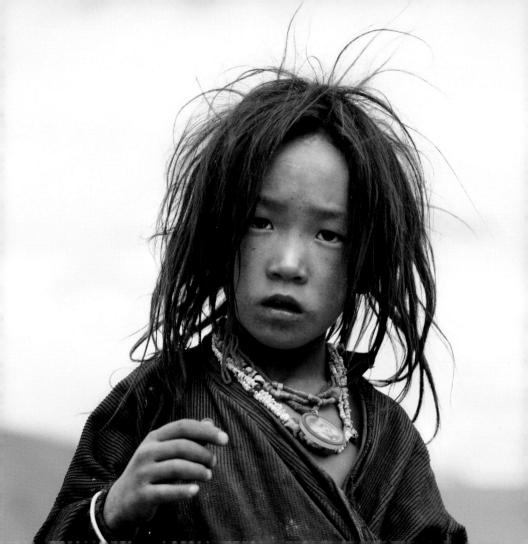

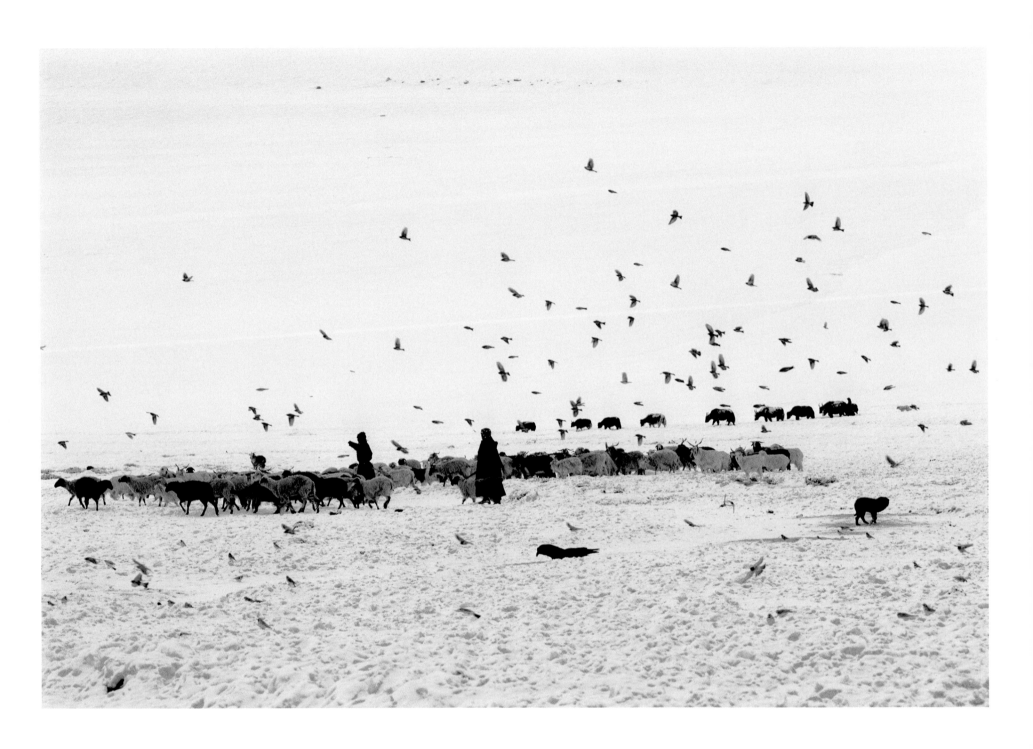

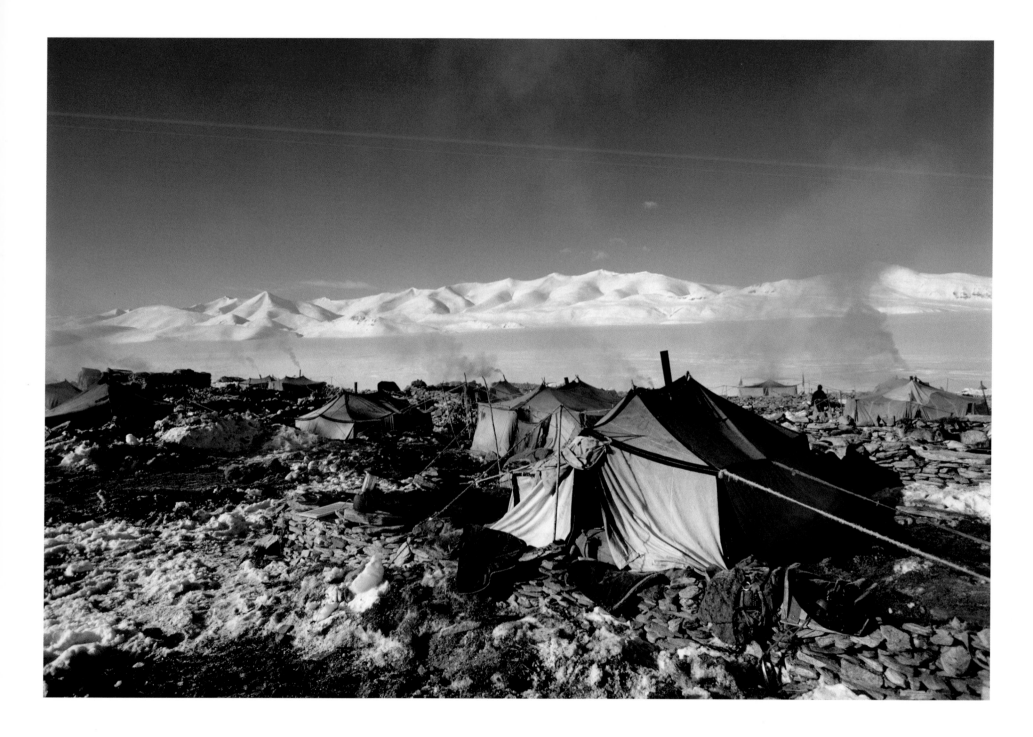

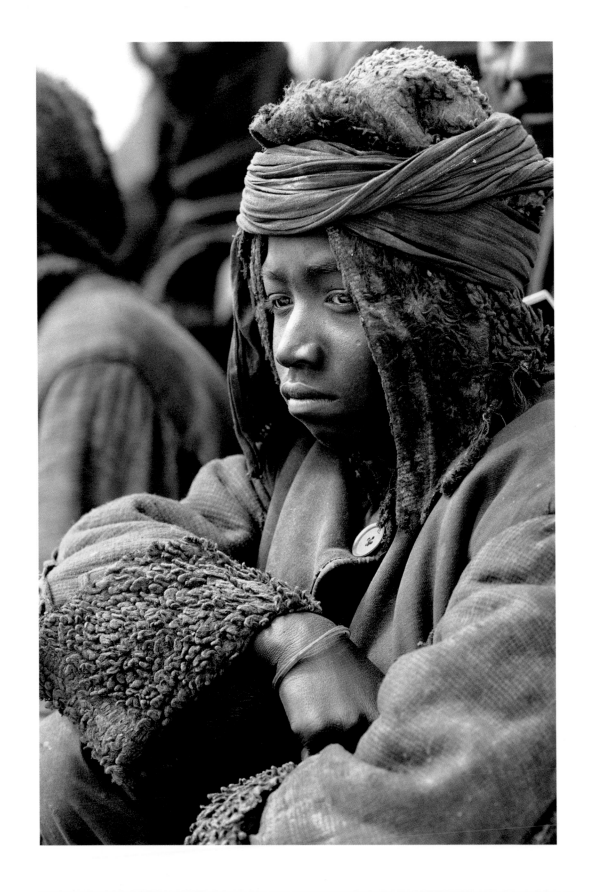

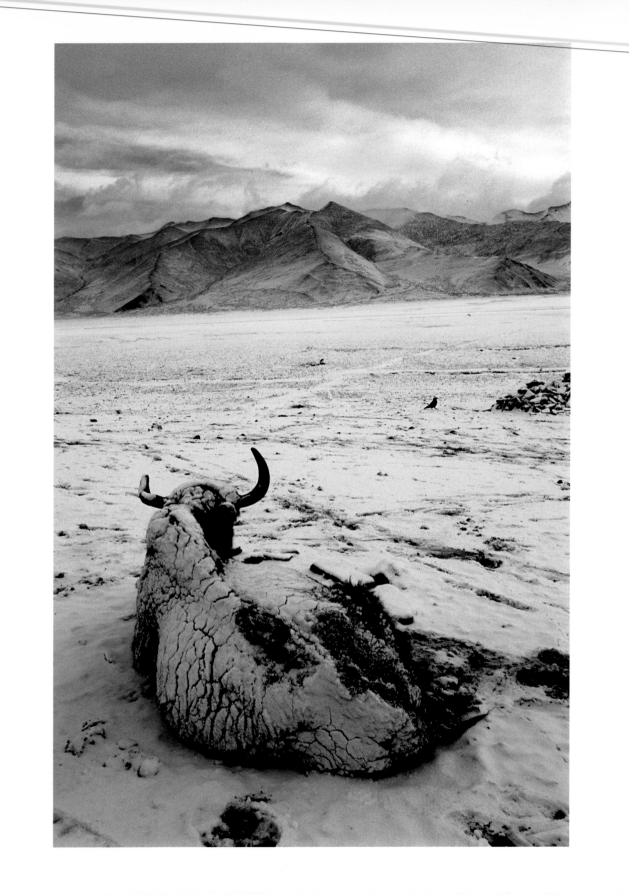

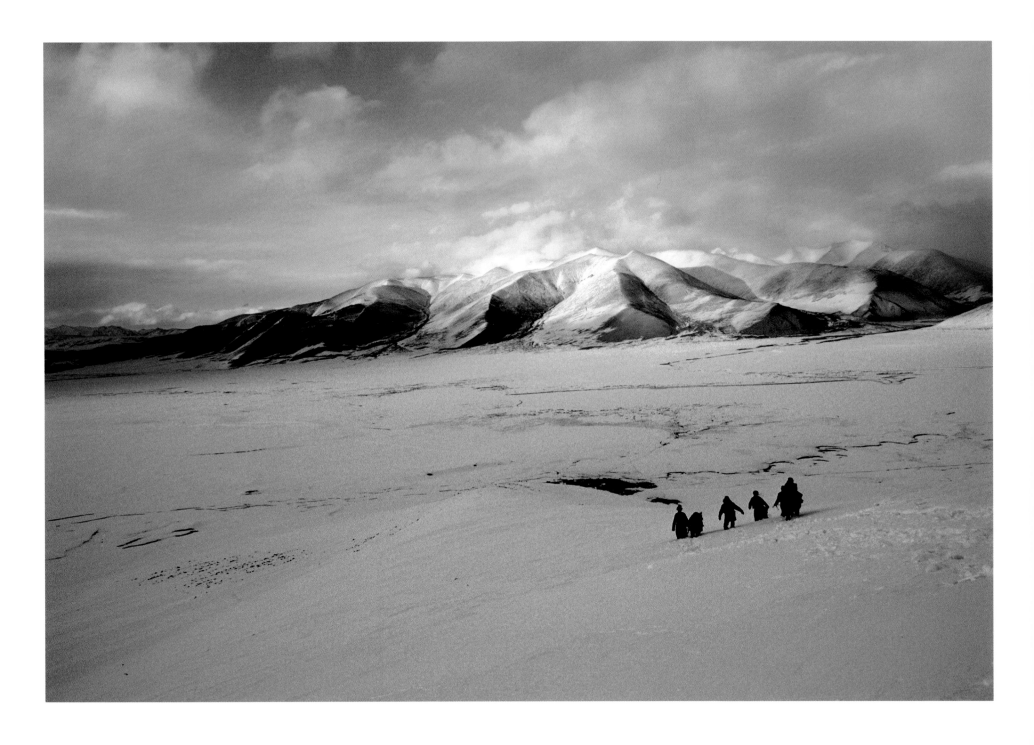

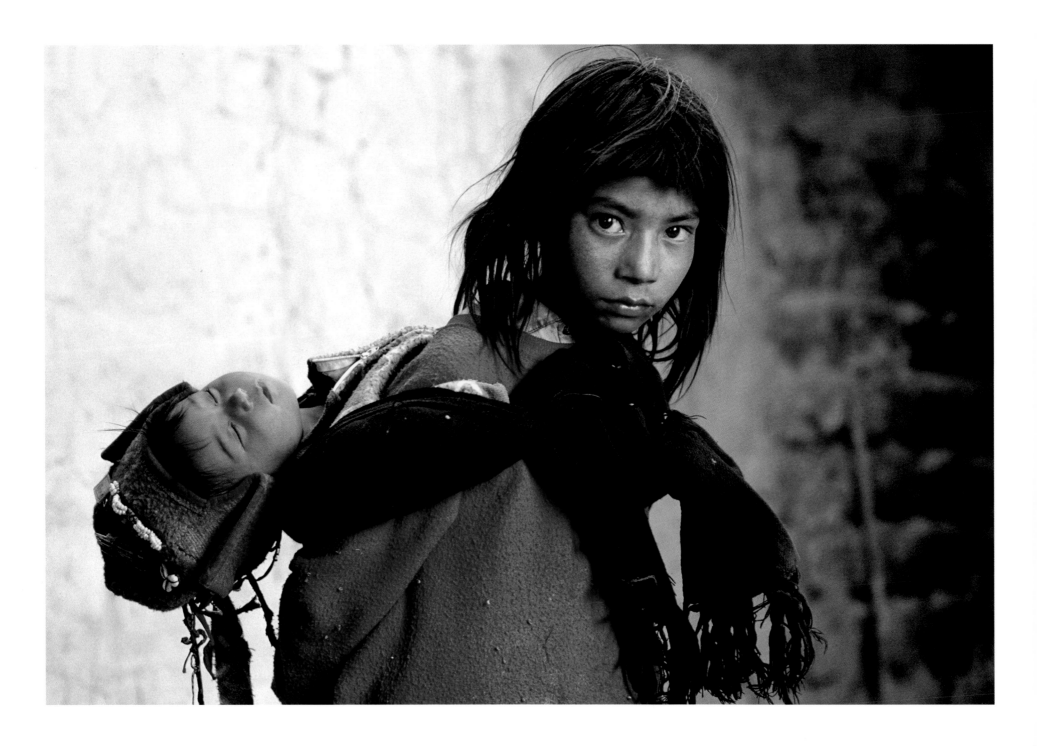

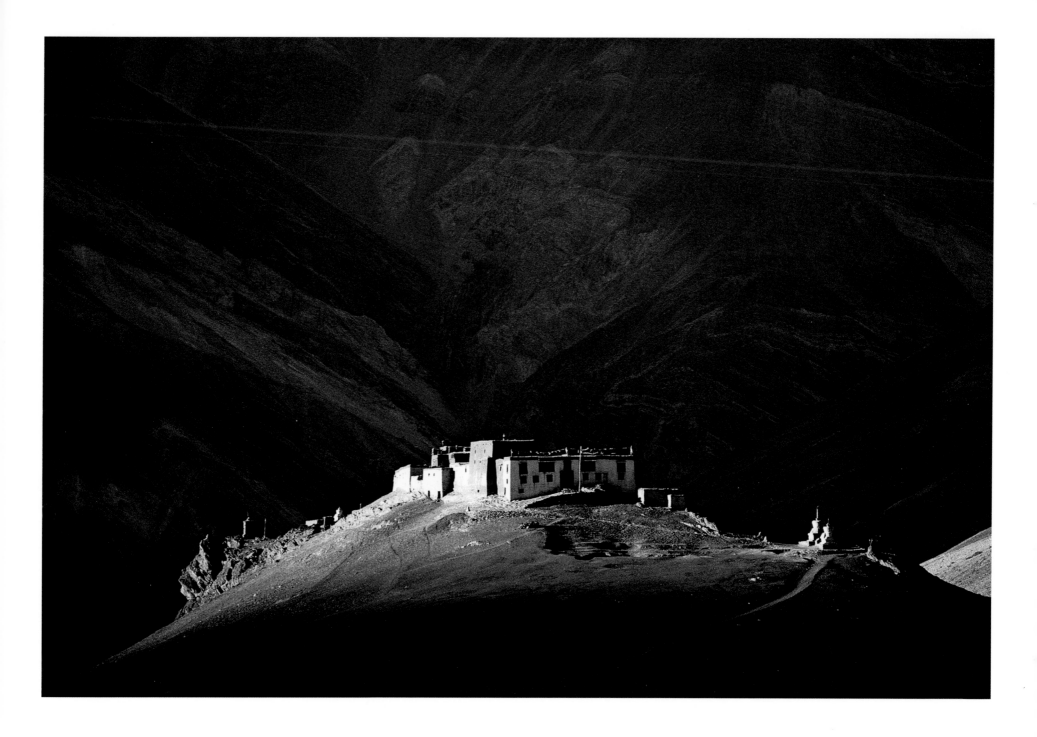

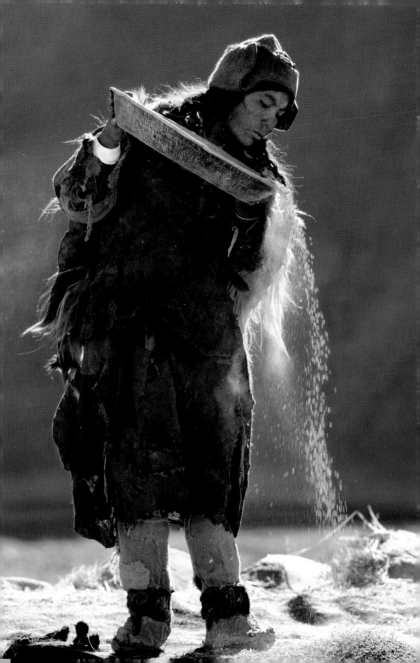

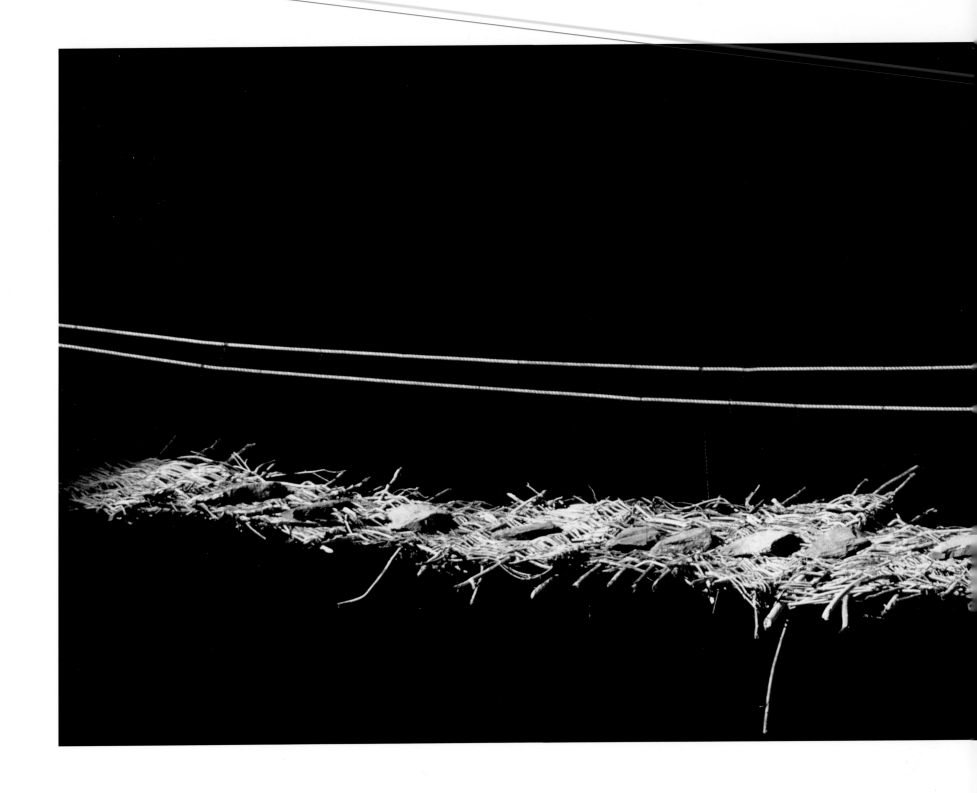

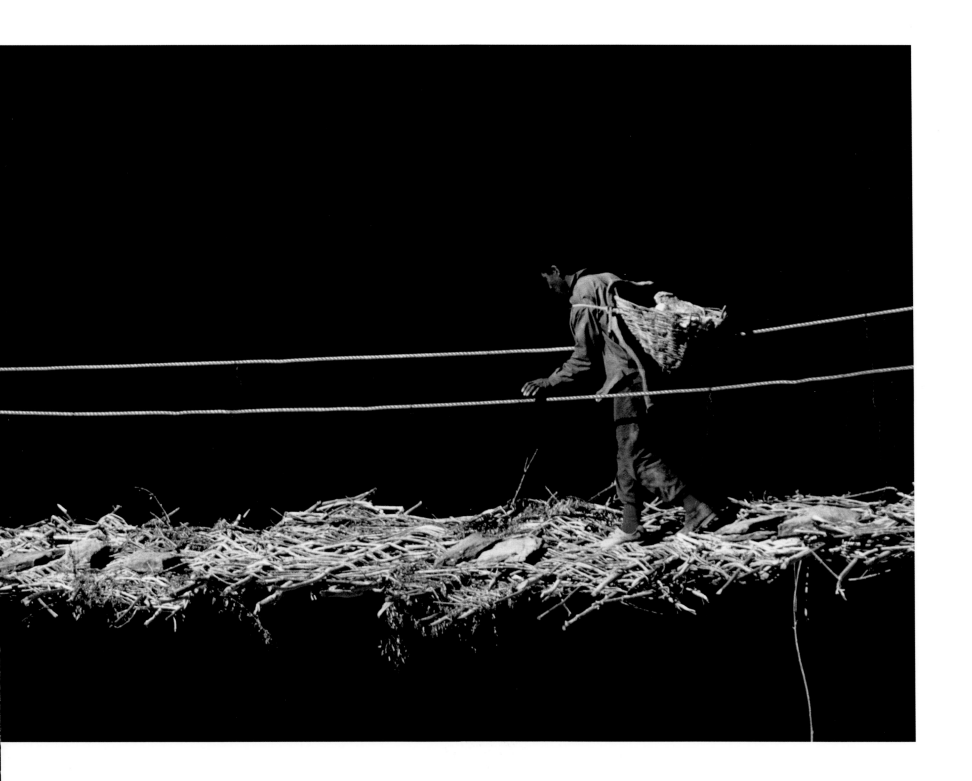

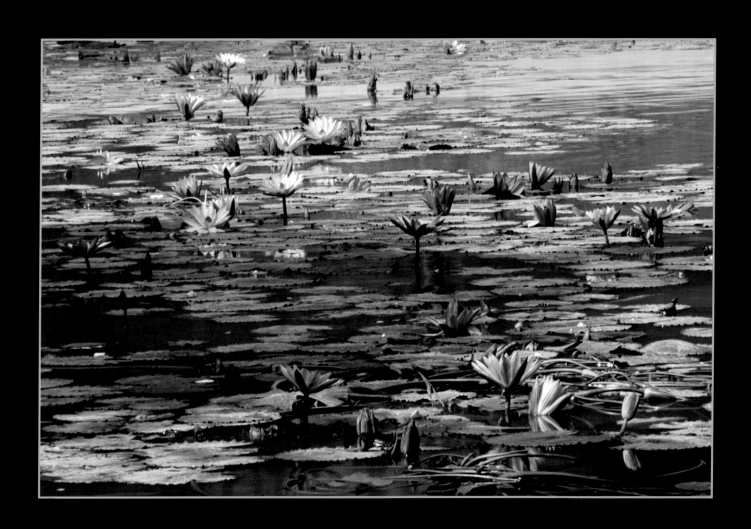

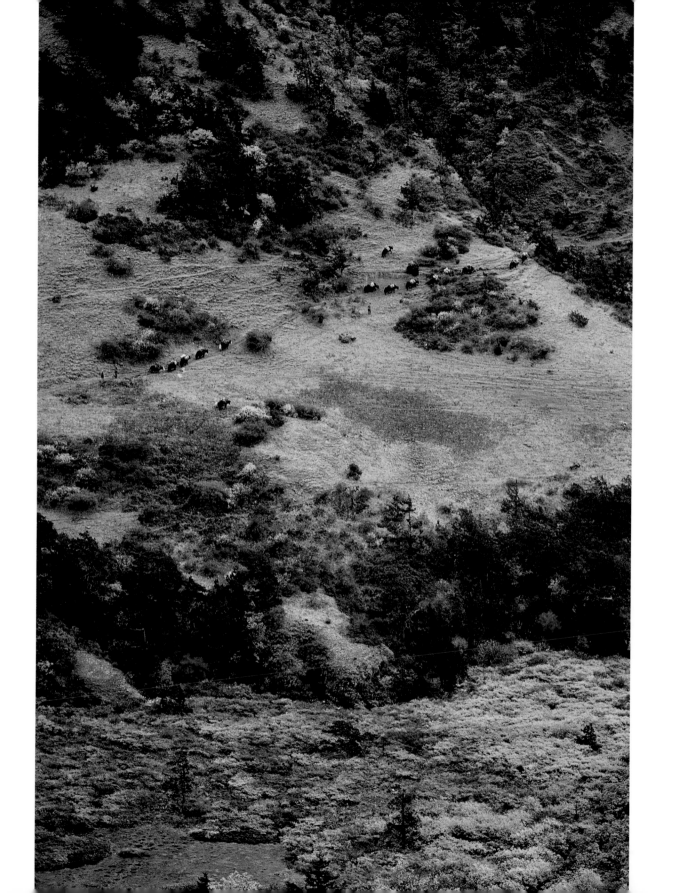

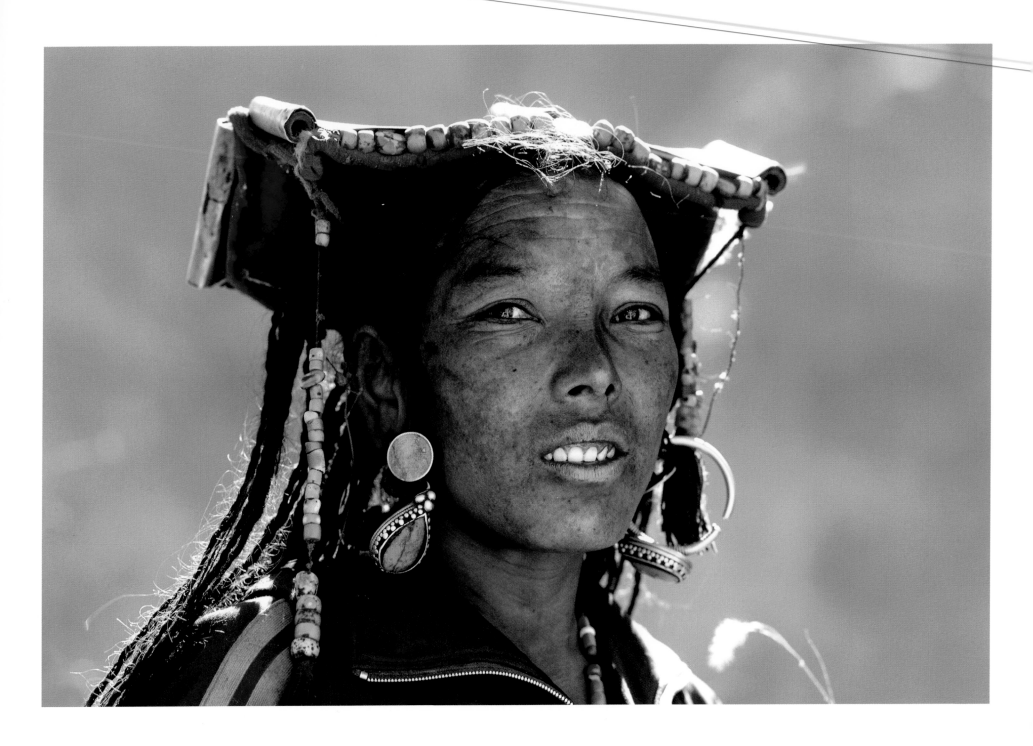

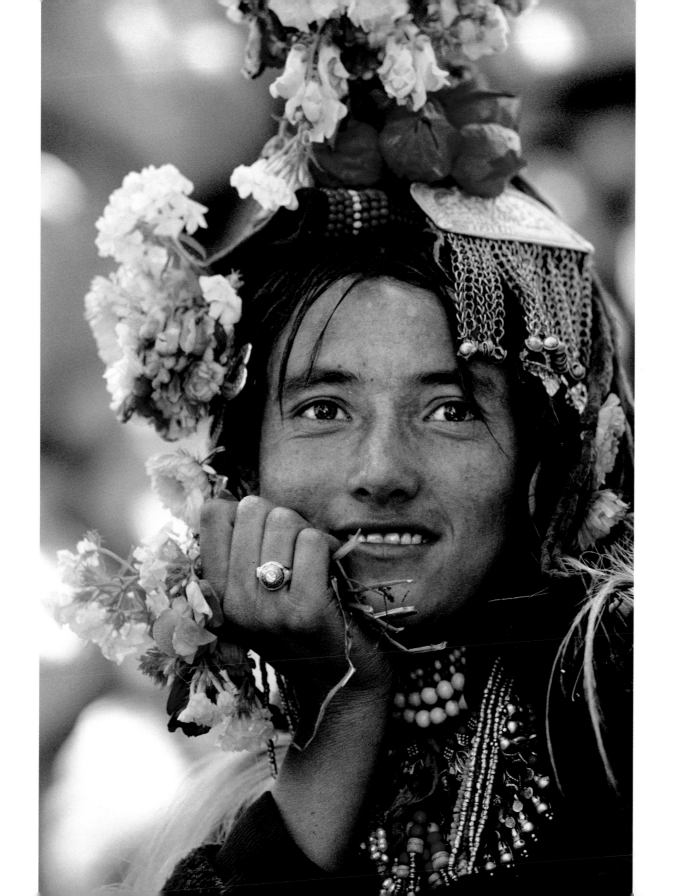

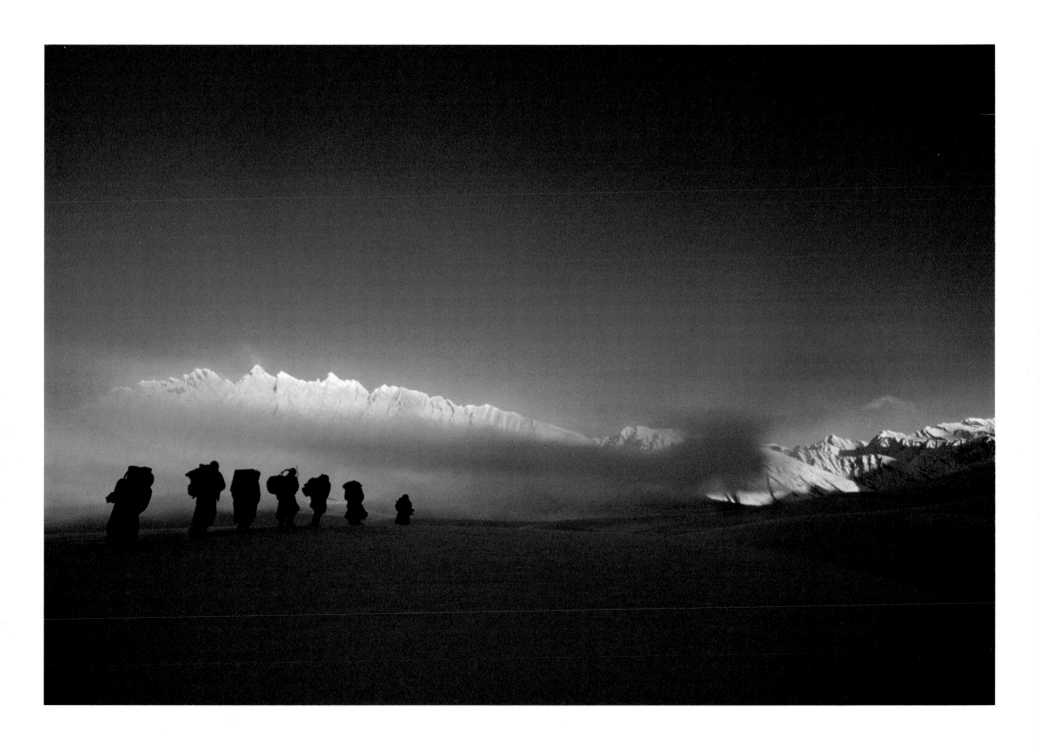

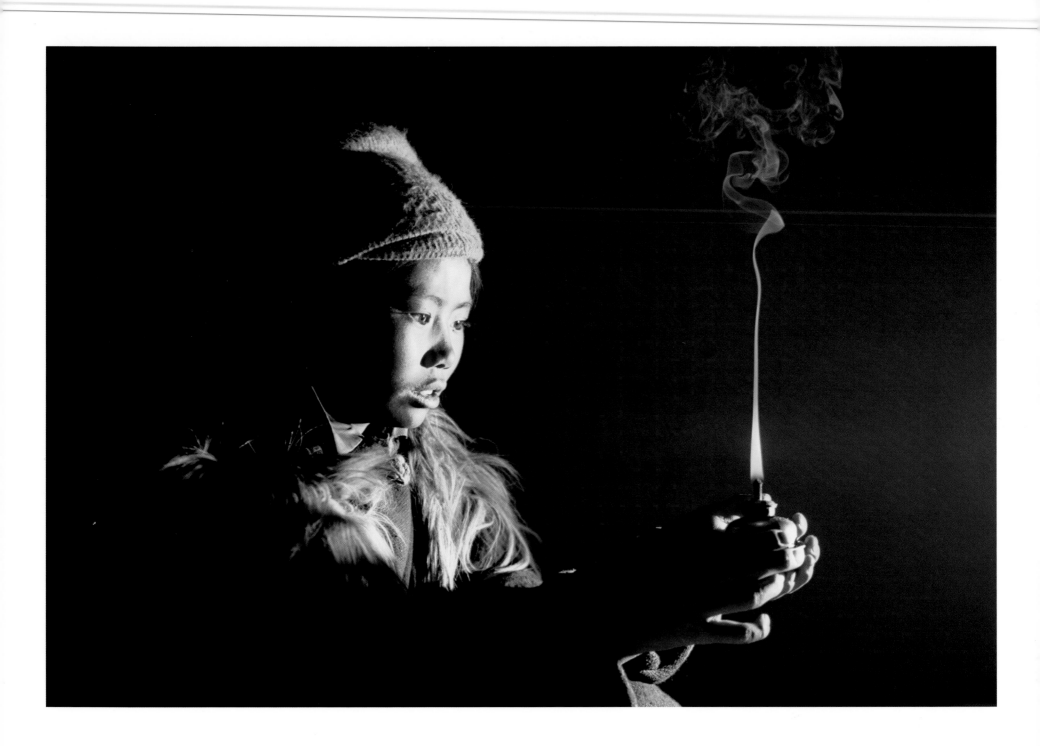

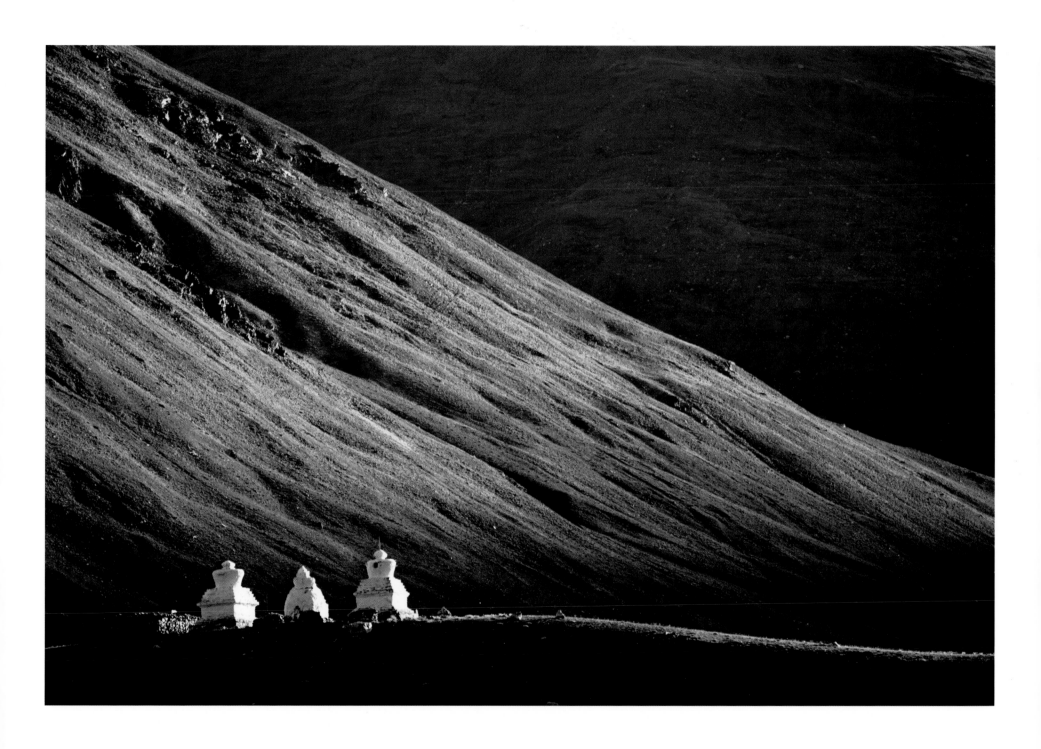

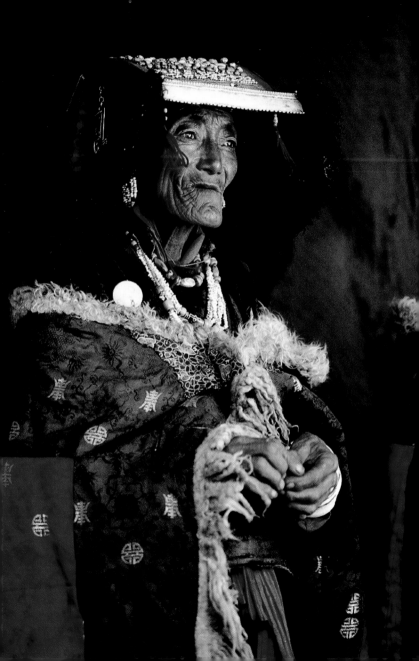

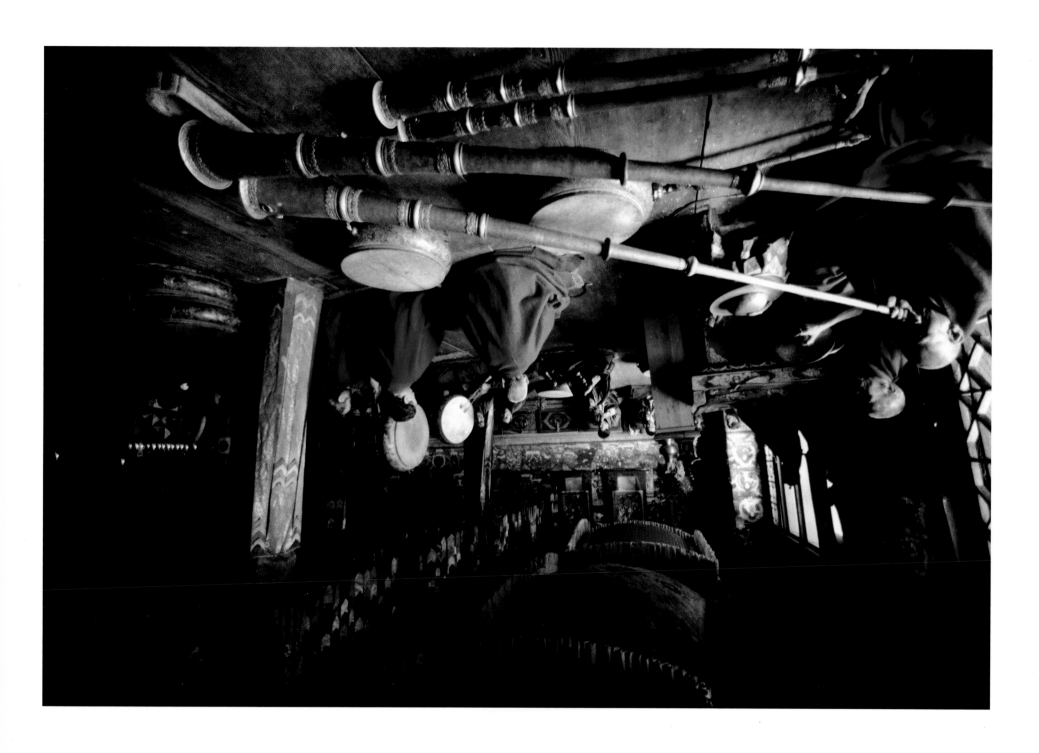

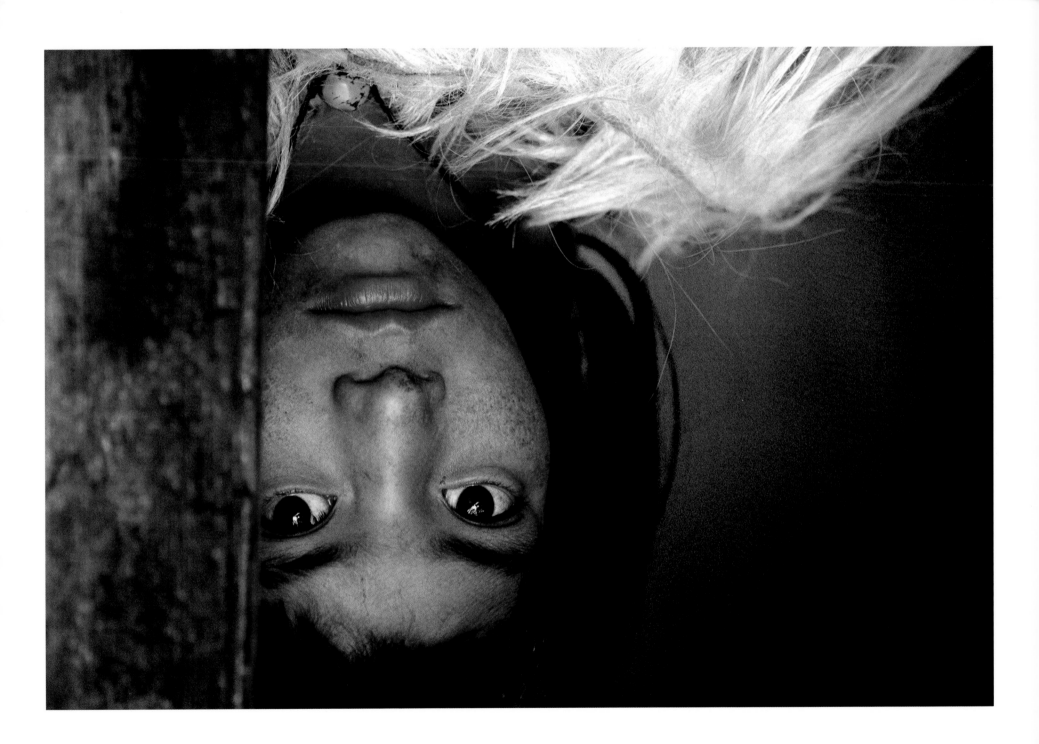

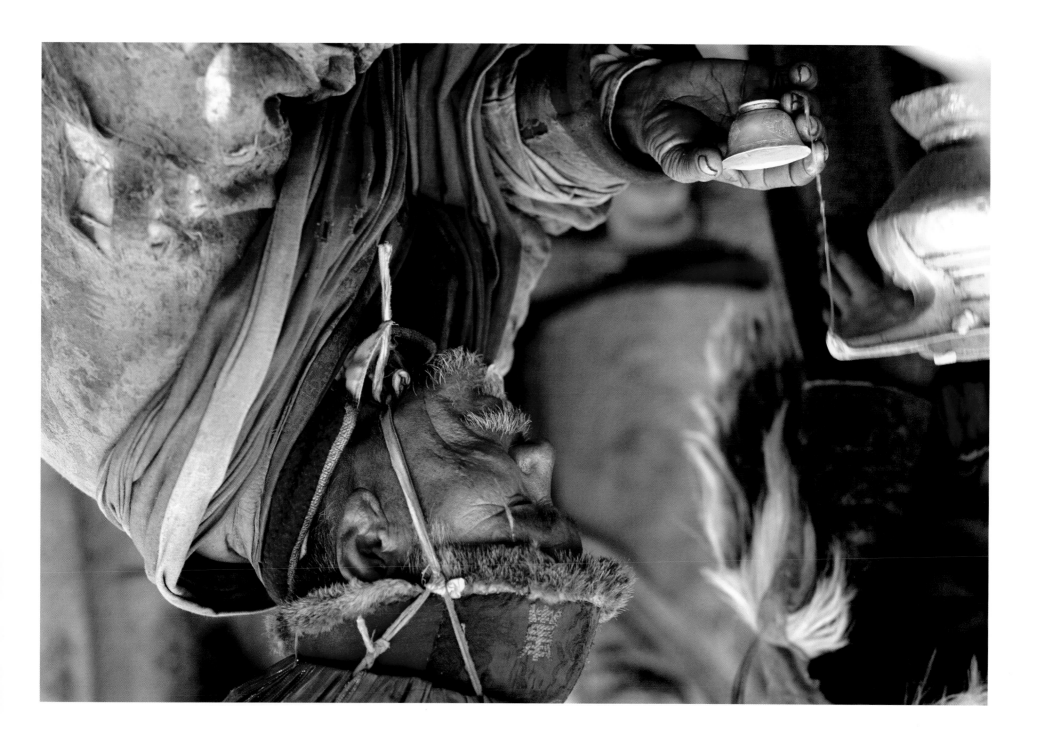

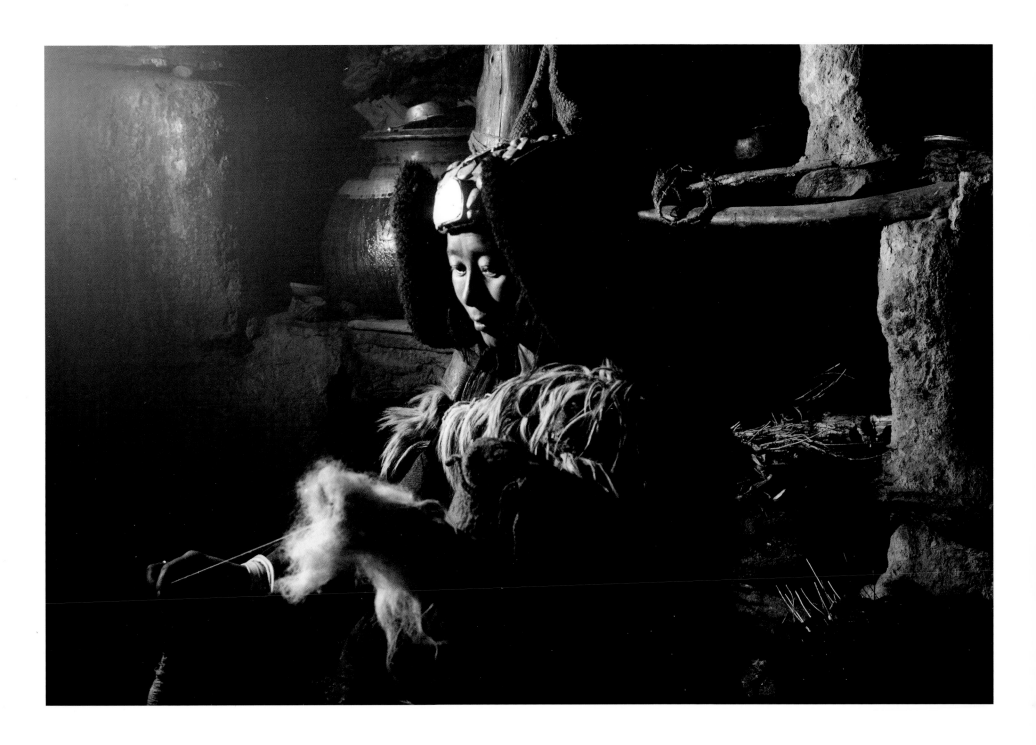

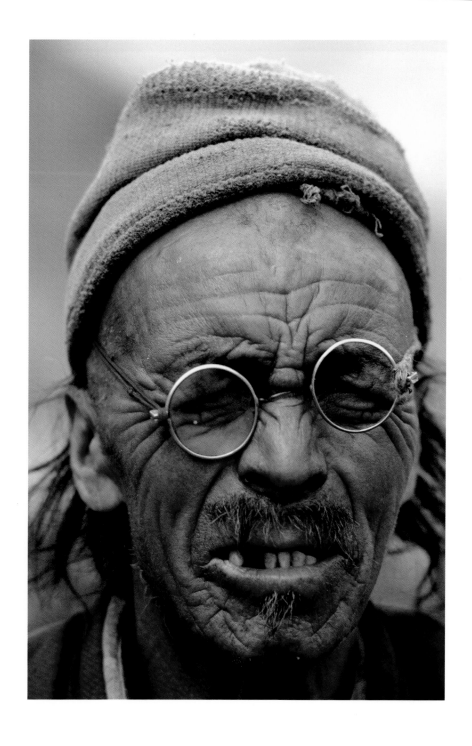

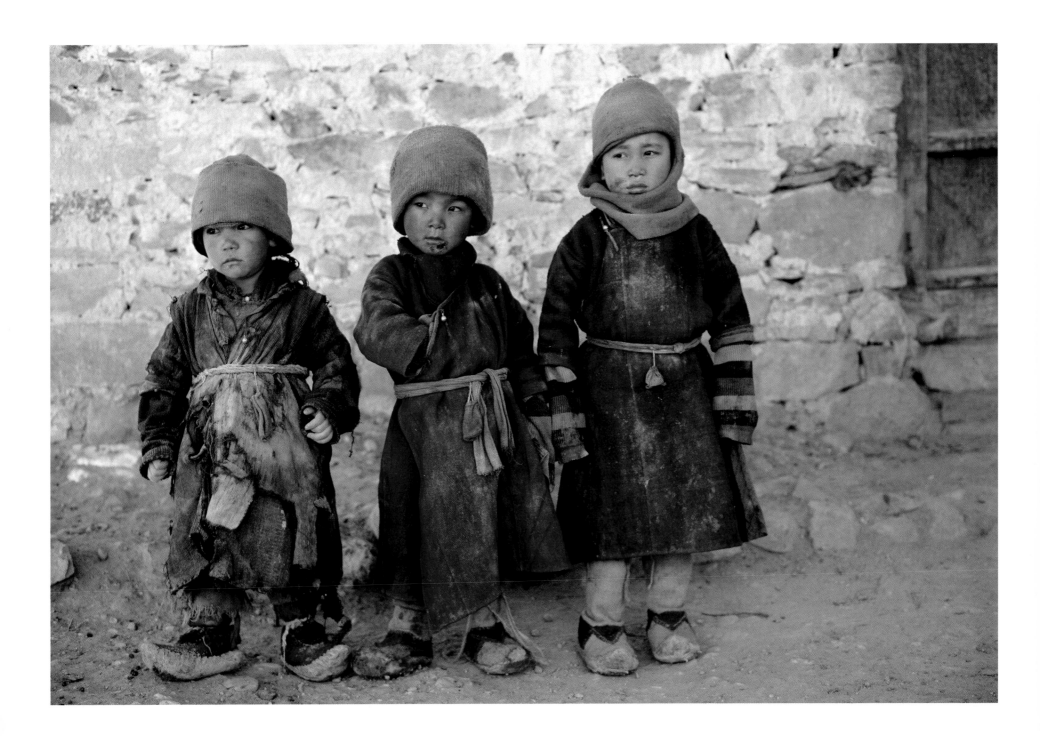

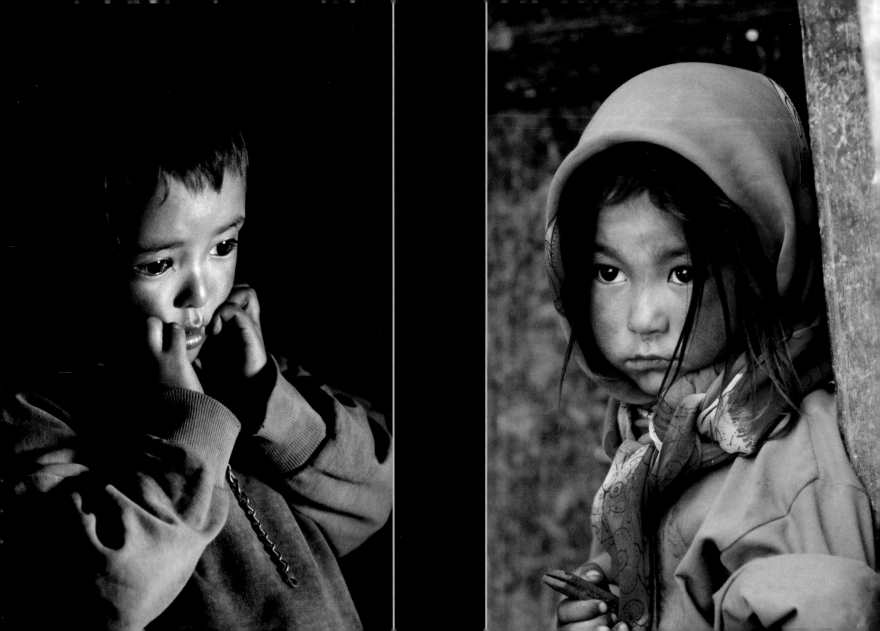

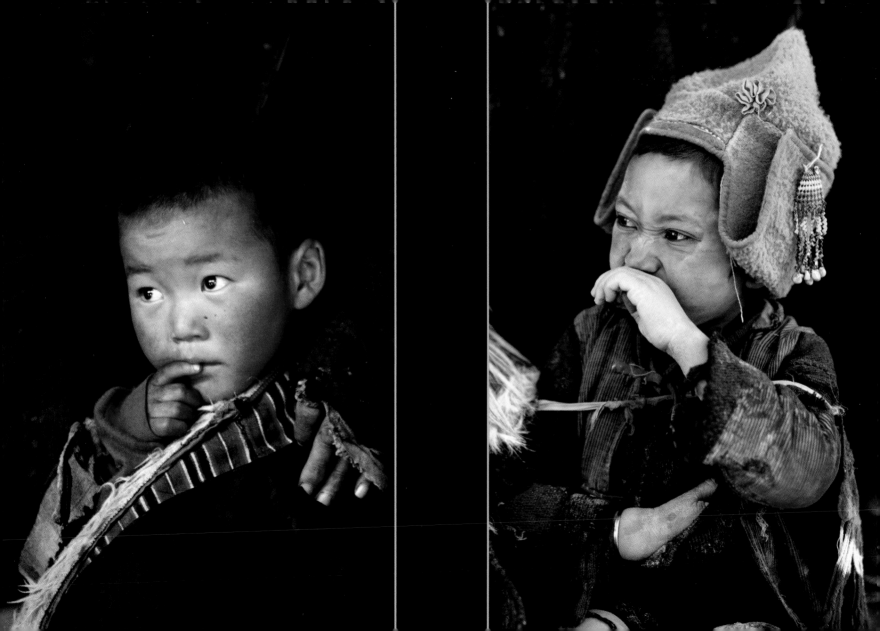

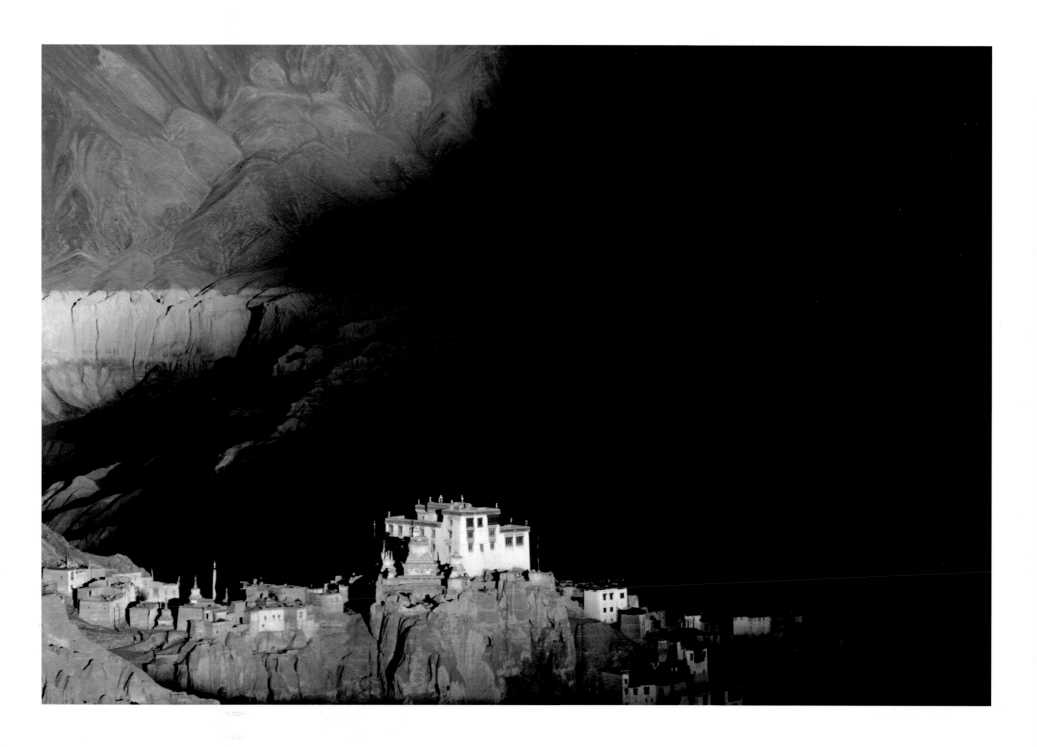

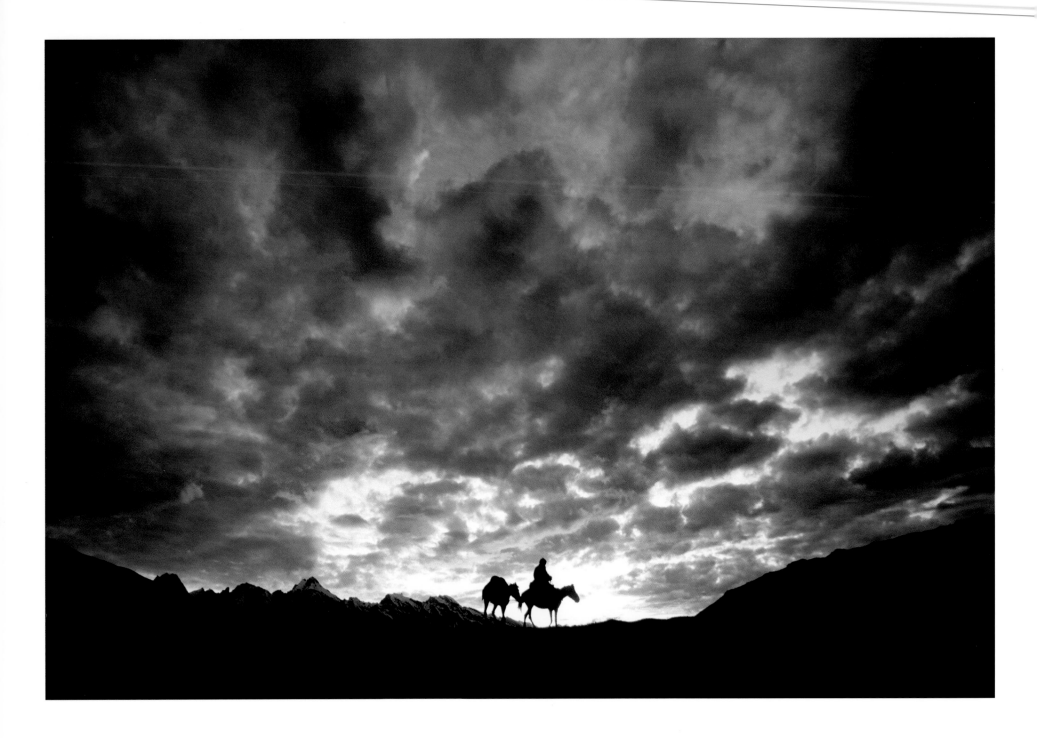

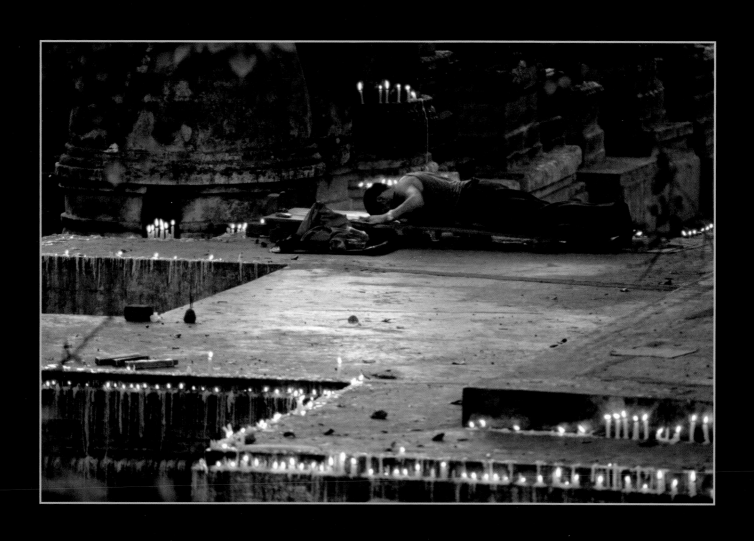

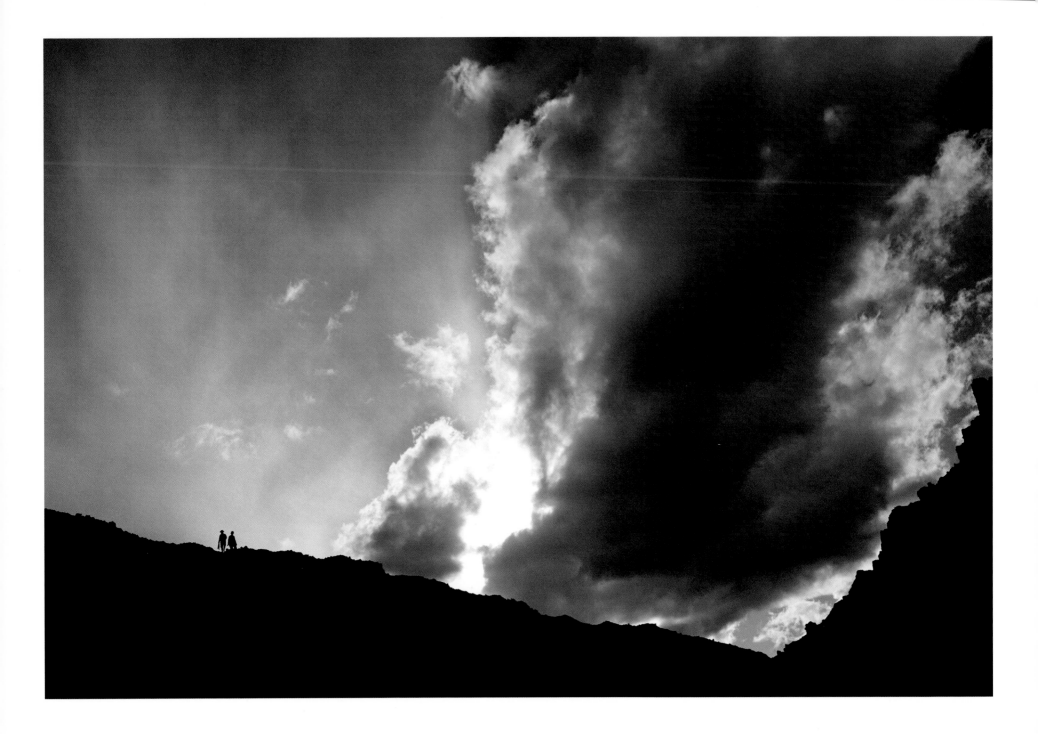

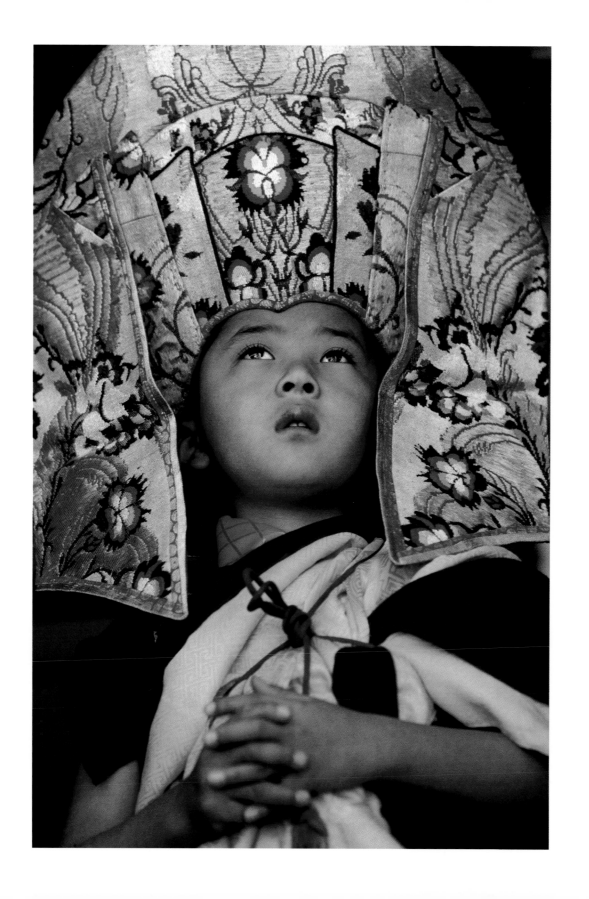

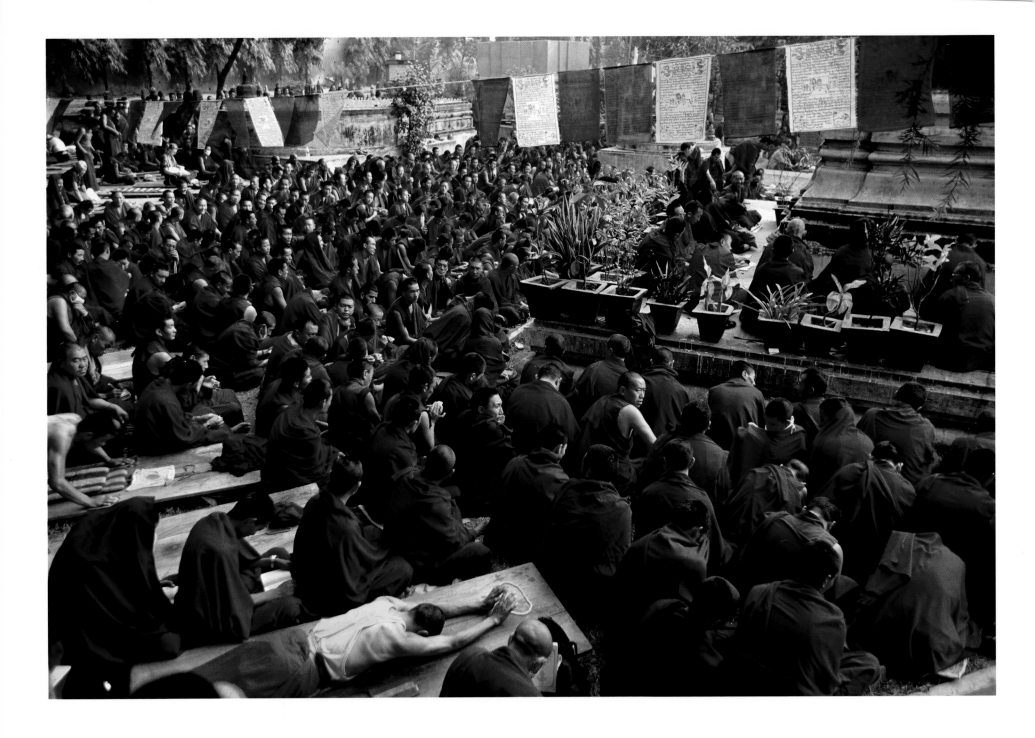

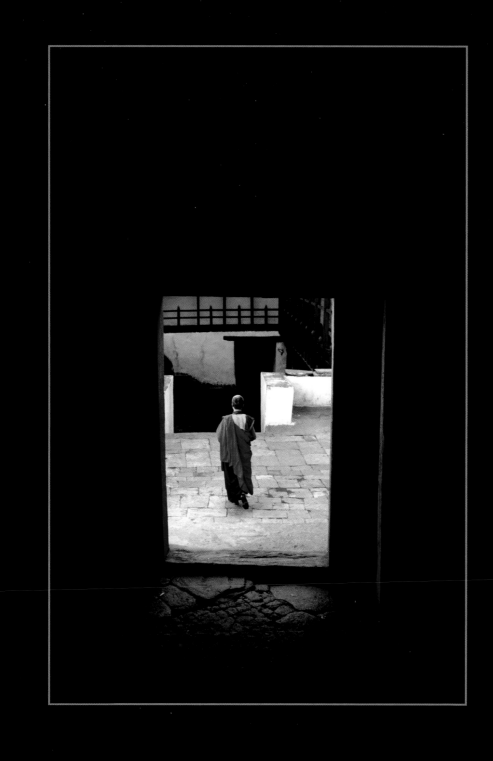

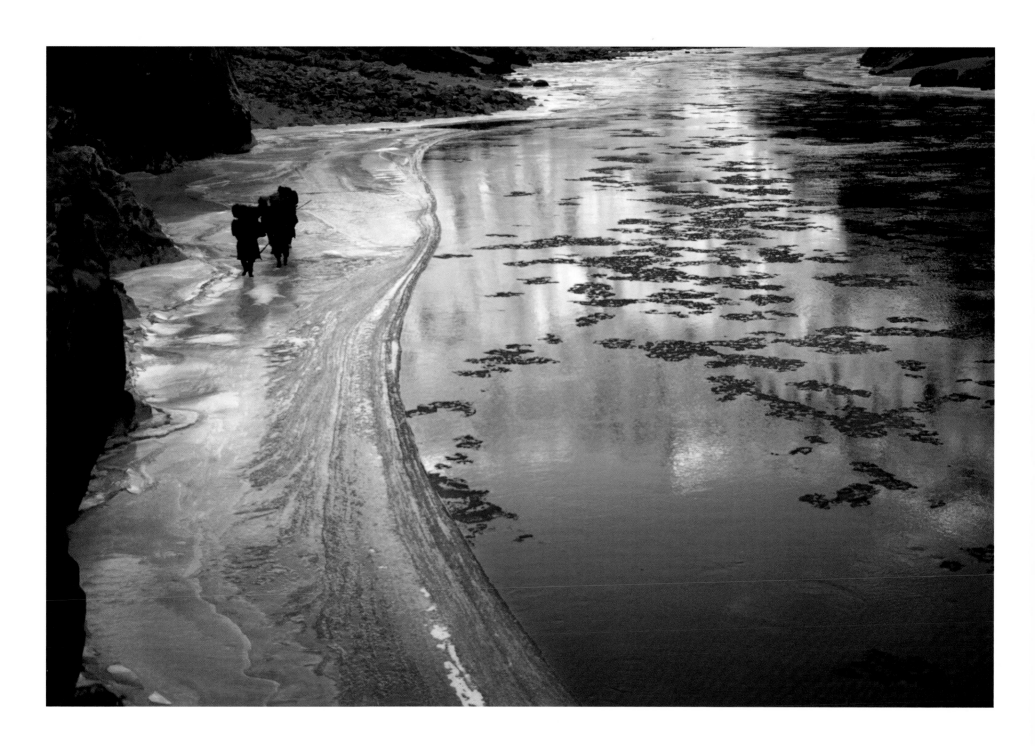

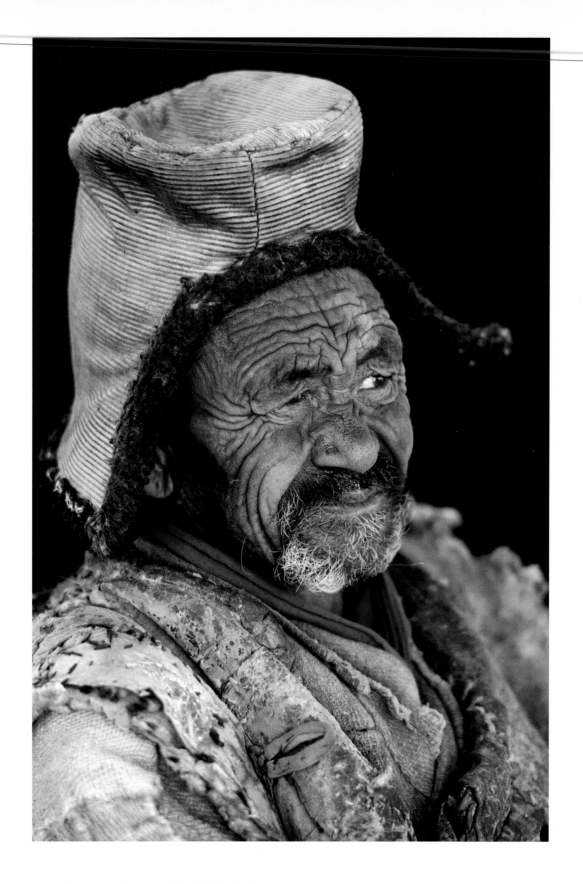

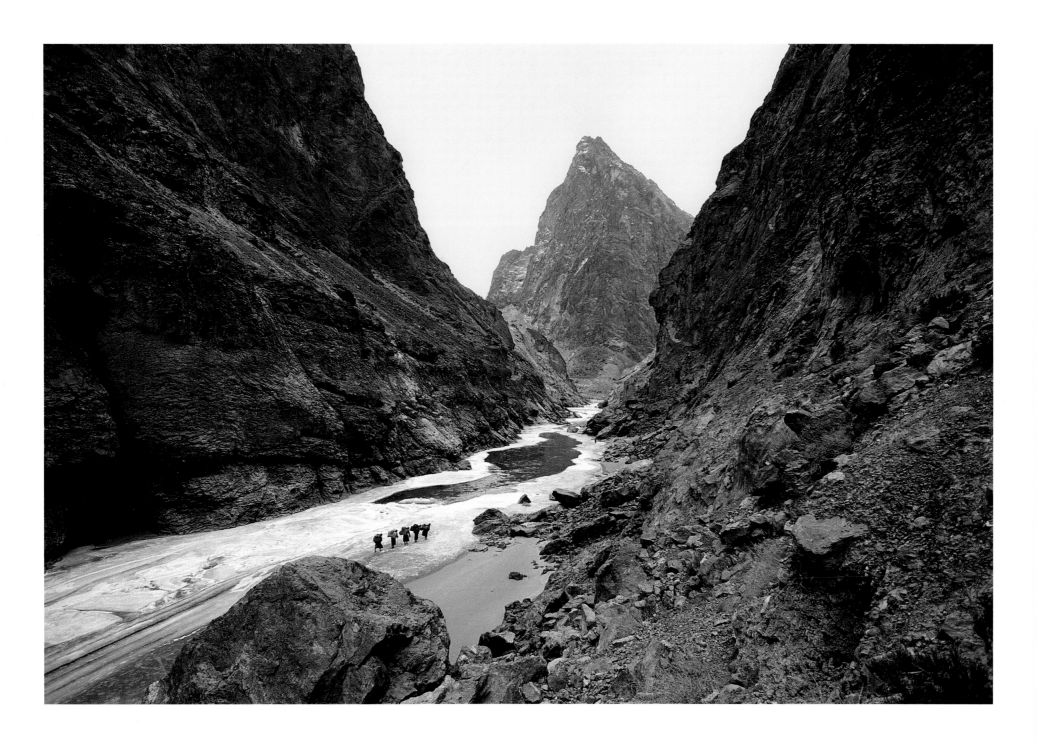

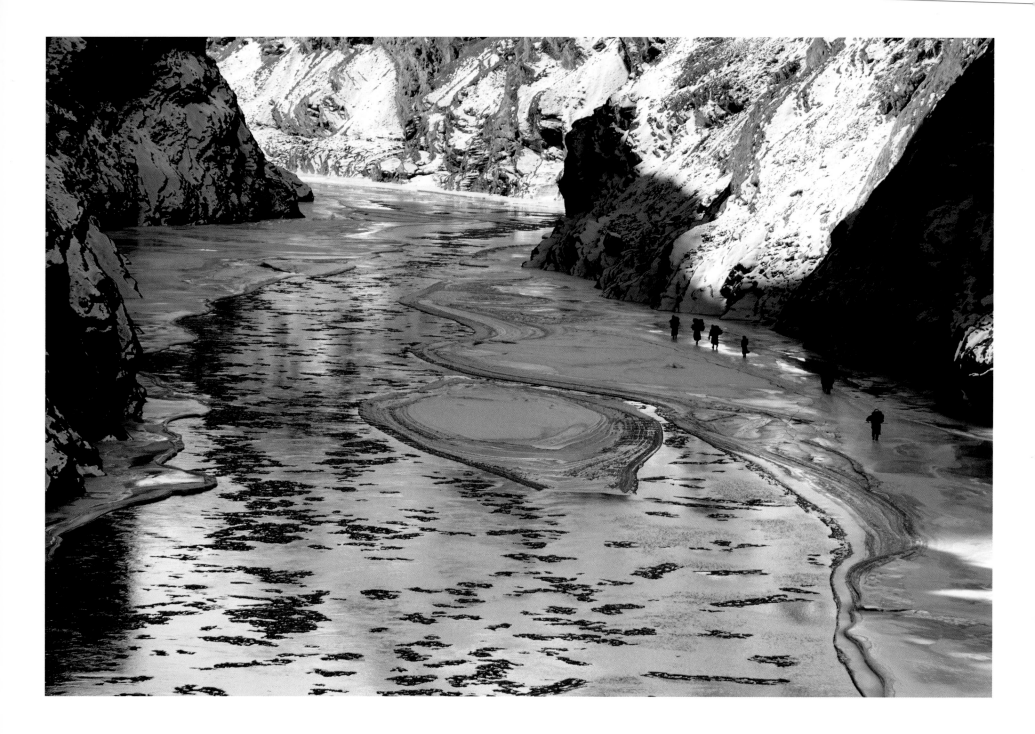

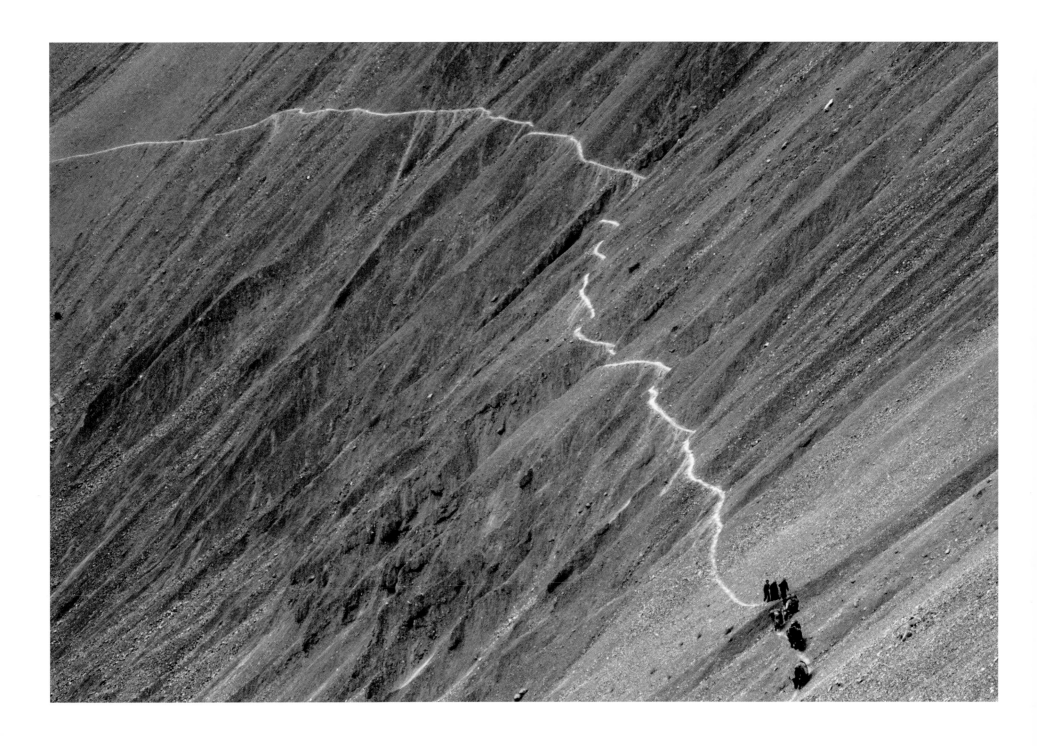

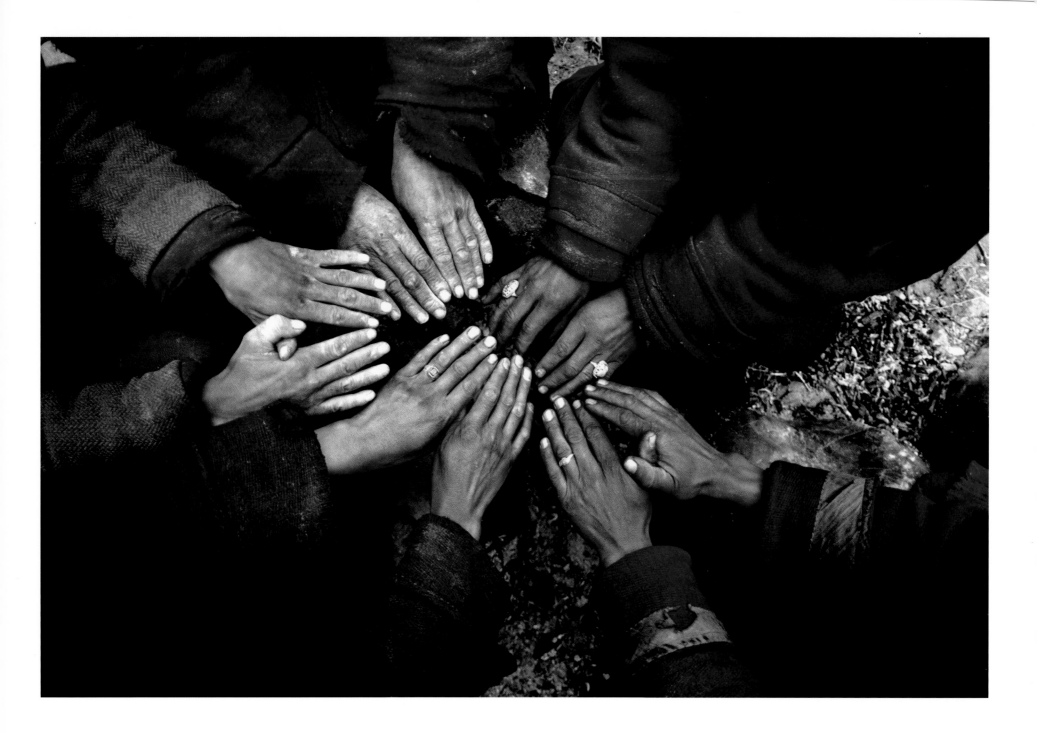

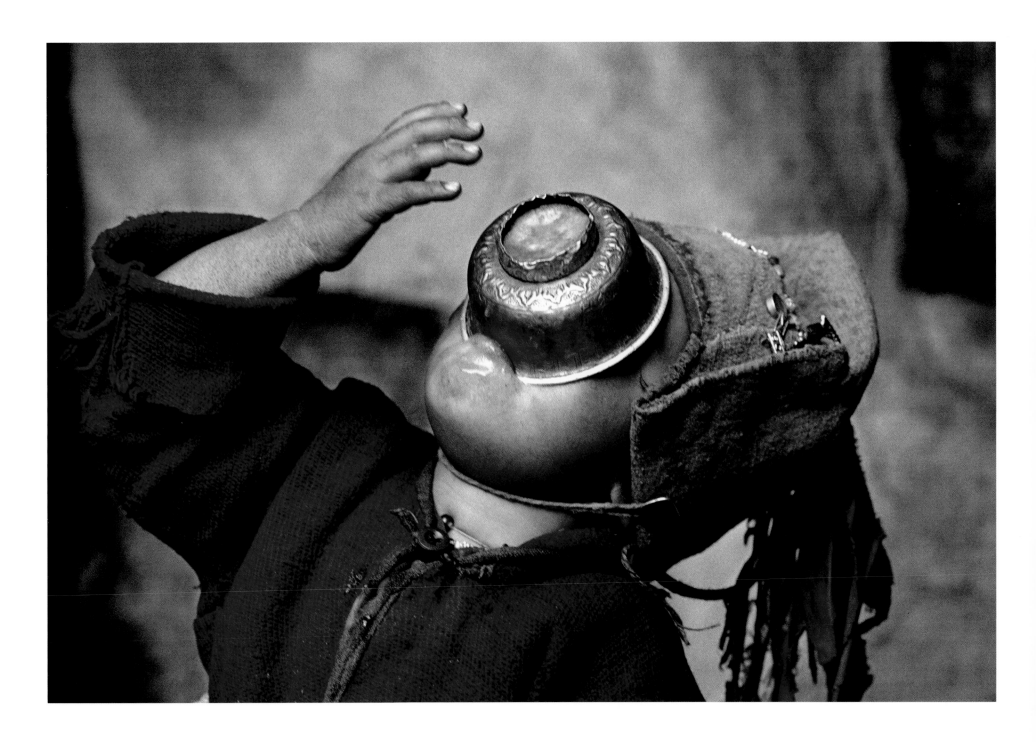

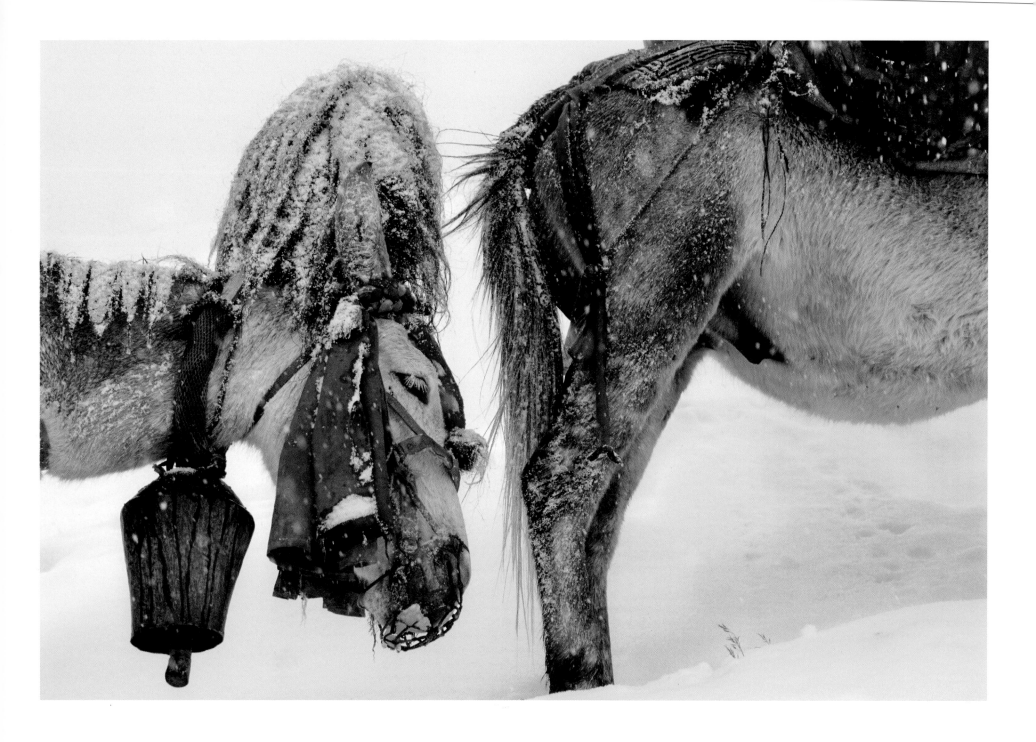

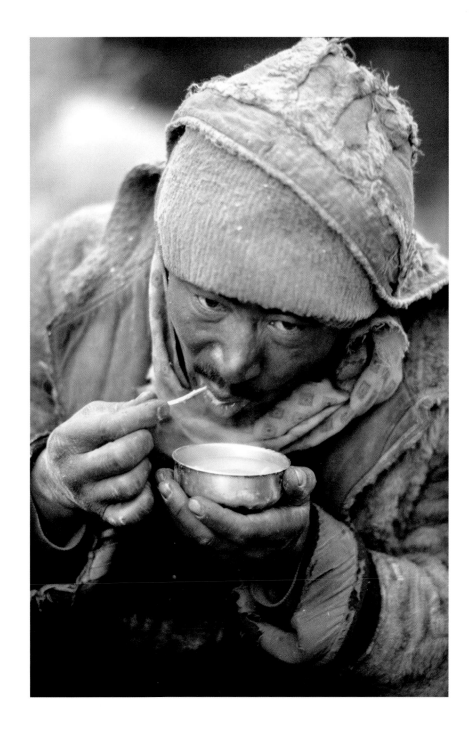

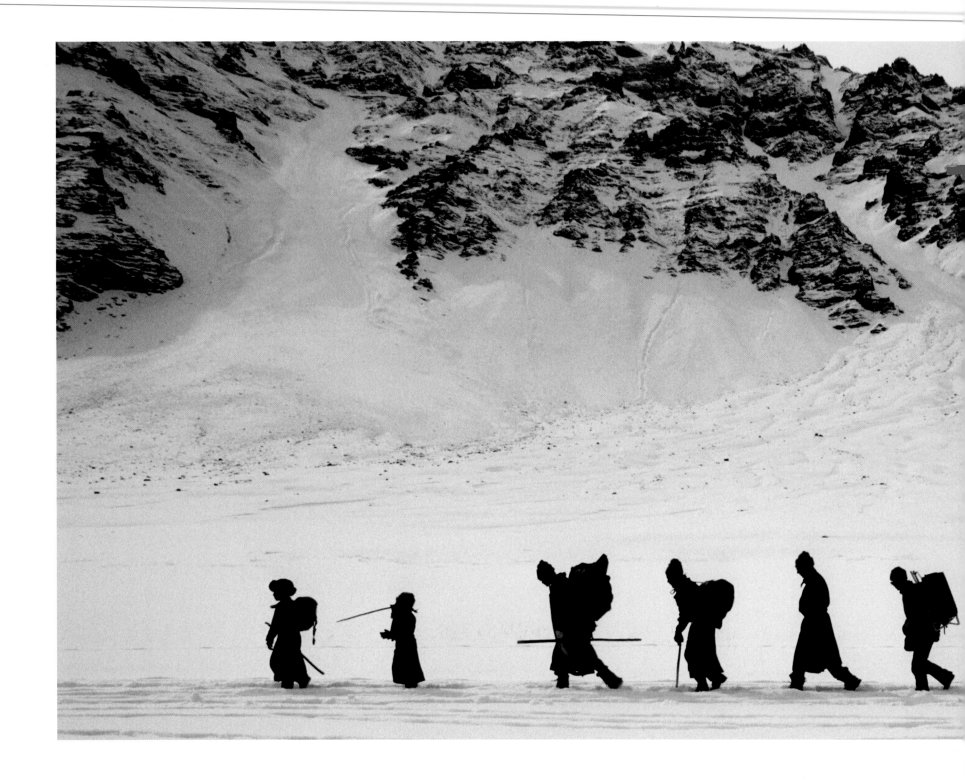

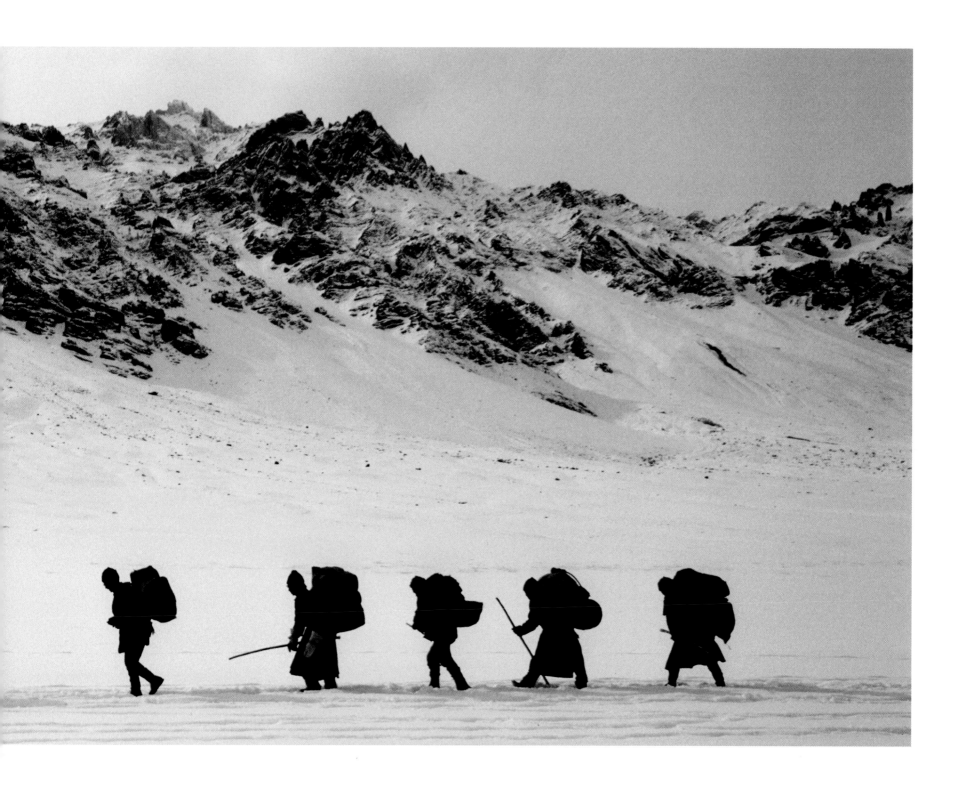

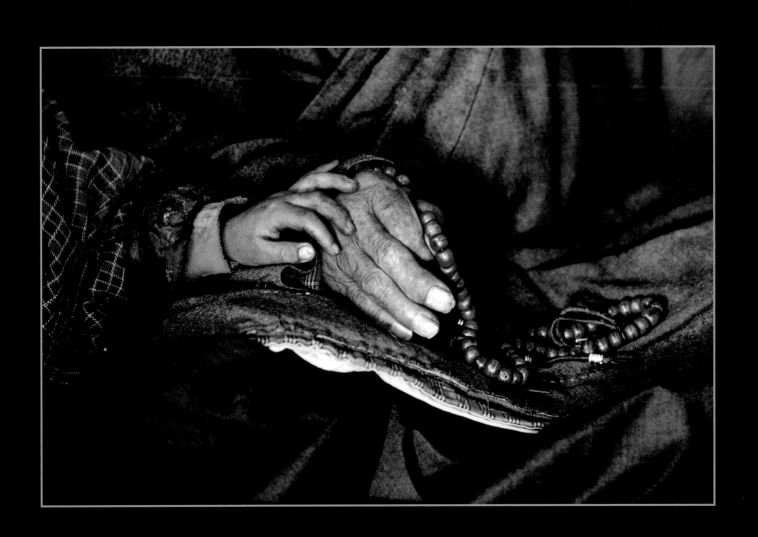

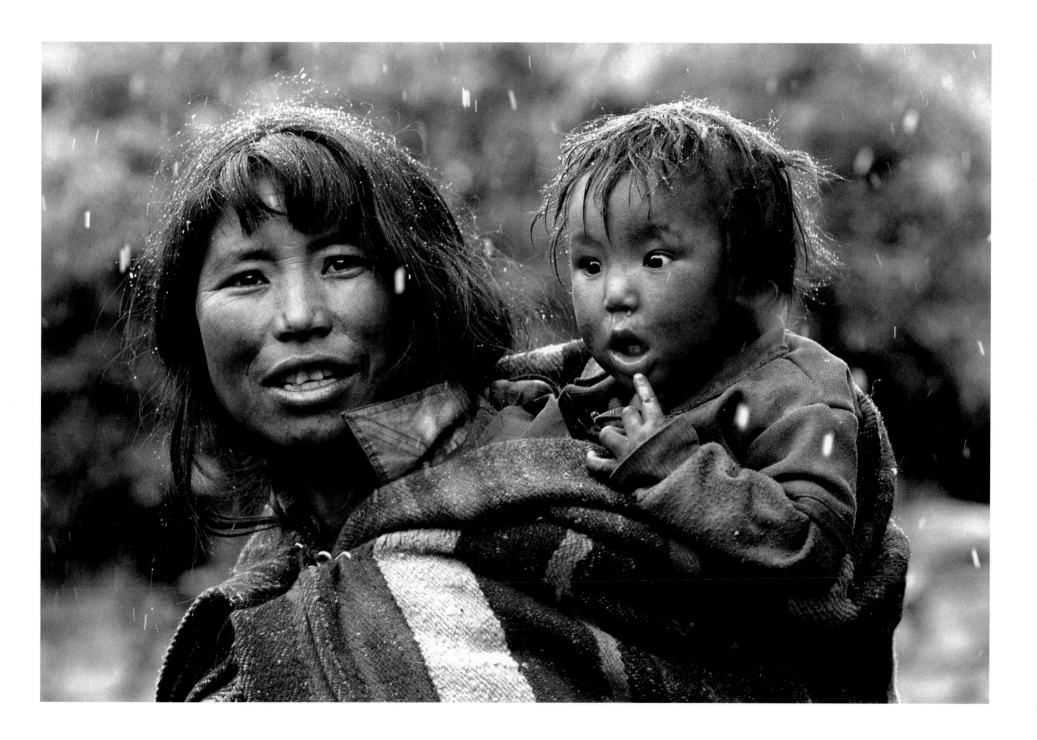

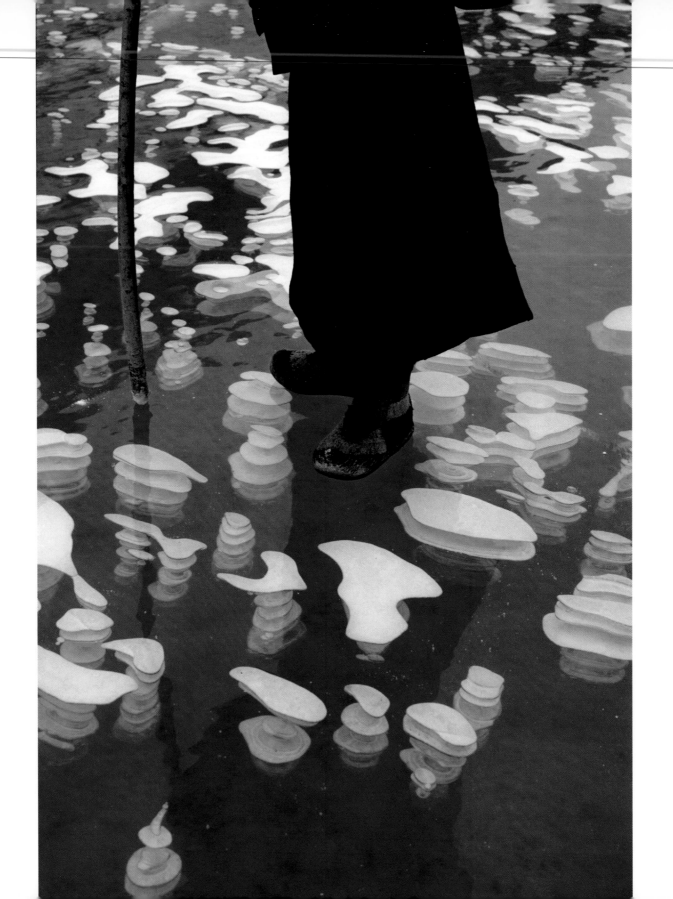

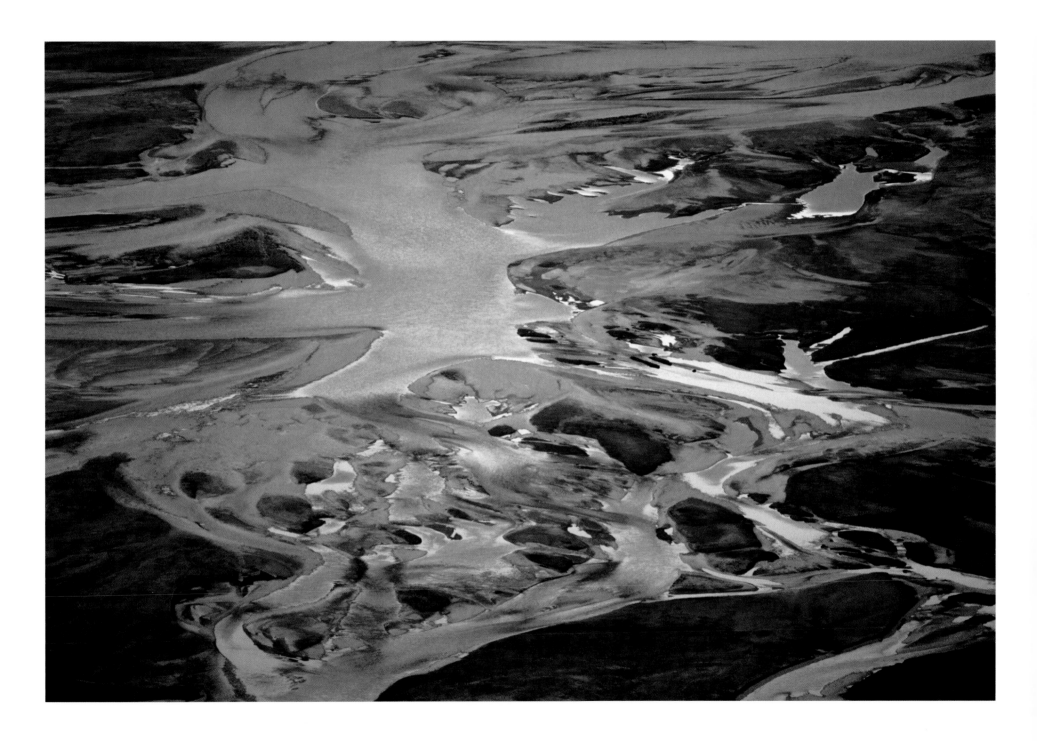

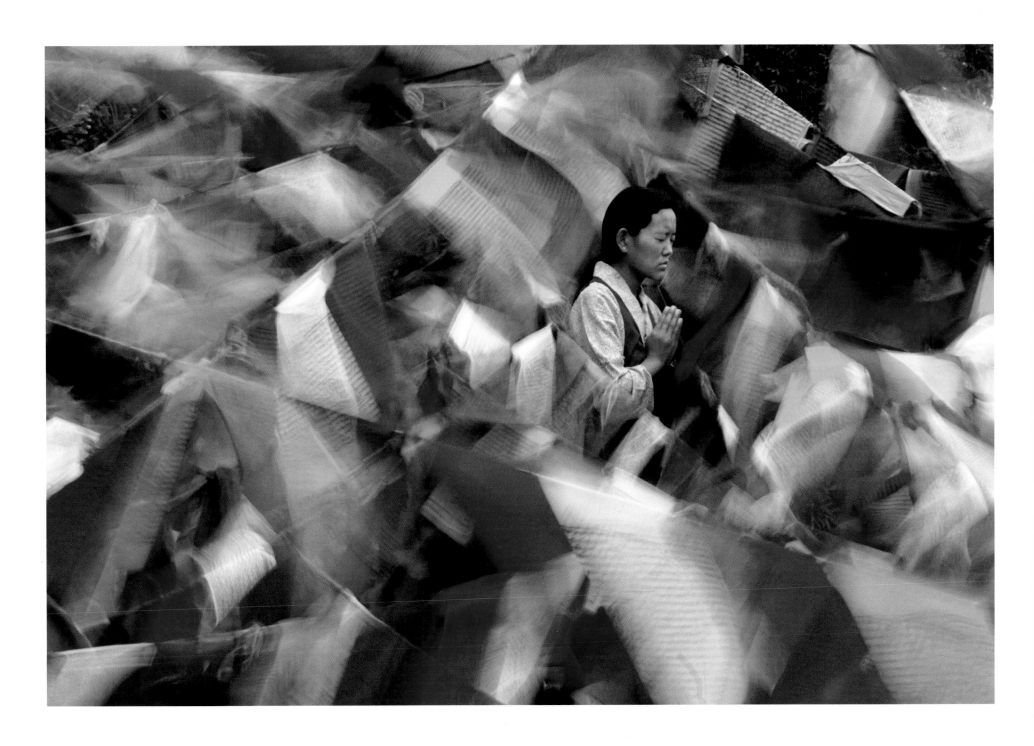

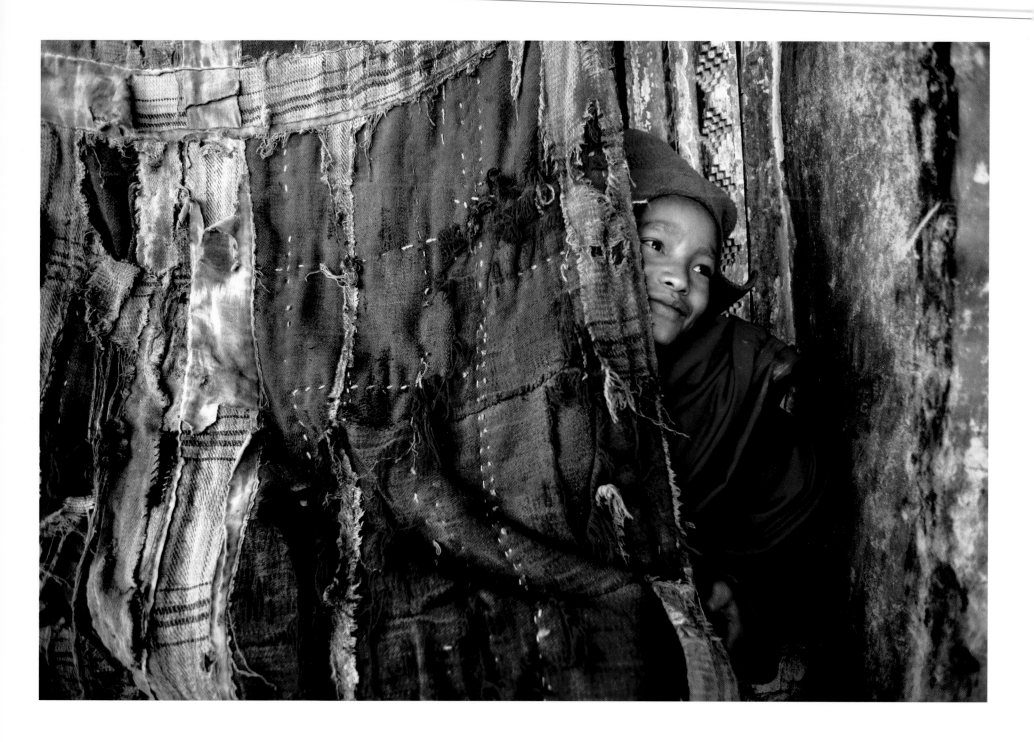

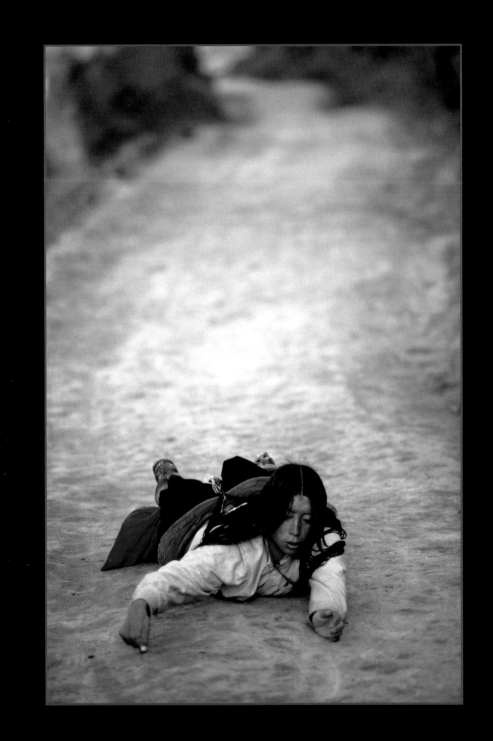

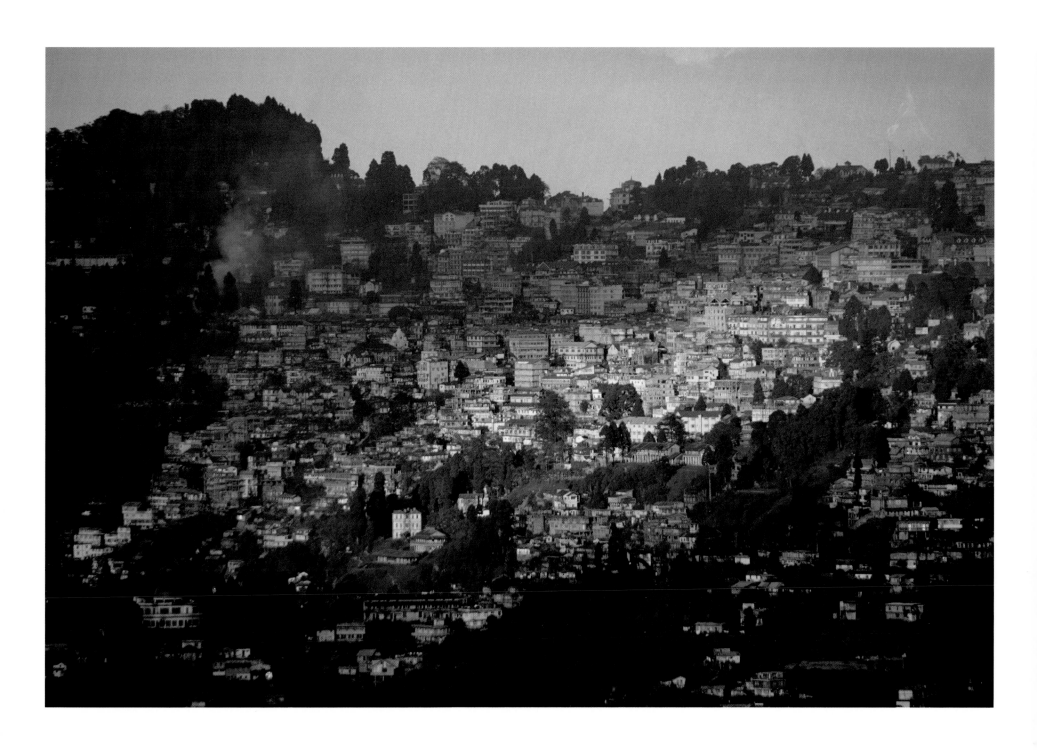

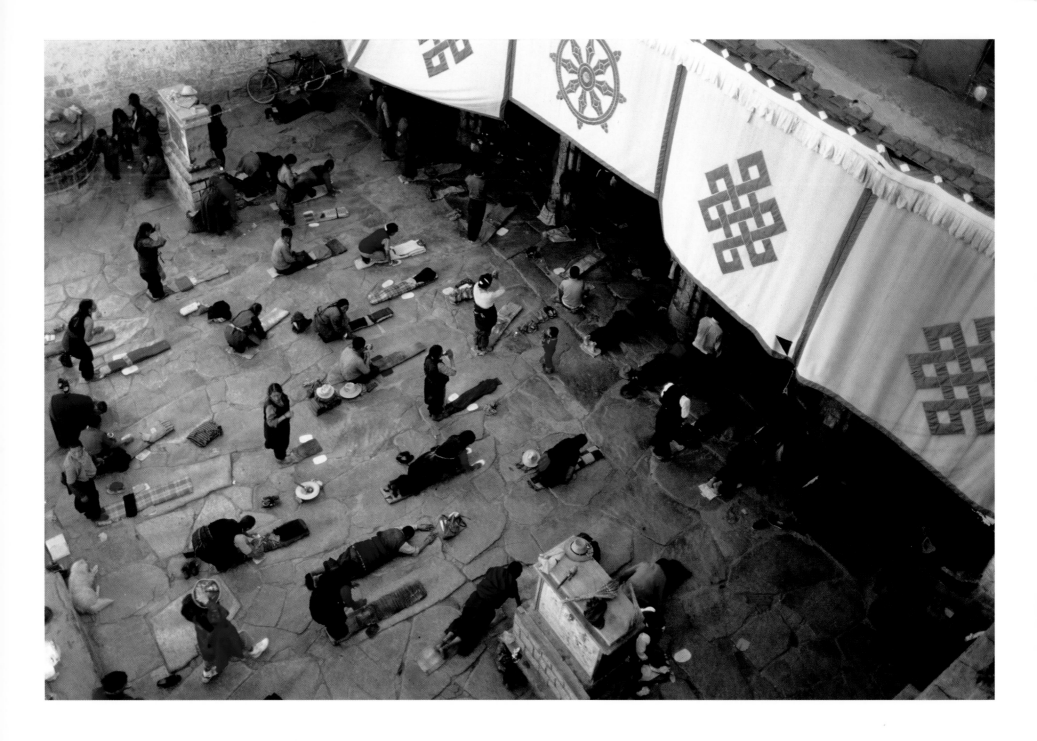

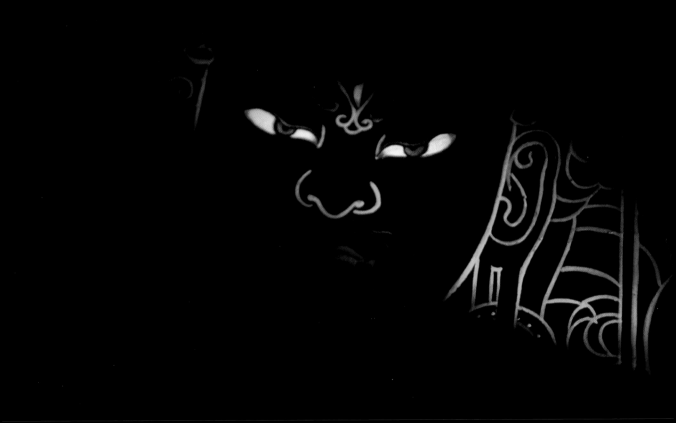

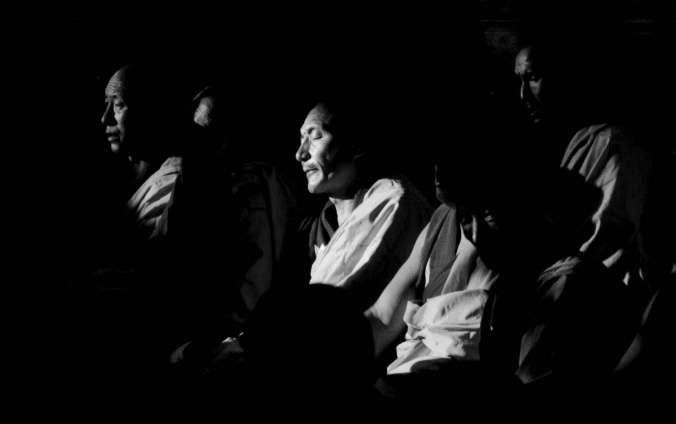

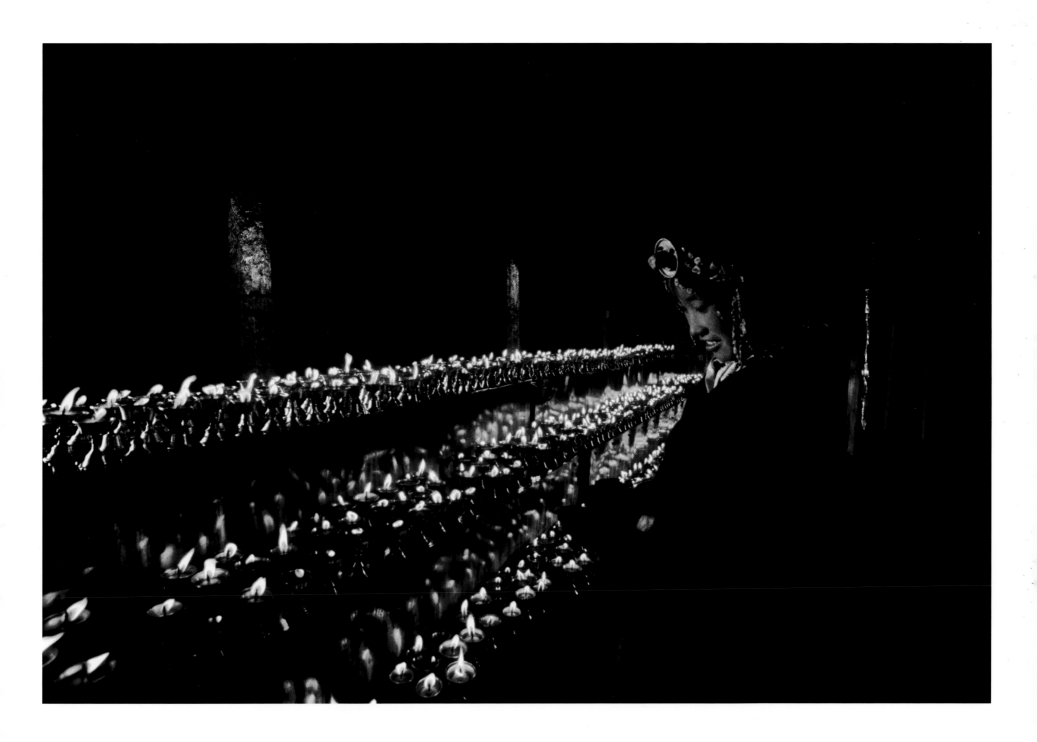

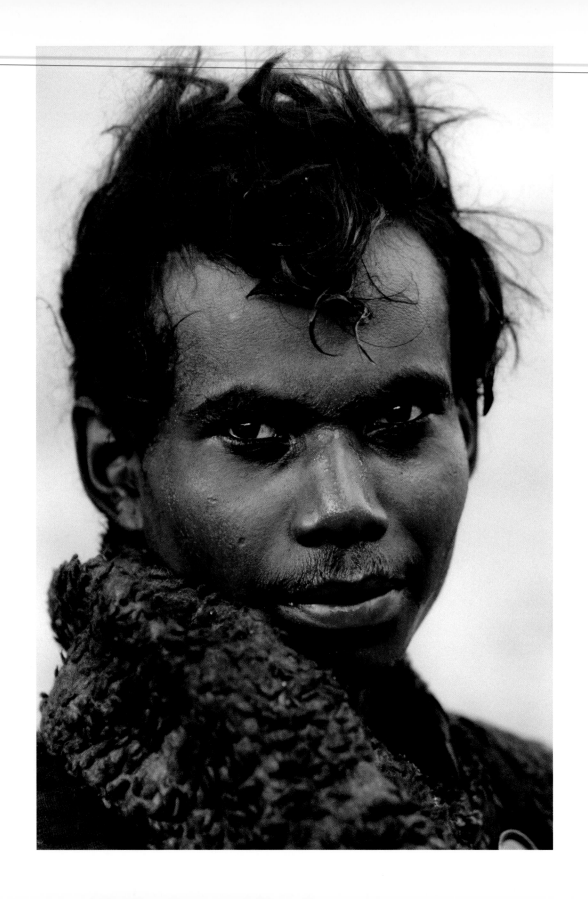

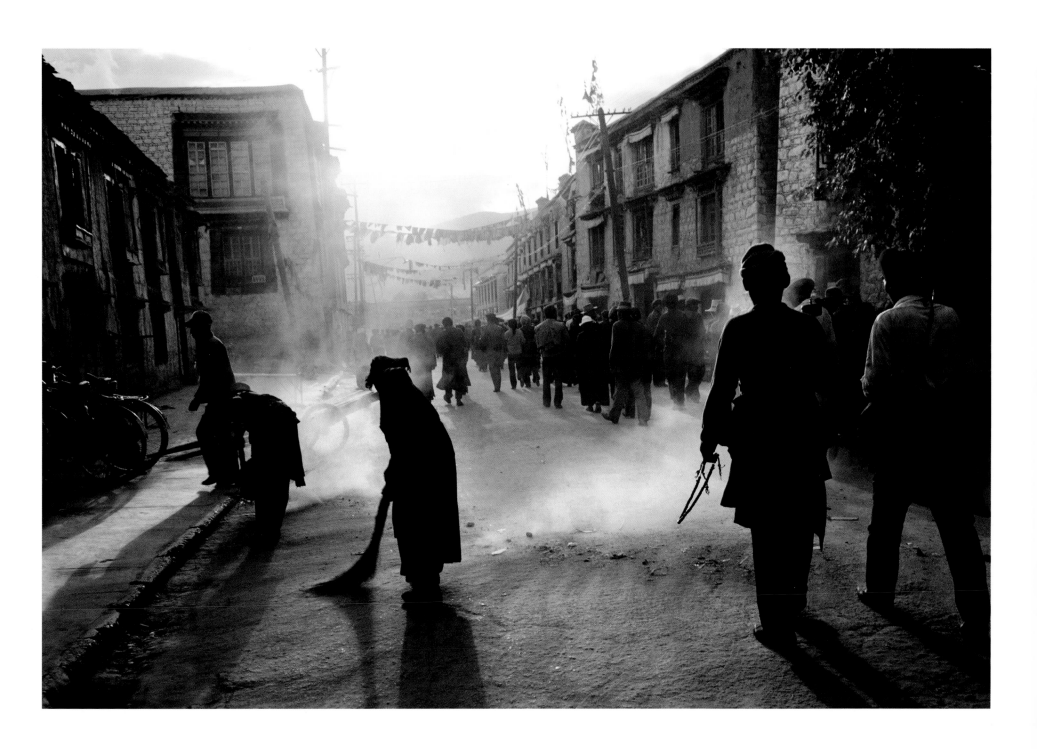

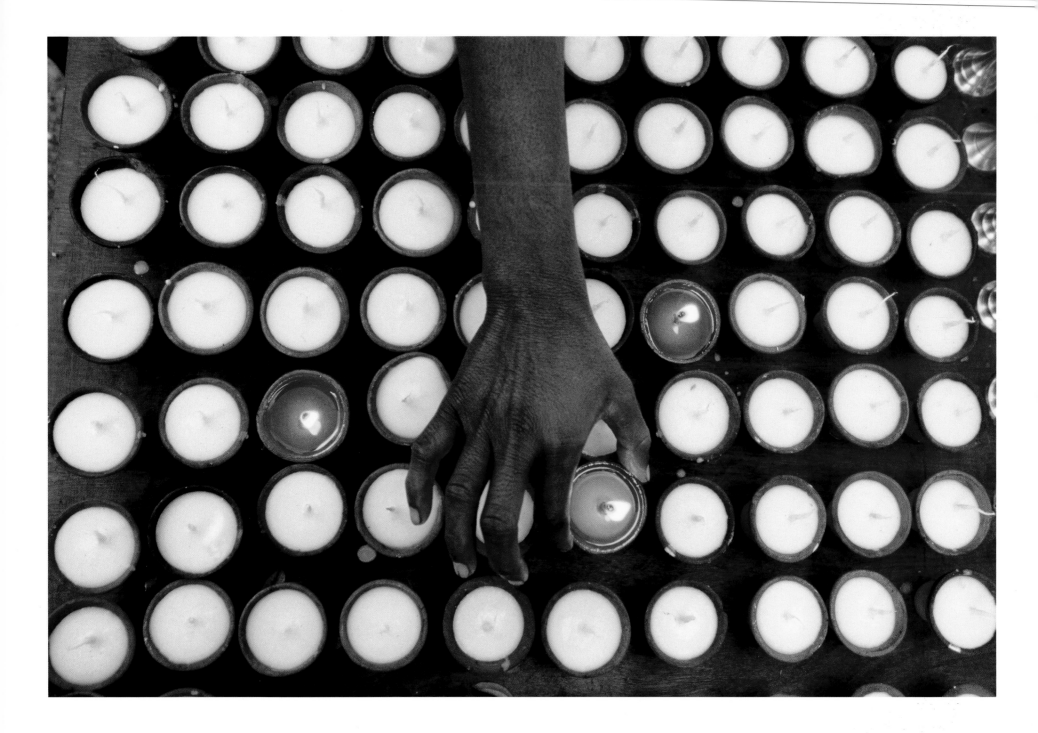

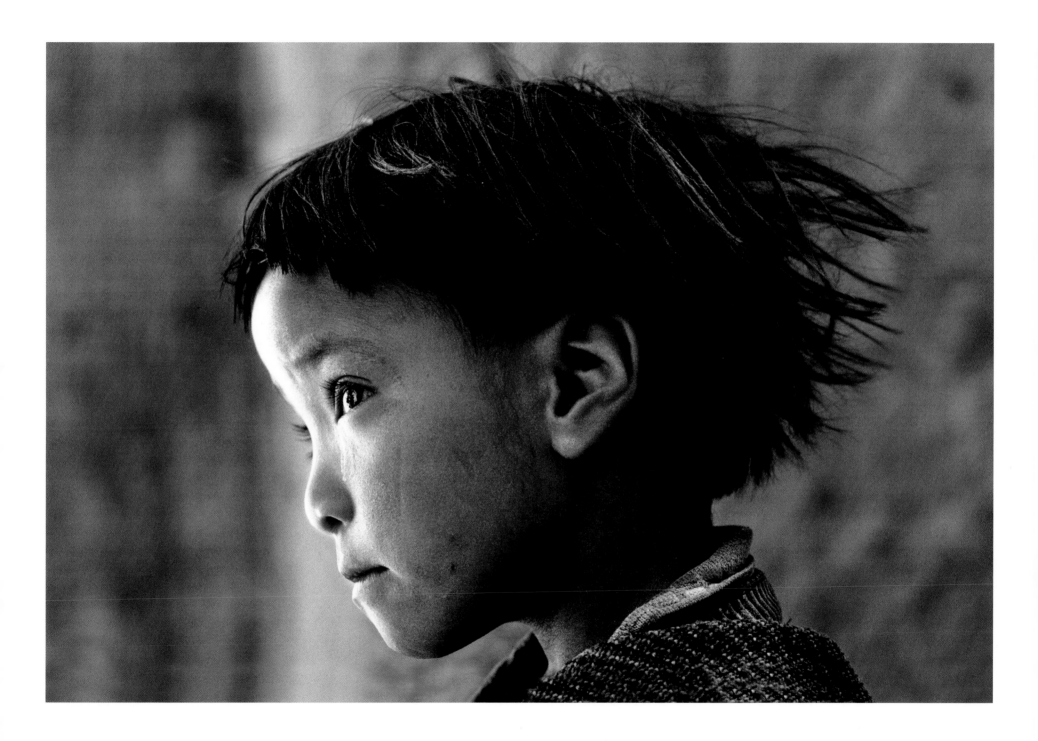

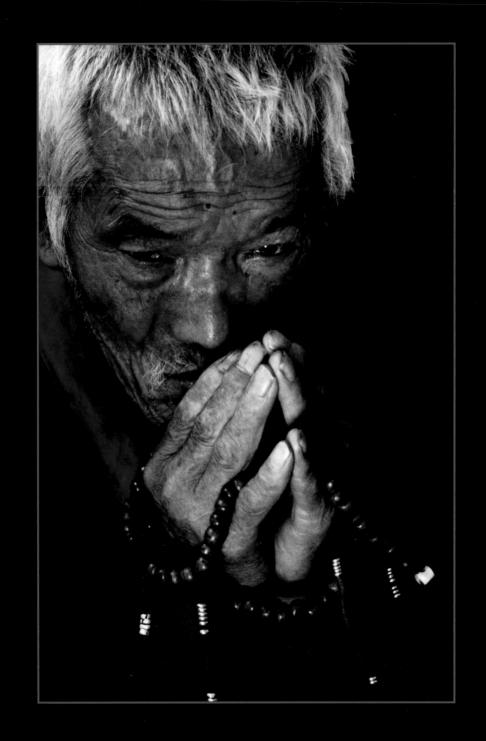

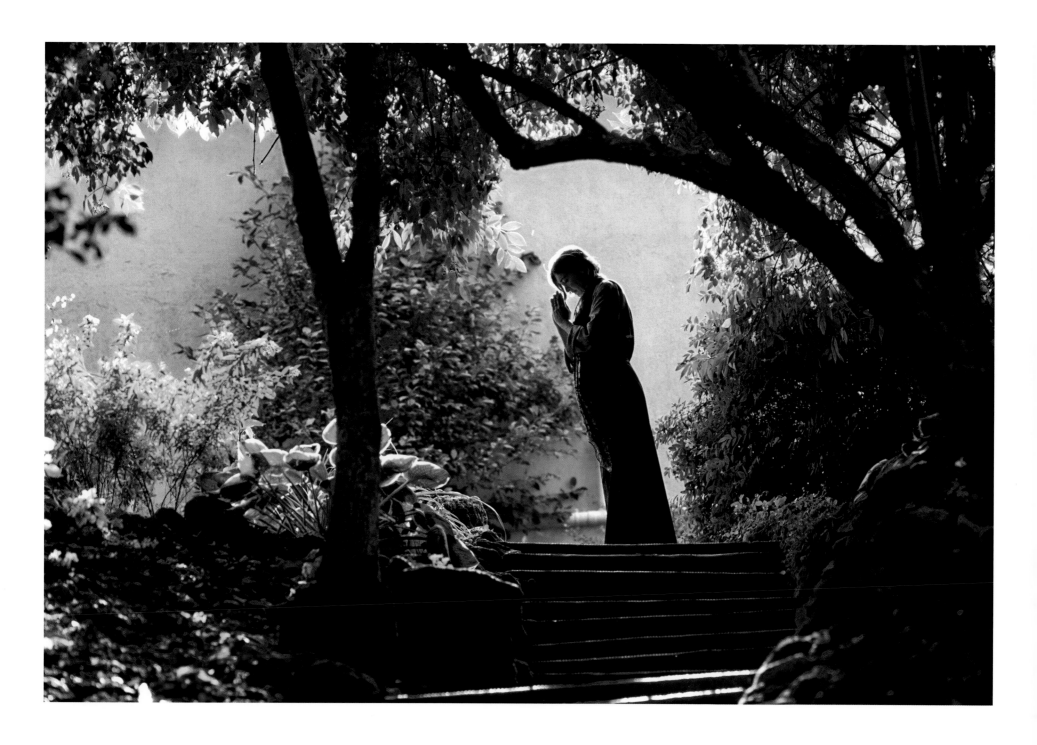

Captions

These photographs were taken between 1978 and 2002.
My equipment naturally changed over the years. Early on, I used
35mm Nikkormat and Olympus camera bodies, then Nikon, before
switching to medium format: Alpa 45 x 60, Hasselblad 45 x 60,
and recently Fuji 60 x 170. Throughout I used wide-aperture, fixed
focal-length lenses. I used only color slide film: chiefly Kodachrome
64 during the early years, and thereafter exclusively Fujichrome.
None of these photographs has been retouched.

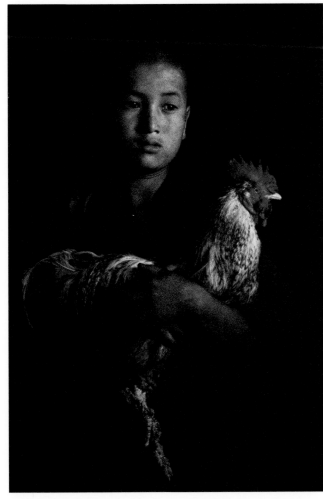

A young monk and the fetish cockerel of Tongsa Dzong, Bhutan. Posed portrait, taken with tripod and reflector. I chose a high-speed film for a more pictorial effect. 135mm (1993).

Page 17. This little girl on the Lhubu mountain pasture, near the monastery of Ganden in Tibet, is holding a woolen rope, plaited and decorated with a multicolored pompon, which she uses to drive her herd of goats. Posed portrait (taken with her permission), with tripod. 85mm (1994).

Page 18. The festival of Gustor at the monastery of Karcha, in Zanskar. At that time I did not know that two of the children in this crowd would become my own. Motup was three years old and Diskit, seen here on her grandmother's lap, one. 135mm (1980).

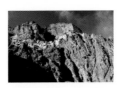

Page 19. The monastery of Phuktal, at an altitude of 13,000 feet (4,000 meters) in a remote valley in Zanskar. After a winter spent living with the monks by the Frozen River, I no longer wanted to leave this place to return to the West. 35mm (1980).

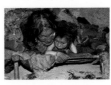

Page 20. Protected from the cold outside in the winter quarters of her mud house (–30°C), and covered by a yak skin, a great-grandmother tells her great-grandson a story. Candid shot, with flash. 35mm (winter 1981).

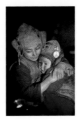

Page 21. Two young sisters hatching a plot in the winter quarters deep beneath their house in Zanskar. Candid shot, with flash. 35mm (winter 1981).

Page 22. A road builder boils tar by hand at a building site on a military road in Ladakh, at 15,000 feet (4,500 meters). Candid shot. 20mm (1987).

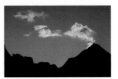

Page 23. At twilight, a cloud slips off the distant summit of Dhaulagiri, 26,000 feet (8,000 meters) in Nepal. 200mm (1978).

Pages 24–25. I undertook this photo reportage of the Dumka road builders to bear witness to the titanic work done by these men who go unrecognized. Once the roads are built, no one would suspect that these thousands of miles of Himalayan highway were built by hand, foot by foot, meter after meter. 135mm (1998).

Page 26. This precious image of Buddha, on the altar in a house in Zanskar, is wrapped in a katak, a white silk ceremonial scarf. Taken with tripod and reflector. 55mm (1988).

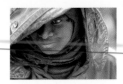

Page 27. A road builder from Bihar, after a grueling day spent repairing, with a shovel, the strategic road over the Taglang pass, at 18,400 feet (5,260 meters), in Ladakh. Candid shot. 85mm (1987).

Page 29. A ridge, gilded by the setting sun, and a small chorten at Shade, Zanskar. The Tibetan chorten is a building that symbolizes the spirit of the Buddha. It is a bridge that leads from the day-to-day world perceived by the senses to the realm of timeless knowledge. Inhabited by spiritual power, it radiates peace and happiness. 135mm (1996).

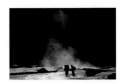

Page 30. On very cold mornings, when temperatures may fall to –40°C, mists form over the Frozen River. This photograph is underexposed, making the scene more dramatic—an effect I find pleasing. It was not deliberate, however: I was too cold to think, and the camera's automatic exposure system malfunctioned because it was frozen too! 135mm (1989).

Page 31. Stormy light over the village of Photoksar, Ladakh. 135mm (1987).

Page 32. At Tongsa Dzong, two mischievous young monks pose during a break from their duties. Taken with a tripod. 85mm (1993).

Page 33. When the ice gives way on the banks of the Frozen River, the traveler must look for a way through and climb the bare rock. 35mm (1989).

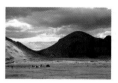

Page 34. Shepherd encampment on the outskirts of Tingri, Tibet. 85mm (1985).

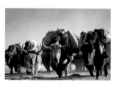

Page 35. A caravan of yaks and herders on summer migration to a new encampment, amid the vast valleys of Rupshu, in Ladakh. 180mm (1987).

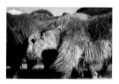

Page 36. Yaks are indispensable to the survival of the herders of Rupshu: they produce good-quality wool from which tents are woven, and the females provide milk, which is made into cheese. After their death, their skins become rugs, their horns are used to store spices, and their tails become fly whisks. Being Buddhists, the herders do not kill their animals, except very rarely when food is scarce. 180mm (1997).

Page 37. Meeting in the autumn wind, Tangbe, Mustang. 135mm (1996).

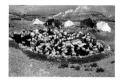

Page 38. Herders' summer encampment at Karnac, Rupshu. 85mm (1993).

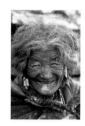

Page 39. Abile, a great-grandmother living on the high pastures of Tasaphuk, Rupshu. "To be happy, you must be beautiful in the hearts of others," she said. 135mm (1999).

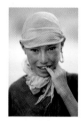

Page 40. Tsering Dolma, one of the first people I met in Zanskar. When I next saw her, twenty years later, she recalled our meeting. I was the first "golden-haired man" she had ever met. 135mm (1979).

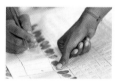

Page 41. Hiring of road builders in Bihar. The men sign with a thumbprint, a formality that fills them with pride. This secures them a livelihood, but working in clouds of tar smoke reduces their life expectancy by at least five years. 135mm (1998).

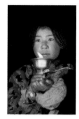

Page 43. In the Jokhang temple, Lhasa, my Sherpa assistant Ang Norbu, and I had just spent three timeless hours, visiting the dark shrines and paying our respects to each deity, with our hands pressed together. When we left the temple we came across this little girl and her father. She looked like a goddess to me. I was transfixed by her beauty and the intensity of her faith. I could not photograph her, for that would have meant placing myself between her and her deities. So I followed them from shrine to shrine. Only later, when they left the temple, did I approach them.

We went in front of the great gilded statue of Guru Rinpoche, the temple's founder, to take their photograph. There, we sought a quiet spot, apart from the pilgrims. Norbu and I explained to the little girl what we had found touching when we had seen her entering the temple, and we asked her to say a silent, very intense prayer for Guru Rinpoche and for her whole family. Accordingly, she calmly began to pray again, ignoring us. Looking at her through my viewfinder, I was overwhelmed. She was so profound.

This photograph, with its message of peace, became a symbol of hope for Tibetans, and it appeared on many posters calling for freedom for Tibet. It was prominently displayed alongside the Dalai Lama when he received a prize in the United States, and the image has been seen around the world. Taken with tripod and reflectors. 85mm (1994).

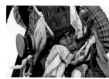

Page 44. The oracle of the herders of Tso Kar goes into a trance. At the start of the ceremony I thought he was a good actor. By the end, I found myself enveloped by an energy I had never before experienced. 85mm (1999).

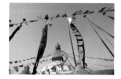

Page 45. The stupa of Bodhnath, around which Tibetans and Buddhists pray every morning. I used to visit this place in the Kathmandu valley to revitalize myself. 20mm (1996).

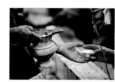

Page 46. Two fathers-in-law swap drinks of tchang (barley beer) at a wedding in Zanskar. Candid shot. 135mm (1980).

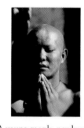

Page 47. A young monk, newly arrived in Lhasa after two years spent prostrating himself on dusty trails, prays fervently before the Jokhang temple. Candid shot taken with the subject's permission. 135mm (1986).

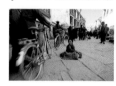

Page 48. This child, on a long pilgrimage lasting many months with his family, beg for money while reciting prayers in the streets of Barkhor, Lhasa. Candid shot. 35mm (1986).

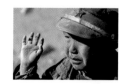

Page 49. This boy has been fighting in the dusty back streets in the village of Sakya, Tibet. Entitled "Tears on the Roof of the World," this image has been used to further the cause of the Tibetan people. Candid shot. 85mm (1987).

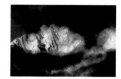

Page 50. The east face of Kangchenjunga, the world's third highest mountain at 28,162 feet (8,586 meters), taken as the monsoon swept over Sikkim. Taken with tripod. 180mm (1998).

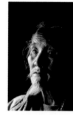

Page 51. A Ladakh villager poses in his isolated house on the edge of Pangong Lake. 85mm (1998).

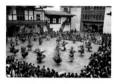

Page 53. The dance of the black hats (shanag) during the festival of Tshechu at Wangdiphodrang Dzong in Bhutan. 85mm (1992).

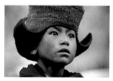

Page 54. I cannot remember what this young monk in Zanskar found so astonishing because I was too fascinated by him to pay attention to anything else. Candid shot. 85mm (1998).

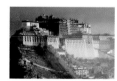

Page 55. The Potala Palace in Lhasa, residence of the Dalai Lamas, is Asia's biggest monument and one of the few that escaped the People's Liberation Army's destruction. 180mm (1994).

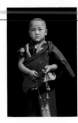

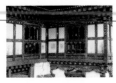

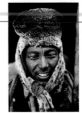

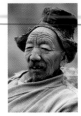

Page 56. This young Bhutanese monk at Bodh Gaya posed for me at the request of his uncle, who wanted him to be recognized as the reincarnation of a great master. Taken with tripod and reflector. 85mm (2002).

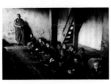

Page 57. Young Bhutanese monks eat their meals together at Tongsa Dzong, supervised by a master whose job it is to enforce discipline. Candid shot. 35mm (1993).

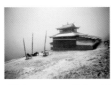

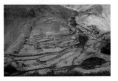

Page 62. Recreation time for young monks at the monastery school of Tongsa Dzong, Bhutan. 85mm (1993).

Page 63. Sparrows hunt for grain near the encampment of Tasaphuk, Rupshu, in winter. 180mm (1999).

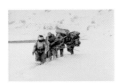

Page 65. The hardest day of my six journeys along the Frozen River. Snow had been falling for three days, softening the ice and keeping us from testing its solidity. Avalanches fell from the cliffs, and our only protection was our murmured prayers. We had been walking for more than fourteen hours to try to get away from the river and escape the trap of its gorge. That day, I took some ill-considered risks. Fueled by adrenalin, I sought refuge in my photographs; it was my way of getting through fear. 35mm (1989).

Page 68. A young Bhutanese monk learns meditation techniques in the monastery school of Tongsa Dzong. Taken with tripod and reflector. 85mm (1993).

Page 69. The monastery of Minyak lies at 12,595 feet (3,840 meters) in Kham, Tibet. Pilgrims have tethered their horses to the three masts that bear the prayer flags. Taken with tripod. 20mm (1995).

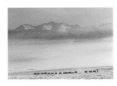

Page 70. A herdsman takes his yaks to pasture in the Tso Kar valley, Ladakh. 180mm (1999).

Page 73. After a night spent in caves by the banks of Zanskar's Frozen River, we came across a group of monks. The temperature was −37°C. They were going down to Ladakh to do some business on behalf of the monastery of Phuktal. I am astonished that the photograph is sharp, for I was almost literally petrified with cold. 85mm (1989).

Page 74. Phuntsok, a friend from Zanskar, photographed during our worst day on the Frozen River, after fourteen hours walking under the snow. The wind whipped our faces, we were soaked, we could find no wood for fuel—and night was falling. 85mm (1989).

Page 78. Looking older than his age on account of the dust, this man was rebuilding a stretch of the collapsed road leading to the monastery of Phuktal. Although his manner was jovial, he suddenly became serious when posing for the photograph. Did he, perhaps, catch sight of his reflection in the lens? 135mm (1980).

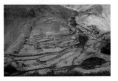

Page 79. The village of Shade, surrounded by its fields of barley, is one of the most remote in Zanskar. However, the villagers are lucky in having everything within easy reach: water, wood, good grazing, fertile fields, and beautiful women of a sunny disposition. 35mm (1984).

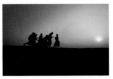

Page 59. A crowd in Bodh Gaya greets the Dalai Lama, who has come to inaugurate the peace of the heart. 85mm (1985).

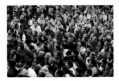

Page 60. Young monks relax after spending a day praying, sitting cross-legged, around the stupa of Bodh Gaya. 35mm (2002).

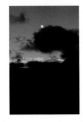

Page 61. The moon rises above the valley of Kali Gandaki, Mustang, on a September evening. The parched landscape, clear sky, and utter silence of the valleys combine to make moonrise in the Himalayas a magical time. 85mm (1996).

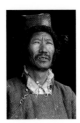

Page 66. Rupshu herdsman. Taken with tripod. 85mm (1999).

Page 67. Winter arrives in a valley in Bhutan. 35mm (1992).

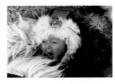

Page 71. A baby is warmly wrapped in a goatskin, which protects it from the −20°C cold, Rupshu. 35mm (1999).

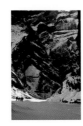

Page 72. The caravan, including my son Motup, climbs up toward Zanskar along the Frozen River. The porters, whose progress depended on the condition of the ice, could not take an alternative path along this ninety-mile (150-kilometer) journey. To take the photographs I wanted, I had to go on ahead and catch them as they passed. 135mm (1988).

Page 75. Rarely does rain drench the Barkhor in Lhasa. 35mm (1986).

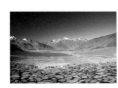

Page 77. The plain of Zanskar, at the foot of the Stonde monastery, 12,136 feet (3,700 meters) in autumn. 35mm (1984).

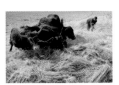

Page 80. Harvest time in the Mustang valley. 180mm (1996).

Page 81. When the animals root about for grain fallen from the harvested ears of corn, the peasants of Zanskar sing to encourage them. 135mm (1980).

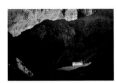

Page 82. I am fond of the devout, peaceful family that lives in this remote house at the entrance to the gorges that lead to the Phuktal monastery. I would always spend an evening with them before visiting the monastery, in order to experience the sweetness of a serene existence. 135mm (1987).

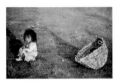

Page 83. In Zanskar, the children go to the fields when their parents cut the hay. It is there that they learn to live in peace and to listen to the silence, with which they are imbued for the rest of their lives. 135mm (1980).

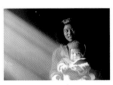

Page 84. The hamlet of Surle consists of four houses, 13,100 feet (4,000 meters) in the high valley of Zanskar. This young mother is proud of her first child, all of whose clothes she has spun and woven herself. 35mm (1980).

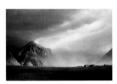

Page 85. In September, in the plain of Zanskar, thermal winds become violent. 35mm (1983).

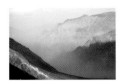

Page 86. The monastery of Karcha, Zanskar. Fifty monks live here. 135mm (1993).

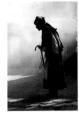

Page 87. A woman prays silently amid the incense smoke before the Jokhang temple in Lhasa. I chose a long lens for this shot because I did not want to intrude. 180mm (1987).

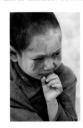

Page 88. Gusts of autumn wind sweep the plain, whipping up swirls of dust. This Zanskar child is playing outdoors; a quarrel has made her cry. 135mm (1980).

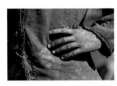

Page 89. After placing tar in an oil-fired brazier, a Bihari road builder waits for the fire to do its work. Candid shot. 135mm (1988).

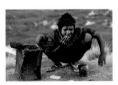

Page 90. A river running beside their makeshift camp allows the Dumka road builders to wash after their hard day's labor amid the tar smoke. 180mm (1998).

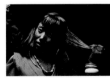

Page 91. Trapped by the snow in the village of Charkha, I shared its families' day-to-day life. I did not know whether I would be forced to remain there all winter. All of a sudden, it seemed to me that I was at the end of the earth. So I decided to take this unearthly photograph. Taken with tripod and reflector. 85mm (1996).

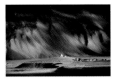

Page 93. The shrine and village of Pipiting, at 11,480 feet (3,500 meters) on the Zanskar plain. 180mm (1998).

Page 94. A remote valley of the Kham, Tibet. The father wanted me to photograph his son; the little boy, who had never seen a camera before, questioned his father about its use. Candid shot. 135mm (1994).

Page 95. The valleys of Ladakh are barely dusted with snow in winter because they are protected from the weather by the Himalayan range. 135mm (1994).

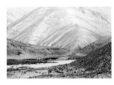

Page 96. A child wanders in his daydreams, in a remote house in the high Ladakh where I spent the night. Candid shot. 185mm, 6 x 6 (1998).

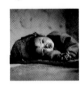

Page 97. Pema, our daughter, at the age of eight. Two years after adopting her, we returned to the Tibetan community that had entrusted her to us. Later, we set off on horseback for Zanskar, where I took this photograph. Taken with reflector. 180mm, 6 x 6 (1996).

Page 98. In an isolated village of the Barbung valley, Nepal, a little girl quenches her thirst in her kitchen of dark-colored wood. Taken with tripod and reflector. This is a reconstruction of an attractive scene I had witnessed a few hours earlier but had not wanted to interrupt. 85mm (1996).

Page 99. Four hundred thousand pilgrims from the Tibetan world have come to Bodh Gaya, India, the Buddhists' holy place, to hear the Dalai Lama's teachings and to pray with him. Candid shot. 135mm (1985).

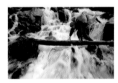

Page 100. Under a yak's-wool tent in winter, in the valley of Tso Kar, cut off by the snow. 35mm (1999).

Page 101. In a mud house in Zanskar, a child seeks comfort from her mother. 35mm (1998).

Page 103. An old nun lives in this little hermitage, at the entrance to Paro Taksang, Bhutan. Taken with tripod. 15mm (1993).

Page 104. Whenever we went over a pass, it was the occasion for joyous prayers—even if, as here in Bhutan, a chilling fog awaited us on the other side. 35mm (1992).

Page 105. The Ngile pass, 15,777 feet (4,810 meters) high, in Bhutan. Flags fly at the top of every pass. They bear prayers of compassion, which the wind carries down into the valleys to free people from ignorance and suffering. 85mm (1992).

Page 106. Amid the tar fumes, a Dumka road builder shows the strain of his work, the altitude, and lack of food. 135mm (1998).

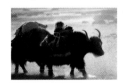

Page 107. Crossing a stream on the way to Kangchenjunga base camp, Sikkim. Taken while standing in the water. 20mm (1998).

Page 108. During transhumance, Rupshu herders' children travel on yaks, wedged among the luggage. Yaks are quick to panic, and they can easily put out a child's eye with a jab of their horns, so children are warned of this danger from a very early age. 180mm (1997).

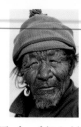

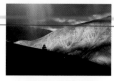

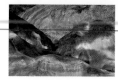

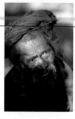

Page 109. The face of this Ladakh shepherd has been furrowed by his life of hard work under the sun, which is very strong at high altitude. 135mm (1993).

Page 116. Evening, before the storm, at the end of a silent day in the high valley of Zanskar. 135mm (1985).

Page 122. Monk in a village in the Barbung valley, Nepal. Candid shot. 85mm (1996).

Page 127. The magical light of autumn bathes the convent in the village of Zongla. 180mm (1998).

Page 133. An everyday scene: the goatherds of Rupshu drive their animals to graze above the encampment, as they do every morning. 135mm (1993).

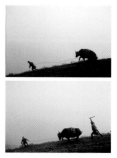

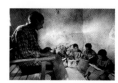

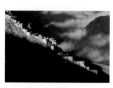

Pages 110–111. Taking yaks to the high pastures can be hard work for the Bhutanese peasants, who normally live at low altitude. Candid shot. 35mm (1992).

Page 117. Tsering, a teacher at the dilapidated state school in Zongla, has always charmed me with his devotion to teaching children the basics of modern science. Taken with tripod. 20mm (1998).

Page 123. Perched on the side of a mountain, the monastery of Karcha towers over the Zanskar plain at 11,800 feet (3,600 meters). It is a place I know well. One stormy evening, I went and stationed myself on a steep trail, hoping an atmosphere like this would materialize. I was lucky. 180mm (1996).

Page 128. Karma, young hero of a film shot in Rupshu. 85mm (1999).

Page 134. Every morning this old man sits in the same place, before the heavy gates of the fortified citadel of Lo Monthang. Taken with tripod and reflector. 135mm (1996).

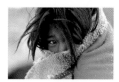

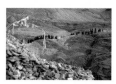

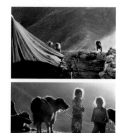

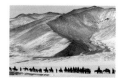

Page 112. This young Rupshu shepherd girl has covered her mouth to keep out the frozen air which, in winter, burns the airways. 85mm (1999).

Page 118. After a religious ceremony at the monastery, the villagers of Lamayuru go to pay their respects to the village altar. 50mm (1978).

Page 129. Shepherds from Tso Kar, Ladakh, en route to a new encampment that is better for their flocks in winter. 180mm (1999).

Page 135. When they are on transhumance, the herders of Rupshu leave in the quiet of the night in order to reach a new pasture before midday. When the sun rises, they are exhilarated, and they sing as they follow their animals. 180mm (1997).

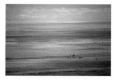

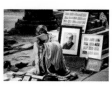

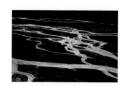

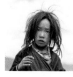

Page 113. The lake of Kokonor in northern Tibet, one of the largest in Asia. 135mm (1986).

Page 119. At the foot of the hill of Swayambunath, Nepal, a monk displays images of spiritual masters, including the Dalai Lama. 50mm (1980).

Pages 124–125. Sunset on the remote mountain pastures of Lhubu, in occupied Tibet. I played with two young shepherds close to their family tent. Taken with tripod. 135mm (1994).

Page 131. Meanders in the Kali Gandaki River, Mustang. 135mm (1996).

Page 136. The young child of a Rupshu herder. Candid shot. 180mm, 6 x 6 (1996).

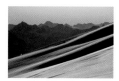

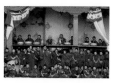

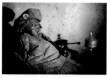

Page 115. Twilight on the slopes of Kangla Gachu 19,680 feet (6,000 meters) high, Bhutan. There are countless unconquered summits; in many cases climbing them is forbidden, for villagers believe their local deity lives on them. 135mm (1992).

Pages 120–121. During the festival of Tshechu at the Gangten monastery, Bhutan, monks laugh at the antics of a young associate whose job it is to amuse the crowd with jokes while keeping them away from the courtyard, where some monks are dancing. 85mm (1992).

Page 126. This old monk, from the Phuktal monastery, has returned to his family to pray with them and die in peace. His happy anticipation made me understand that death is not to be feared. Taken with bounced flash. 35mm (1989).

Page 132. The first snowflakes of autumn fall on a shrine in an unfrequented valley that links the Barbung valley in Nepal with the village of Charkha. 85mm (1996).

Page 137. Too much snow fell this winter, with disastrous effects on the Rupshu herders: all their animals died of exhaustion, hunger, and cold. Each morning, even the birds would follow the men who led their animals from the camp in the hope of finding a few tufts of thin grass to nibble. 35mm (1999).

Page 138. Some of the poorer Rupshu shepherds live under parachutes, formerly belonging to the Indian army, converted into tents. In winter, the temperature inside falls to −20°C. 35mm (1999).

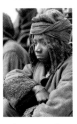

Page 139. It took me several months to recover from making this photo reportage on the Dumka road builders who build Himalayan roads by hand. Like them, I could no longer smile. 135mm (1998).

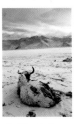

Page 140. At the Tasaphuk encampment, the herders of Rupshu in Ladakh suffered their worst winter. Snow blanketed the entire valley and their animals, unable to graze, became weak and died of hunger and cold. The conditions under which the nomadic shepherds of the high plateaus survive are the most extreme faced by any Himalayan people. 35mm (1999).

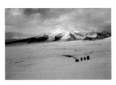

Page 141. Karma and Tarchen, his father, reach the encampment of Tasaphuk, at Tso Kar. 35mm (1999).

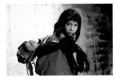

Page 143. A little Zanskar girl poses with her sleeping younger brother, whom she is looking after while their parents work in the fields. Amulets attached to babies' bonnets protect them from illnesses and harmful spirits. Taken with tripod. 85mm (1998).

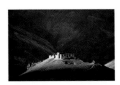

Page 144. I am fond of the monastery of Rangdum, which lies at 13,100 feet (4,000 meters) in Ladakh. It is like a solitary lighthouse in the middle of a desert plain swept by the wind from three valleys. I am most attached to it because it was my first sight of the unearthly, on my first journey to Zanskar. To convey this isolation, I underexposed this shot so as to intensify the already deep shadows of autumn. 180mm (1984).

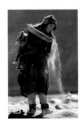

Page 145. One of my first images of Zanskar, taken during the autumn harvest. I was astonished at what I saw. 135mm (1979).

Pages 146–147. This temporary bridge made of ropes and branches at 13,100 feet (4,000 meters), leads to the monastery of Phuktal, one of the jewels of the Himalayas. One autumn day, descending from the monastery, I caught a glimpse of the bridge lit by the sun's last rays. By the time I had gotten my camera out, the sunlight had gone. I returned the following year, in summer, but the sun was at a different angle and it was impossible to photograph the same scene. So I returned the next year, in autumn, but the weather was overcast. Only the following year was I finally able to shoot the picture. My reward was that when I did, a monk was crossing the bridge. 85mm (1986).

Page 148. For Buddhists, the lotus that blooms in the open air—seen here taking root in the basin of Bodh Gaya—symbolizes the opening up of the spirit. Taken with tripod. 300mm (2000).

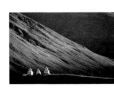

Page 149. Our yak train crosses the brightly colored pastures of Bhutan in autumn. 85mm (1992).

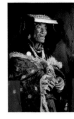

Page 150. This woman lives in a poor village in Barbung, at the foot of the Dhaulagiri massif; her riches lie in the tradition of which she is part. Candid shot. 135mm (1996).

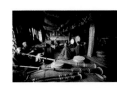

Page 151. Wearing her festive headdress, this young Dard girl is absorbed by the actors in an impromptu theater set up on the village square. Candid shot. 135mm (1996).

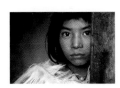

Page 153. The Karas trail is a magical journey under the stars; in spring, it is possible to walk on the frozen snow by night. At sunrise, our caravan crossed the Pensi Pass, 14,400 feet (4,400 meters). I was assailed by a growing wave of nostalgia. I was leaving Zanskar after eight months of winter, and I felt no joy whatsoever at returning to the modern world. 35mm (1989).

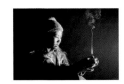

Page 154. One winter evening, in the house of a Zanskar family, I witnessed this furtive scene, which was impossible to photograph without ruining its atmosphere. The next day I quietly asked Chönzon to adopt the pose I had found so appealing. Luck very often plays a part in photography. I hadn't asked for the wreath of smoke! Taken with bounced flash. 35mm (1989).

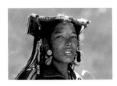

Page 155. The last rays of the autumn sun in the high valley of Zanskar. 135mm (1988).

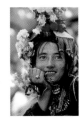

Page 156. A Rupshu shepherdess in ceremonial dress at a religious festival in the monastery of Korzok. Candid shot. 85mm (1996).

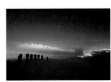

Page 157. Prayers in a shrine of the Gangten monastery, Bhutan, during a religious festival. Taken with tripod. 20mm (1992).

Page 158. From my first stay in Zanskar, I became very fond of Raften's family, who lived in Zongla. Photographing them was always a delight. As the years went by, the children enjoyed posing, like models. Each year I brought them the photographs, and their shrine is decorated with family pictures. Taken with tripod. 85mm (1998).

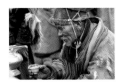

Page 159. A wedding ceremony in Zanskar. Candid shot. 85mm (1998).

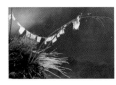

Page 160. Prayer flags are everywhere in Zanskar and all over Tibet. In the valleys, the wind flutters these prayers of compassion, printed on cloth faded by the sun and attached to the roofs of houses, thus spreading a constructive and beneficial energy. 135mm (1985).

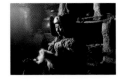

Page 161. This photograph astonished me when it was developed. It reflects all the quiet peace of the days spent in the winter quarters of families throughout the season. At the time, I possessed neither the equipment nor the technical skill needed to take such a photograph. It was just a stroke of luck. 35mm (1980).

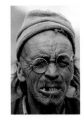

Page 162. This old Zanskar man, whom I met on the edge of a village, posed for me unaffectedly. He had left the valley only once in his life: five years before, when he went to Manali—a seven-day trek on foot—and bought his glasses at the bazaar. 135mm (1984).

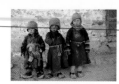

Page 163. Children in Zanskar never own more than one set of clothes for day-to-day wear. These are often handed down from their elder siblings and are worn and patched. If the family can afford it, new clothes are woven for festivals. Candid shot. 35mm (winter 1981).

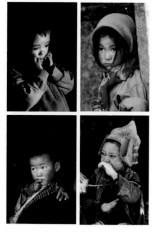

Pages 164–165. I love the children of the Himalayas. Their family upbringing is based on learning by example and on the simple life of people who always retain a sense of wonder. Ladakh, Zanskar, Bhutan, and Zanskar. 85mm and 135mm (1984–1996).

Page 167. The monastery of Lamayuru, Ladakh, on an autumn evening. 135mm (1987).

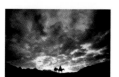

Page 168. At twilight, a Zanskar horseman passes our encampment on the way back to his village. Candid shot. 20mm (1998).

Page 169. At the peace gathering that brought 400,000 pilgrims to Bodh Gaya, a man prostrates himself before the stupa on the site where the Buddha attained enlightenment 2,500 years ago. Taken with tripod. 180mm (2002).

Page 170. Two villagers return from the mill one evening as the monsoon clouds spill over the range of the Himalaya, in the high valley of Zanskar. 85mm (1987).

Page 171. Recognized as the ninth reincarnation of the spiritual master of the monastery of Korzok, Ladakh, this child now presides over the monastery's festivals. 85mm (1996).

Page 172. Twenty thousand monks from all Tibet's religious orders pray with the Dalai Lama for world peace, around the stupa of Bodh Gaya. 35mm (2000).

Page 173. At Wangdiphodrang Dzong, a monk leaves the monastery school where he has been teaching young novices. 35mm (1993).

Page 175. Because of its strong flow, the Frozen River never freezes over completely. Only its edges freeze over on the surface, allowing Zanskar to be reached in a five-to-twelve day walk, depending on the state of the ice. Candid shot. 85mm (1989).

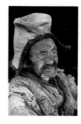

Page 176. Motup and Diskit's uncle has come out his main door to say goodbye to us before we set off along the Frozen River. Candid shot. 135mm (1989).

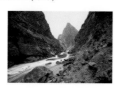

Page 177. Our party enters the gorge of the Frozen River, the start of a ten-day walk to take Motup and Diskit back to their family. I was wild with delight at the prospect of experiencing this adventure once again. 20mm (1989).

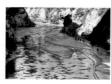

Page 178. This is one of my favorite pictures of our journey along the ice of the Frozen River. For me, it conveys all the beauty of this adventure with Motup and Diskit, which was accompanied by the constant prayers the porters murmured as they probed the ice. 85mm (1989).

Page 179. Accompanied by monks from the monastery of Phuktal, a Tibetan master journeys to the remote village of Shade to carry out an initiation ceremony. Although the trail is extremely steep, he cannot dismount from horseback because the monks, who want to honor him, try to keep his effort to a minimum. For the master, however, who lives as a refugee in southern India and is unaccustomed to the horses and ancient saddles of Zanskar, this path is an ordeal. 135mm (1986).

Page 180. After a short halt on the banks of the Frozen River, the porters in our caravan warm the palms of their hands over the dying embers before setting off across the ice once more. This photograph, a symbol of solidarity, has been published many times. Candid shot. 20mm (1989).

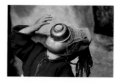

Page 181. A Zanskar child relishes a festival meal, licking the last grains of sweetened rice from his bowl. Candid shot. 85mm (1998).

Page 182. There is no marked path leading up the steep slopes to the Putha Hiunchuli base camp. It has been snowing since morning, the laden mules' hooves are slipping, evening draws in, and the whole party is gripped by anxiety. 35mm (1996).

Page 183. Tsering Dorje silently savors some hot soup during a break in the journey along the banks of the Frozen River. Candid shot. 85mm (1989).

Pages 184–185. Danielle and the porters walk across the frozen Zanskar plain on the way to the canyon of the Frozen River. In front of them are the two children, Motup and Diskit, whose parents have just entrusted them to us so that we may take them to school. We are seized by terrible uncertainty. Should we be taking these two children? Motup and Diskit, for their part, advance confidently and eagerly toward their future. 35mm (1988).

Page 186. A child in the village of Ura, Bhutan, enjoys the company of his grandfather, who is praying peacefully. Candid shot. 85mm (1992).

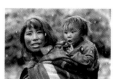

Page 187. This young mother in the village of Charkha, Dolpo, posed proudly for me to photograph her only child. Snowflakes began to fall. The child was astonished. 135mm (1996).

Page 188. On the Frozen River, air bubbles produced by the current are trapped in the ice. The surface is very slippery in such spots, and there were many falls! 35mm (1980).

Page 189. Meanders in the Kyichu River, overlooked from the monastery of Ganden, Tibet. 180mm (1994).

Page 191. I was sent to Bodh Gaya by the magazine *Paris Match* for a reportage on the 400,000 pilgrims who had come down from the Himalayas to pray with the Dalai Lama and counter the negative energy that was destroying peace in the world. A few hundred miles from there, war was raging in Afghanistan. I was looking for an image to symbolize the Tibetan people's desire for peace, when I spotted a man who was praying among these prayer flags. I thought that with a slow shutter speed and a little wind, the flags would be blurred and could symbolize the energy of this gathering. The next day I asked Nyima Lhamo to pray among the flags. Nyima Lhamo is like our daughter: we have watched her grow since she was eight years old. I explained to her that a photograph only works if it is sincere, and that she should not pose for me but pray as fervently as if she were under the tree of the Buddha. It took two three-hour sessions before the right gust of wind came along. Rapt in her prayers, Nyima Lhamo never once raised her head in those six hours. Taken with tripod. 300mm (2002).

Page 192. A young monk at the entrance to the shrine of the Karcha monastery, Zanskar, India. 35mm (1998).

Page 193. The Fourteenth Dalai Lama, accompanied by a large number of monks, prays under the tree of Bodhi, in whose shade the Buddha attained enlightenment 2,500 years ago. This spot, also known as "India's Diamond Throne," is at Bodh Gaya, northern India. 20mm (2002).

Page 194. A young shepherdess prostrates herself every three strides as she walks around the monastery of Kumbhum, Amdo. Each time, her act symbolizes the desire to gather up the suffering of the world. 180mm (1986).

Page 195. The town of Darjeeling, in Sikkim on the Himalayas' southern flanks, during the monsoon. 180mm (1998).

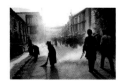

Page 196. Pilgrims prostrate themselves before the Jokhang temple in Lhasa, the Tibetans' holiest site. 35mm (1986).

Page 197. In order to render the intimate, mysterious atmosphere of the shrines within the Jokhang temple, I used a mirror to direct a ray of sunlight, which was shining in through a skylight, onto this painting of the god of shadow. Taken with tripod. 135mm (1986).

Page 198. Monks at prayer during the Kalachakra, the initiation of the peace of the heart, as taught by the Dalai Lama at Bodh Gaya. 135mm (1985).

Page 199. Murmuring prayers, a woman lights butter lamps in the Jokhang temple, Lhasa. Taken with bounced flash. 35mm (1994).

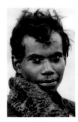

Page 200. Freshly washed after a day spent boiling tar amid the noxious smoke of a building site in Ladakh, this Dumka road builder poses for his photograph. 85mm (1998).

Page 201. The busy back street of Barkhor, Lhasa, encircles the Jokhang temple, around which pilgrims walk, praying as they go. The street is swept every day. 35mm (1986).

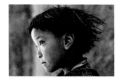

Page 202. The offerings made during the prayer for world peace at Bodh Gaya, when 400,000 pilgrims gathered around the Dalai Lama. Shot from atop a very rickety chair, during my reportage for *Paris Match*. 20mm (2002).

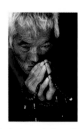

Page 203. A rare snatched portrait, taken in Zanskar. 85mm (1998).

Page 204. I asked permission of this elderly man who welcomed me in the little village of Ura, Bhutan, to photograph him in his wooden kitchen. He chose to be depicted while praying for the happiness of all living things. Taken with tripod and reflector. 85mm (1993).

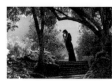

Page 205. Danielle poses for me at the Rigpa center in Lerab Ling in the south of France. We were the official photographers of the Dalai Lama, who was teaching in France, and I was trying to convey the peace that reigned in the center, where 10,000 Westerners of all faiths had gathered. Taken with tripod. 35mm (2000).

My aim has been to highlight the pictures
dearest to me in a more intimate setting; this art book is
the reflection of my work in the Himalayas.

My next book will be devoted to my photographs of India.

Year after year, continent after continent, I will build up,
in collaboration with the Éditions de La Martinière in France,
a series of prestigious books, in parallel with the series
"Offerings for Humanity,"
which gathers the most inspired
thought produced by each culture.

I would like to thank
an anonymous donor,
Lotus and Yves Mahé,

as well as
 FUJIFILM

and the **DUPON**
photography lab in Paris,
who have supported me on
this wonderful adventure.

None of these pictures would have existed
without all of you,
without you,
in Tibet, in India, in Nepal, Bhutan, and in the West,
who accompanied me along life's journey, supported,
welcomed, inspired by your presence,
your advice, your glance, your sensitivity,
your light, and your prayers.

With my deepest gratitude
I dedicate this book
to you,
to all of you
whom I was privileged to meet
and who created my happiness.

OLIVIER FÖLLMI

Born in 1958, **OLIVIER FÖLLMI** shared twenty-five years of his life with the peoples of the Himalayas and did much to promote awareness of Tibet's heritage through his photographs which, reproduced many times, have been seen around the world. With his wife, Danielle, he has been close to the community of Tibetan exiles that gave the couple children for adoption. Olivier and Danielle also founded HOPE, an organization that promotes education in the Himalayas.

Photographing the inner world of different peoples is a task dear to Olivier Föllmi, who now travels the world with his assistants, putting together the series entitled Offerings for Humanity. Every year, in autumn, this series will celebrate the thought of different cultures through photographs that have never been seen before.

In parallel, following *Homage to the Himalayas*, a prestigious title will also be produced, by the same publisher, containing the most beautiful photographs from the entire series.

"**BENOIT NACCI,** artistic director at Éditions de La Martinière, has been behind the production of France's most beautiful books of photographs for the last thirty years. His way of always looking at a subject afresh, his sensitivity, and his technical and creative skill have guided and inspired me along the way, as he has guided a whole generation of photographers who reached maturity thanks to his immense talent."

"**ANG NORBU** is a Sherpa, born at the foot of Mount Everest, in Nepal. A faithful companion in adventure, he has been my assistant throughout my years in the Himalayas. Together we have wandered the valleys of India, Nepal, Tibet, and Bhutan, climbed countless mountain passes, and conquered several summits above 23,000 feet (7,000 meters). We have traveled along Zanskar's Frozen River six times, and slept for months in caves at temperatures of –30°C. He has been immensely helpful everywhere, carrying my luggage when I was exhausted, cooking my rations when I was too cold, and unfailingly helping me with my photography. With intuition and foresight, he has always made himself charming to villagers and resolved all differences. It is thanks to him that I have been able to experience the Himalayas so intensely, and bring back all my images."

OLIVIER FÖLLMI

Project Manager, English-language edition: Céline Moulard
Editor, English-language edition: Virginia Beck
Design Coordinator, English-language edition: Tina Henderson
Jacket design, English-language edition: Robert McKee
Production Coordinator, English-language edition: Steve Baker

Library of Congress Cataloging-in-Publication Data:
Föllmi, Olivier, 1958-
[Hommage à l'Himalaya et à ses peuples. English]
Homage to the Himalayas / Olivier Föllmi; preface by His Holiness the Dalai Lama, in collaboration with Benoit Nacci; translated from the French by Simon Jones.
 p. cm.
Includes bibliographical references and index.
ISBN 0–8109–5913–5 (hardcover : alk. paper) 1. Himalaya Mountains Region—Pictorial works. I. Title.
DS485.H6F69 2005
954.96'0022'2—dc22

 2005005866

Published in 2005 by Harry N. Abrams, Incorporated, New York.
All rights reserved. No part of the contents of this book may be reproduced without the written permission of the publisher.

Printed and bound in France
10 9 8 7 6 5 4 3 2 1

Harry N. Abrams, Inc.
100 Fifth Avenue
New York, N.Y. 10011
www.abramsbooks.com

Abrams is a subsidiary of
LA MARTINIÈRE